Self-Mutilation and Art Therapy

of related interest

The Revealing Image
Analytical Art Psychotherapy in Theory and Practice
Joy Schaverien
ISBN 1 85302 821 5

Art Therapy and Dramatherapy
Masks of the Soul
Sue Jennings and Åse Minde
ISBN 1 85302 027 3
ISBN 1 85302 181 4

Contemporary Art Therapy with Adolescents
Shirley Riley
Forewords by Gerald D. Oster and Cathy Malchiodi
ISBN 1 85302 637 9
ISBN 1 85302 636 0

More Than Just a Meal
The Art of Eating Disorders
Susan R. Makin
Forewords by Bryan Lask and Cathy Malchiodi
ISBN 1 85302 805 3

Self-Mutilation and Art Therapy
Violent Creation

Diana Milia

Jessica Kingsley Publishers
London and Philadelphia

First published in the United Kingdom in 2000 by
Jessica Kingsley Publishers Ltd,
116 Pentonville Road, London
N1 9JB, England
and
325 Chestnut Street,
Philadelphia PA 19106, USA.

www.jkp.com

Library of Congress Cataloging in Publication Data
Milia, Diana.
 Self-mutilation and art therapy : violent creation / Diana Milia.
 p. cm.
 Includes bibliographical references and index.
 ISBN (invalid) 1-85302-683-4 (pbk. : alk. paper)
 1. Self-mutilation--Treatment. 2. Art therapy. I. Title.
RC552.S4M55 1999 99-42607
616.85'82--dc21 CIP

British Library Cataloguing in Publication Data
A CIP catalogue record for this book is available from the British Library

Printed and Bound in Great Britain by
Athenaeum Press, Gateshead, Tyne and Wear

Contents

List of figures

Acknowledgements

This book is based on an article originally published in the *American Journal of Art Therapy* (volume 34, no. 4, pages 98–106). It has come into being through the participation of clients in art therapy and through the support, both inspirational and technical, from the faculty and extended family of the art therapy department at New York University. Particularly influential has been the work of Edith Kramer and Laurie Wilson, with valuable assistance from Eileen McGann and Laura Cosgrove. Also special thanks to family members and friends for continued support, encouragement, and patience. Finally, I would like to thank Jessica Kingsley Publishers for the initiation and realization of this project.

Introduction

Growing public awareness of self-mutilation

Public interest in self-mutilation has dramatically increased in recent years. Articles on the subject have appeared in mainstream journals, and a lively exchange of information and personal experiences regarding self-mutilation has been taking place in chat rooms and websites on the internet. Support groups, self-help books, and clinical articles on self-mutilation have proliferated. It was recently the topic of an episode on a current network television show geared toward family audiences. At the same time, aesthetic forms of body modification such as tattooing and piercing have moved from the margins of society into mainstream culture and fashion. Another phenomenon, sado-masochism, is a flourishing business in urban centers, having spread from underground performance venues to theme bars and restaurants, boutiques and sex shops, and designer clothing.

Self-mutilation is difficult to treat clinically, in part because it has so often been done privately with assiduous secrecy. However, now that it has been widely acknowledged publicly, those who practice it are more apt to seek treatment. Statistically, it is difficult to determine the prevalence of self-mutilation, because of the secrecy involved. Briere and Gil (1998) estimate that 4 per cent of the general population and 21 per cent of clinical patients engage in self-mutilating behavior, with an even distribution between the sexes. Favazza (1998) reports that 'superficial/moderate' self-mutilation, mostly involving damage to the skin surface, has a prevalence of at least 1 per cent of the population per year. More severe forms of self-mutilation are far less common and are more likely to be found in patients suffering from psychotic conditions.

The shame associated with self-mutilation rises from the fact that the morbid and violent aspects of the act are so disturbing to a civilized consciousness at large. While we may become desensitized to the high levels of ritualized killings that occur in movies, war, and even the evening

9

news, the sight of self-inflicted wounds forces us to confront violent and destructive urges within ourselves that we may prefer to keep enshrined in the unconscious. Victims of violence at the hands of others are more likely to receive empathic understanding and treatment than those who hurt themselves. Health care providers may feel that their time is wasted on self-destructive patients, whose 'elective' problems divert attention and resources from the care of 'real' victims. It is often difficult for clinicians to see self-mutilation as a form of victimization, especially when self-abusers appear almost maliciously to undo whatever treatment has been given by hurting themselves over again. The caregiver, already revolted by the morbidity of the act itself, is made to feel rejected and, in a sense, victimized for trying to help. Many current professional papers and books on self-mutilation are aimed at providing support and insight for clinicians faced with clients suffering with this difficult problem. Owing to the comprehensive and pivotal work on self-mutilation done by Armando Favazza (1987) linking 'pathological' self-mutilation to cultural rituals of transformation and healing, it is now more widely viewed as 'a morbid form of self-help' (Favazza 1998, p.267). This perspective leads to the possibility of an empathic approach to treatment, based on an acknowledgement of the centrality of self-inflicted pain and violence in human culture and religion, or that self-mutilation is not alien to human nature.

Growing need for treatment options

The growing public awareness of self-mutilation, resulting in more people seeking treatment, sets up a need for the development of effective treatments. The case studies in the later chapters of this book explore the use of art therapy in combination with individual and family psychotherapy in the treatment of children and adolescents whose clinical profiles include self-mutilation, self-destructive behavior, or both. This book does not attempt to provide a recipe for the treatment of self-mutilation *per se*, but does aim to provide insight into the possible benefits of art therapy in an effective overall treatment plan. While explorations have begun on the use of art therapy in the treatment of eating disorders (Schaverien 1995, Haeseler 1991), little has been published on self-mutilating clients in art therapy. Yet, the therapeutic art process may be one of the few arenas of treatment that can incorporate and transform the

violence inherent in the act of self-mutilation. In the following chapters, an attempt will be made to unveil the similarities and connections between the creative process in fine art and the self-transformational process of self-mutilation, with its counterpart in cultural rituals of sacrifice. Along with a central theme on the transformation of destructive energy with creative inspiration, the discussion will also cover other aspects of art therapy that may be effective in addressing specific needs of self-mutilating patients.

Aside from the consideration of art therapy as a treatment modality for self-mutilating clients, another aim of this book is to provide insights into the dynamics of self-mutilating behavior itself. Because the creative art process has the potential so clearly to parallel and reflect acts of self-mutilation, much can be learned about the latter by witnessing art therapy sessions with self-mutilating clients. The descriptions of the art therapy sessions in the case studies included here will attempt to give the reader a close-up view of actions and interactions occurring in the art process related to the theme of self-mutilation. Some analysis of symbolic aspects of the artworks will be included, as these may be seen to shed light upon the experiences of these self-mutilating clients in particular, and upon various themes associated with self-mutilation in general.

For those readers that are familiar with art therapy, or are practicing art therapists, the following discussion hopes to provide deeper insights from a creative perspective into the dynamics associated with self-mutilation and self-destruction played out in the art therapy medium. Because this is not an approach that involves the use of specific directives, actions and interventions are described and clarified in detail to remove as much as possible the mystery that may surround the actual process. In this method of working, there is no prescribed action other than what is mandated by the client, or by the client and the therapist working together and interacting in the process of making art. Since each client is unique, therapeutic interventions must be informed by a deep and confident knowledge of art therapy practice and theory, as well as familiarity with the meanings of self-mutilating and sacrificial rituals. This discussion hopes to provide a deeper and richer understanding of such rituals for those readers who are art therapists and would like to apply their expertise in this area of clinical work.

For readers not familiar with art therapy, it is hoped that this view of self-mutilation from the perspective of the creative process will enrich and deepen general knowledge of the subject. It is also hoped that it will inspire an interest in art therapy in general, and more specifically as a possible method of treatment for self-mutilating clients. While attempting to unveil the working process of a modality that may seem shrouded in mystery at best or superficial at worst, it is hoped that this discussion will impart a sense of the potential depth of the art therapy process in treatment. In short, it is hoped that this book will contribute toward the consideration of the use of art therapy on a wider basis, particularly at a level that is consistent with its potential. Although art may be inherently therapeutic for some self-mutilating clients, the presence of a qualified art therapist in the session is a crucial factor in the containment and processing of potentially volatile psychic material that may arise during sessions of intense creative work.

Overview of chapters and theoretical viewpoint

The theoretical ideas expressed here are based on the view of self-mutilation as a form of healing, or attempted healing, through violent or self-destructive means. In this discussion, the morbidity associated with various forms of self-inflicted violence is placed within the context of cycles of creation and destruction inherent within the creative process. Because creation and destruction are viewed here as neutral forces operating in response to one another to effect transformation, morbidity is potentially a meaningful part of an entire process of change. In the self-healing view of self-mutilation, the concept of transformation is a key that opens many doorways and connective pathways between ritual, culture, psychology, and art. Transformation is linked to rituals of sacrifice, which in turn lies at the core of the cultural meaning of self-mutilation. Psychological meanings of self-mutilation draw upon this culturally based core concept, with the additional provision of the concept of 'pathological' forms of self-mutilation, distinct from 'culturally sanctioned' forms. Both are aimed at healing; what constitutes pathology in the former is the fact that its use is considered idiosyncratic, and therefore not meaningful within a cultural context. An art-based view of self-mutilation seeks to transcend the ritualistic act of violence, transforming it into an aesthetic form of expression. This final

transformation involves a gradual change from ritual acts to completely formed and liberated symbols.

The distinctions made between pathological and culturally sanctioned forms of self-mutilation have value in terms of clinical diagnostic use and certain behavioral approaches to treatment. However, in this book I would like to discuss a treatment approach that is slightly different. It looks at self-mutilation according to a scale of variation between sacrifice and symbolism, incorporating to varying degrees both ends of the scale. From this perspective, the work done in art therapy by self-mutilating clients may be looked at in terms of movement toward, or away from, symbolization. This theme will be developed from various perspectives: from a cultural viewpoint, from a variety of psychological dimensions, and through a series of case studies.

The first part of the book examines cultural and psychological interpretations of self-mutilation. Chapter 1 focuses on self-mutilation in various cultural contexts, ranging from the ritualistic/sacrificial to the aesthetic/symbolic. This is arranged and explained in terms of a continuum from sacrifice to symbolization. The connection between sacrifice and symbolization is explored, both from constructive and deconstructive perspectives. The desconstructive perspective, corresponding to a feminist-centered approach, involves desymbolization aimed at exposing cultural biases of violent exploitation of women, and assumptions about femininity and victimization. Chapter 2 focuses on psychological interpretations of self-mutilation, arranged according to ideas loosely grouped around unconscious sacrificial motives, and moving on toward concepts of mental organization at the level of communication and symbol formation. The transformational psychological process of movement from the unconscious toward the conscious is seen as a parallel to the transformation of matter to spirit in sacrifice, and the transformation of sacrifice to symbolization in the creative process.

Chapters 3, 4 and 5 are each devoted to case studies that employ the process of making art in a therapeutic environment as a means to develop symbolic capacities. In each case, sacrificial analogs will be described, particularly where these shed light upon related acts of self-mutilation. Various psychological themes associated with self-mutilation will be revisited, as these arise during the process of destruction and creation, in the appearance of symbolic forms and within the interactions between the

client and the art therapist. Chapter 6 isolates and briefly summarizes a variety of the qualities and types of interventions inherent in art therapy that may serve the particular needs of self-mutilating clients. I conclude with a short review of the themes presented throughout the book. It is hoped that the reader will be left with a clearer understanding of the role of violence in self-transformation.

Sacrificial and Aesthetic Aspects of Body Modification

Sacrifice and communal rituals involving self-mutilation

The economics of pain

Suffering and the endurance of pain have long held a place of value in economic equations. This is reflected in terms such as 'hard labor' and 'sweat equity', when these are exchanged for money, services, goods, debt, or absolution for crimes. The 'labor' of childbirth links the notion of pain and suffering with productivity. This linkage may be seen as virtuous, as in a 'work ethic'. Pain is also seen as a reward for wrongdoing. In 'paying for one's crimes', a person must at least undergo the pain of shame and humiliation, if not the pain of corporal punishment. Body mutilation, flogging, prolonged exposure to the sun, and force-feeding of unpleasant substances were common forms of punishment in antiquity (Haj 1970).

In shamanic societies, the shaman uses the economics of pain endurance to prove his or her power as a spiritual intercessor to the potential client. Physical suffering rather than purity or humility is the requisite for attainment of shaman status (Radin 1957). According to Radin, this is because 'true' possession by the spirits is seen as violent in nature and the shaman, in order to communicate effectively and bargain with the spirits, must be able to endure this dangerous and painful physical process. Acts of self-mutilation and feigned or actual epileptic-like seizures, from which the shaman emerges healed and intact, serve as evidence of the shaman's power, thus increasing his or her chances of obtaining employment. Besides interceding on behalf of individuals, the shaman may also service the community as a whole, directing or performing sacrificial acts. These function to prevent collective ills such as natural disasters, poor weather,

war and violence through the notion of prepayment to appease the spirits of violence and ill will. Pain, whether actual or symbolic, must somehow be incorporated into sacrificial rituals, either as a form of payment or as evidence of the petitioner's sincerity.

Origins of sacrifice

Sacrifice may have developed as an extension of gift-giving, following a 'law of exchange' (Radin 1957, p.171) among 'primitive' societies that obligated the receiver of a gift to return one of slightly higher value. The spirits in this case are expected to respond accordingly to a gift by the granting of some greater blessing. This introduces the concept of sacrifice as an exchange of a part for the whole, a theme that will be developed in more detail with reference to self-mutilation, in chapter 3.

Girard (1977) theorizes another origin of sacrifice. He suggests that sacrifice is a form of institutionalized violence directed at a scapegoat, which serves to protect a group or society from boundless reciprocal violence against its own members. The term 'reciprocal violence' refers to an unending chain of violent retaliatory acts set off by an original insult or other transgression. As in the case of a blood feud, each violent killing or attack invites a retaliation of equal or greater value, leading to an unending cycle of violence precipitated by a single event. The institution of sacrifice is seen by Girard to have developed as a result of an initial 'generative' experience in which the killing of a suitable substitute victim had the effect of restoring peace and harmony within the community. Girard explains that a suitable substitute must be of sufficient likeness to the original object of vengeance to convince the community of its malevolence, yet be removed enough from the community not to leave behind survivors capable of retaliation. The sacrifice of a substitute victim therefore satisfies the need of the community to exercise its violent urges, while breaking the chain of ongoing vengeance. There may be in other species some precedent for the use of a substitute in the discharge of aggression. Certain mating rituals, such as the 'triumph ceremony' in the greylag goose, have been observed to incorporate a symbolic attack upon an outsider which is supposed to discharge aggression that might otherwise be directed against the mate. The mating ritual serves to reinforce a

bond of attachment and harmony between the members of the goose couple (Lorenz 1966).

According to Girard, sacrifice is based on the concept that violence is necessary to prevent violence. Sacrifice is a special kind of violence sanctioned by the community and controlled within channels of ritual and symbolism. One of the purposes of sacrifice is to maintain a sense of order in the community, such that a clear boundary is established between violence that is 'good' and legitimate and violence that is 'bad' or unsanctioned. One way in which legitimate violence is kept 'pure' is through the sanctification of the sacrificial victim. Paradoxically, the victim – referred to by Girard as a 'sacrificial substitute' – must undergo vilification and sanctification almost simultaneously. Vilification absolves the community from guilt for satisfying its violent urges; sanctification occurs when the victim performs the 'selfless' service of giving its life for the good of the community. As an agent for peace in the community, the victim in death is elevated to the status of deity, becoming a distanced, safe repository for violence. In its association with violence, the sacred becomes taboo, untouchable. Symbolically, the sacred victim comes to represent that which is both evil and transcendent of evil. The ritual of sacrifice forms a bridge to transcendence of sin, and in this way accomplishes purification.

The sacred significance of blood

Sacred or ritual objects and sites are often taboo, their symbolism reflecting a violent nature. Blood and the color red are frequently found in association with the sacred. Spilled or collected blood is incorporated into sacrificial rituals in a variety of ways. Red pigmentation has been used extensively in sacrificial and burial rituals (Holler 1995; Levy 1948). Indigenous funeral rites in Australia and North America 'always included self-wounding, because blood was the physical counterpart of the mystic life-union. It was probably represented in the red ocher sometimes painted over the bone' (Levy 1948, p.64). Paleolithic gravesites were often found drenched in red ocher staining the bones and objects buried with the corpse, as well as the ground surrounding it. The purpose for this may have been to simulate a transfer of the life force into the afterlife. Red paint is

used to mark sacred objects in the Lakota sundance ceremony, which is described in greater detail below (pp.21–26).

A connection has been made between the symbolism of blood in sacrifice and taboos on menstrual blood. Menstrual blood is seen to be a physical representation of sexuality, which itself may be a source of violence and disorder (Girard 1977). Strict taboos placed on menstrual blood and menstruating women (Frazer 1922) probably account for the fact that femininity has been generally associated with such related ideas as evil, violence, purity and the sacred. In some cases, men engage in ritual self-mutilation to simulate the menstruation process in women. Favazza (1987) describes a practice among men in a south Pacific island culture in which the nasal tissue is scratched to induce bleeding as a form of 'vicarious menstruation' (p.94). If menstrual bleeding is viewed as a form of cleansing and purification of the body, it is easy to see how parallel rituals might become incorporated into ceremonies of purification. An extension of this idea can be seen in the belief and practice of bloodletting to drain illness from the body. Just as violence has been split into good and bad types – that which is sanctioned for the purpose of maintaining societal order and that which is unlawful – blood has also been classified in opposite types. A high value is placed upon 'pure blood' while 'bad blood' is tainted and vilified. The dual nature of blood becomes apparent as its presence represents the life force, and its spillage heralds the draining away of life.

Duality, twinship, and sacrifice

Duality appears in several contexts in relation to the practice of sacrifice. First, in the doubling of the sacrificial substitute for an original object of violence; second, in the concept of the sacrificial victim as human and divine; and third, in the dual nature of the blood as both tainted and pure. Sacrifice symbolically seems to perform an act of splitting and killing off of the human or tainted twin for the survival of the remaining purified twin – a metaphor for the cleansed community. For a sacrifice to be successful, the community must be unified against the offending victim, thus ensuring that peace and order will prevail. Victim and unified community face off as two sides of a conflict, standing in for the original conflict between siblings, or among other rival pairs of equal status within

a community. Much has been written about various superstitions and taboos surrounding twins. In Girard's theories about the origins of sacrifice, twins represent rivalry and pose the threat of the filial violence that is the most dangerous disintegrative force within a community, leading to unending cycles of violence and revenge. Twins are easily mistaken for one another, and the resulting confusion causes a blurring of distinctions that engender chaos. At a societal level as well, chaos may occur when boundaries between members are unclear, or when distinctions among members disappear, and all are perceived as equal. For this reason, sacrificial rituals were instituted to establish arbitrary or symbolic boundaries and distinctions to prevent more violence. It should be noted that Girard distinguishes primitive from modern societies in that modern (i.e. democratic) societies have replaced the institution of sacrifice with the judicial system as a fairer method of dealing with violence. A breakdown of the legal and judicial system, on the other hand, might precipitate what Girard terms a societal 'sacrificial crisis', in which the boundaries between sanctioned and unsanctioned violence are blurred, and societal order dissolves into chaos and civil warfare.

The sacrificial ritual serves to re-enact and resolve the sacrificial crisis. For this reason, sacrificial rituals are usually preceded by a period of festivities in which normal taboos are lifted. This may include overeating or indulgence in alcohol, hallucinogens, or other restricted substances to aid in the removal of inhibitions and the distortion of reality. It may involve the loosening of sexual taboos and boundaries, resulting in adulterous, incestuous or other forms of illicit intercourse. Costumes and masks may be used to promote anonymity and blurring of identity and social ranking. In some cases, staged fights or duels occur. At a certain point, the unleashed passion and aggression of the crowd is turned toward a victim. When the victim is sacrificed, order is re-established and calm is reinstated. Periodic ritual releases of aggression are intended to prevent the unwelcome occurrence of unpredictable violent outbursts in the community. One aspect of the sacrificial rite is the blending of violence with pleasurable experiences of ecstasy and spiritual oneness or transcendence. Again, the dual nature of the event is apparent.

Mapuche sacrifice

Tierney (1989) investigated a child sacrifice that allegedly occurred among Mapuche tribal people in the Lake Budi region of Chile in the early 1960s. His account parallels some of the points that Girard makes regarding the functions of sacrifice. Overtly, the sacrifice of an 'orphaned' child was performed for the stated purpose of cleansing the community of sins that may have caused a destructive earthquake and tidal wave that occurred in the region in 1960. According to rumors, a local medicine woman performed the sacrifice; although Tierney's investigations uncovered evidence that politically powerful men in the community had actually ordered the event to take place, with the participation of 'hundreds' of others. The child chosen as the victim was spoken of as an orphan, but in fact his mother had simply been sent away for a period of time and was not present to resist or retaliate against those who seized her child. The ceremony took place around a totem pole, and involved dancing, drunkenness and a simulated battle between naked men with spears. The sacrificed child became identified as a 'saint', whose spirit joined with that of the sacred mountain where he died. In this case there were two victims: the child that lost his life in payment for communal sins believed to have caused the natural disasters; and the medicine woman, who Tierney identified as a surrogate victim. As a marginalized but important member of the community, she was both respected and vilified, serving as a repository for the communal guilt surrounding the murder of the child.

While Girard aims to demystify the practice of sacrifice by exposing its origins in an actual, primordial experience that is later mythologized, Tierney emphasizes the experience of sacrifice in its mystical and irrational aspects. 'There is an unbridgeable gulf between the analysis and the experience of sacrifice' (Tierney 1989, p.22). Having witnessed rituals of sacrifice, Tierney describes it as a vicarious experience of death and resurrection in which surrender plays a role: 'losing control in the excitement and fear of ultimate risk' (p.23). He sees as a counterpart to the mystical experience of sacrifice the yoga 'corpse posture', in which the practitioner is taught to 'visualize his own dismemberment and decapitation' (p.19). A progressive relaxation exercise, it does embody an idea of dissimulation and reintegration that is central to the theme of sacrifice, whether concrete or symbolic. Just as a sacrificial act involves symbolic elements, the entire act may move to a symbolic level, as this example

suggests. Similarly, somewhere along the scale from concrete to symbolic, self-mutilation appears as a form of sacrifice mixing physical and symbolic elements.

The Lakota sundance

The sundance, originally practiced by the Lakota people of North America, incorporates ritual self-mutilation as the primary form of sacrifice. It is an elaborate ceremony, involving extensive preparations preceding the two- to four-day event. Holler (1995) cites a variety of nineteenth century accounts, contemporaneous or later eyewitness accounts told from memory, to reconstruct in detail the Lakota sundance as it was practiced during that period in history. He follows this with an analysis of contemporary sundance practices surviving a US government ban on the rites. The following description of the sundance draws from Holler's historical research, and is presented here to illustrate how ritual self-mutil- ation can be seen to fit into a broader theory of sacrifice. There are variations in the details of the ritual from one account to another, but the general outline and the styles of self-mutilation used are universal. Like the Mapuche sacrifice described earlier, the sundance features a sacred tree as a centerpiece. The selection and cutting down of the tree is an important part of the preparatory rituals. Experienced male warriors head out as though to battle in search of a tree. After a series of charges on horseback to a nearby hill and back, a tree is selected. On the day that it is to be cut, the warriors rush at and strike the tree with physical and verbal blows as though it were an enemy. After each strike upon the tree a gift is made to the community, such as a horse. Women participate in felling the tree and trimming its lower limbs. Red paint is applied to the 'wounds' where the limbs are cut off. The tree is decorated with ritual objects and carried to the site of the dance in such a manner that no hands may touch it, as it is sacred and taboo. It is erected in the center of the circular ceremonial area, consisting of a sacred inner circle and an outer shade area for viewers and supporters of the dancers. During the sundance, the inner circle is restricted to the dancers, the 'medicine elders' and the dancers' helpers.

The dancers prepare for the dance by fasting and having their chests painted red with symbolic designs. They dress in ceremonial costumes such as red skirts and buffalo robes, some wearing war bonnets or the skin

from buffalo heads. When the dance begins, their hands are painted red, and they may touch only certain sacred objects. Red painted buffalo skulls are carried into the circle and placed at an altar; in some cases, red painted horses are brought in and tied to the sun pole. The dancers submit to a variety of tortures, all involving piercing of the skin and gazing at the sun. In the mildest form, a small piece of skin is cut away, enough to cause a flow of blood. Women and children may participate in these flesh offerings. The more severe forms of torture involve lifting the skin, making an incision and inserting a sharpened stick through the flesh. To this is attached a rope, from which may be suspended a buffalo skull that the dancer drags around the dance area. Some dancers may be tied between four stakes, attached by four ropes connected to the skin of their chests and backs. Others dance while attached by the skin of the chest to ropes hanging from the sun pole. The most extreme torture involves full suspension from the sun pole. During all of these tortures, the dancer is expected to gaze directly at the sun. Food and water are prohibited for the duration of the dance. A dancer may be released from the dance when he is able to break free from the tree by ripping the flesh away from the ropes. If a dancer is unable to break away, he is untied at the end of the dance, although this form of release accords less prestige to the dancer. A dancer may also be released if he faints, or if his family pays heavily in gifts for his release.

The sundancer's financial obligations are considerable, in terms of gifts that must be given at various points before and during the annual event, which takes place in the summer months of June and July. To become a sundancer or, at the highest level of torture and sacrifice, a shaman, one must possess considerable wealth to distribute among the community. However, because of the redistribution of wealth that occurs as a result of the ceremony, the sundance is a time when a person's fortune may change considerably.

Besides redistribution of wealth, another communal function of the traditional sundance is symbolic purification to prevent disasters such as famine and epidemics. Personal reward is also allowed, as the sundancers compete to gain respect and leadership in the tribe through demonstrations of superior courage, will, and physical endurance. Sacrifices are often made for personal reasons, such as the recovery of a sick relative, or in repayment for one's own recovery from an illness or affliction. Sundancers

may also dance to test and strengthen themselves as warriors and hunters, in preparation for the upcoming year of hunting and for possible battles. They may undergo sacrifice and purification as a request and advance payment for success in war and hunting.

In Lakota symbolism, red is the color of the sun and is sacred. The sundance traditionally begins at dawn, at the hour when the sun is typically a reddish color. Red paint is used extensively in the sundance, on the bodies of the dancers and on a variety of ritual objects. The blood flowing from the piercing wounds adds more red symbolism to the ritual. Its presence is evidence of pain and serves as a guarantee of the dancer's sincerity when making pledges or asking for favors. Pain endurance is a demonstration of strength and will. Gazing at the sun is said to prove a dancer's sincerity, by showing his willingness to look the sun straight in the eye when making a request. Scars on the chest and back earned from the sundance piercings serve as evidence of a warrior's eligibility for leadership roles, and of the integrity of his reputation and word. The giving of flesh is considered to be the ultimate sacrifice, to show that a part of the integral body is given along with material gifts of lesser value.

The Lakota sundance was banned by the United States government in the 1880s. According to Holler, this was part of an effort to 'confine and…civilize' the native people, as a preferable alternative to the army's extermination of them (Holler 1995, p.111). Since this 'liberal humanitarian' effort was carried out by religious leaders, civilization translated as Christianization. The self-mutilation rituals were seen as particularly uncivilized in Christian terms (although self-mutilation is a common feature in Christian martyrdom). The ban on the sundance was officially lifted in 1934, but accounts of the ritual's reappearance, complete with piercing, do not appear until the 1950s. It is not clear to what extent the ritual was practiced secretly during the ban; however, it is clear that the sundance as it is practiced openly today preserves much of the original form and meaning of the ritual.

The sundance is still observed annually in the summer. It takes place in a circular arena, surrounding a felled tree set upright as a center pole. Spectators in the shaded area view the dancers in the restricted 'mystery circle' making vows of suffering to 'Wakan Tanka', a Lakota deity. The mystery circle remains a place of power and spirit. A modern sundancer states her belief that the ceremonial circle has looked the same for 2000

years, and expresses the pride and humility she feels in the survival of her culture through oppression and terrible odds (Thunder 1995). She describes the power of the ritual space: 'Inside the Mystery Circle the spirits came to be with us. As I danced, my Ancestors crowded around me.' (p.207.)

Piercing continues to flourish in approximately the same forms, with a degree of severity consistent with that of the period before the ban. 'The essential belief in the relevance, necessity, and efficacy of the blood sacrifice remains prominent in the modern dance' states Holler (1995, p.200). Thunder describes the transformation of pain and suffering to the 'joy and ecstasy of union with the Creator' (1995, p.208). When the dancers break free from the ropes, the skewers pulling through their flesh is an offering to the creator. According to Thunder, the moment of breaking free is determined by the point when a dancer receives a vision.

While women apparently are currently involved in the ritual as sundancers and may become shamans, the most severe forms of torture are reserved for male dancers. Women dance and give small flesh offerings, but probably do not participate in the skewering and tearing of the flesh. This may be because women are believed absolved from the need for suffering and purification owing to their role in childbearing. Former American Indian Movement leader and activist Russel Means describes the sundance as the way that Indian societies recognize women: 'We want to get in balance with the female, so we create purification ceremonies for boys and men to understand what it's like to give birth.' (Wideman 1995, p.71.)

The cultural context in which the contemporary sundance is practiced has an impact on the symbolism of the self-mutilation ritual. Holler observes that the change from a dominant regional culture with sundance at its center to a marginalized group of people within another dominant culture, has altered the meaning of the ritual. No longer challenged by direct forces of nature or warring tribes, the contemporary Lakota face obliteration as a distinct cultural group by the overwhelming force of mainstream culture. Following extermination measures and the long ban on their religious expression, the Lakota's will to survive is apparent in the vigorous resurgence of the ritual in the 1980s and into the present. In its modern context, the sundance has come to represent, celebrate, and solidify cultural identity. Its practice maintains and continues religious

traditions against all odds, as each sundance marks another year of cultural survival. The self-mutilation ritual now serves to distinguish the 'pure' or true natives in terms of culture, identity, and commitment. Repetition of the ritual ensures its survival, and the survival of the ritual means the survival of a people. The will to survive is a theme that weaves through the literature on self-mutilation, across a wide range of circumstances and applications.

Another characteristic of contemporary sundance noted by Holler is the extent to which it is being used in combination with the sweat lodge as a healing agent in the treatment of problems such as drug and alcohol abuse and trauma. These are perhaps the contemporary battles that warriors face, in part caused by the impact of marginalization and threatened annihilation of their society and culture. Such cultural battles may be played out on the individual body in relative isolation. In other words, uncontrolled and habitual self-abuse may be an unconscious re-enactment of cultural victimization. On the other hand, the ritual sacrifice of self-mutilation may help to strengthen self-esteem and integrity through the process of identification with native traditions, and may also represent an assumption of power and control by the self over habit. In another example of the application of violence to contain or prevent uncontrolled violence, the willing and self-imposed surrender to pain can be seen to achieve a transformation from helpless victim to creative survivor.

The Lakota sundance illustrates the range of functions that a sacrificial ritual may perform in a society, communally and individually. For the community, the ritual involves an exchange and equalization of resources, an opportunity for the communal discharge of aggression, and the restoration of solidarity and peace. It may provide magical protection against environmental dangers, such as weather, and against invaders or threats from within, such as internecine rivalry and loss of faith in common spiritual values and social structures. For individual members of the community, participation in sacrificial rituals may further personal goals, including healing, the attainment of distinction and glory as a warrior, acknowledgement and repayment of blessings, or passage to higher levels of physical or spiritual maturity.

The exchange value of sacrifice must be related to the degree of pain and suffering involved. Human sacrifice implies an expectation of high

return, while self-mutilation is a less extreme form, substituting a portion of the body for total loss of life. The expectation of return may be scaled back to the level of the individual. Multiple acts of self-mutilation, as in the case of the Lakota sundance, may add up to communal salvation. In either case, the sacrificial act occupies a place of exchanges and balances, not only on a human economic plane, but also between material and spiritual realms.

Body modification arts

Tattooing and scarification

In the Lakota sundance described above, the scars acquired by the dancers served as tangible evidence of their sincerity in suffering, while the painted emblems on the chests of the traditional dancers served a symbolic function to imbue power, strength, or other qualities most likely associated with totemic animals. A combination of these two factors – symbolization and suffering (although the degree of pain may be negligible) – merge in body modification practices such as tattooing, scarification and piercing. In these instances, sacrifice begins to make the transformation or sublimation of aggression into an emerging art form. The scar, or the evidence, becomes a permanent record of the act, yet removed from it to an aesthetic plane slightly distanced from the painful and sometimes brutal act of mutilation itself. In a sense, the transformation of the wound to an object of adoration and aesthetic value purifies the wounding act of its violence. This re-enacts the transformative purification process that is said to occur with human sacrifice, of evil into goodness and sanctity.

Body modification practices are ancient and worldwide. Tattooing, scarification and piercing all have in common that they treat the body, particularly the skin, as a pliable yet permanent medium of expression. In Japan, tattooing is considered to have reached its highest development as an art form when prior to a government ban in the mid-nineteenth century many tattooists were also *ukiyo-e*, or woodblock, artists. In the Japanese style of tattooing, the entire body is envisioned as one canvas, the overall design incorporating negative areas of untouched skin bordering richly decorated and brilliantly stained areas of tattoo. The natural curves of the body are taken into consideration and incorporated in the graphic design.

Such a work of art may take years to complete, and is intended to provide decorative and aesthetic pleasure and self-esteem throughout a lifetime.

In contrast, contemporary Western tattooing has favored a pastiche style of decoration, in which individual designs are placed on the body more in a whimsical than an aesthetically planned order. Tattooing in the West, with rare exceptions, has been viewed as a questionable practice within refined society – more suitably confined to marginalized groups such as sailors and prison inmates, and in an artistic sense worthy only of sideshow curiosity. Until recently, Western tattooists have been viewed as technicians rather than artists, satisfying the idiosyncratic demands of their customers and offering only stereotypical stenciled designs. Such tattoos are often chosen impulsively, and may exhibit vulgar humor or passing interests. In some cases, the customer returns for additions and cover-ups to existing tattoos. In the pastiche or 'fill-in' style, tattoos may be added wherever there is room until the entire body, with the exception of the face and hands, is covered with indiscriminate and unrelated designs. In the 1970s, Scutt and Gotch (1974) decried this style as 'kitsch' and lamented the fact that society's persistence in considering tattooing as a form of self-mutilation stood in the way of its development as a serious art form. In the last decade, however, contemporary Western tattoo designers have begun to experiment more with aesthetic approaches to tattoo design. While tattooing and other body modification arts, especially piercing, have experienced a dramatic resurgence in popularity, these practices to a degree still enjoy an elite status within the mainstream of society.

Tattooing is a relatively simple operation that has changed little with the introduction of technology. Primitive forms included the rubbing of dye into cuts in the skin, the burning of skin with a red-hot metal instrument covered in dye, the pulling of blackened threads through the skin, or the forcing of dye into the skin with needles or sharp pointed instruments (Scutt and Gotch 1974). Contemporary tattooing employs the latter technique, with the addition of an electric vibrating tool that has the capacity to hold a bundle of needles for more rapid shading. The skin is pulled and held taut while this operation occurs. Some bleeding occurs during the process, and the wound generally develops a scab that takes several days to heal. When the scab comes off, the tattoo design is revealed in its final state. Scarification is similar to tattooing, in that the skin is lifted

or stretched and cut. Vegetable ash or some other irritant that inhibits healing is rubbed into the wound to promote the formation of a raised scar.

In tribal cultures, body markings are primarily used to define social status (Sanders 1989), especially passage to adulthood. As a rite of passage, the pain involved in the process of scarification or tattooing is an essential part of the ritual experience. The ability to endure pain is a test of a young person's worthiness to accept the responsibilities and the privileges of adulthood. The sexual privileges granted with passage to adulthood must be paid for in advance. This may have to do with the need of the society to tame the rebellious impulses that are traditionally accorded to adolescence, the period of sexual maturation. Anarchic desires may be seen as a threat to the social status quo, particularly with reference to sexual boundaries. Painful rituals may serve as a reminder and a warning of the consequences of the transgression of boundaries; underlying the cutting rituals is the suggested threat of castration (most directly implied in the case of rites of passage that involve circumcision).

Initiation rites are a variant of rites of passage, and usually involve some type of suffering in payment for a change in status. Where body marking is involved, the markings serve as proof of identity and status as a member of a select group. In some cases, initiation may refer to passage between material and spiritual planes, and the markings may identify the owner for magical purposes of protection of the body or soul in the afterlife. Other magical uses of body markings include protection from accidents, illness, misfortune, or infertility.

Body marking for enhancement of sexual attractiveness may be an aspect of puberty rites, or may simply represent a shift toward a more aesthetic practice. In either case, the pain involved in the cutting may carry certain sexual connotations. Tattooing especially, which involves painful penetration by a needle, may symbolically re-enact a masochistic relationship between the passive customer and the powerful tattooist (Scutt and Gotch 1974). The intimacy of the tattoo parlor, where bare flesh is exposed often in private areas of the body, furthers the suggestion of an erotic or illicit relationship. That pleasure may be derived from this relationship is indicated by the many customers that return regularly for additional tattoos, almost as an addiction. Besides the fact that the image as well as its placement on the body may elicit an erotic response, the

tattoo may also be displayed as a battle scar and medal of honor – an emblem of bravado and the ability to conquer pain. Symbolically, it provides a layer of protection in the actual formation of scar tissue, which may embody the victim/warrior's shield of protection against the aggression of the dominator, particularly within sado-masochistic fantasies.

Body modification arts in punk and neo-tribal cultures

Sometimes, the acquisition of a tattoo serves to establish one's identification with a marginalized subgroup of society. The need to join a group that is in opposition to mainstream society may stem from feelings of powerlessness and victimization; alliance with the group may provide some sense of security and protection and may also help to strengthen identity. The wearing of markings may help to solidify an identity that feels weak or insignificant, while openly declaring opposition to and rebellion against established authority and the status quo. Punk style can exemplify this, with the wearing of leather, steel spiked jewelry, spiked and unnaturally dyed hairstyles, and anarchistic or sacrilegious tattooed patterns and slogans, with a special emphasis on piercing for shock value.

Among followers of the various genres of punk music, the prolific use of piercing and other body modification practices serves not only to indicate adherence to a particular musical group, but also expresses defiance of social norms and values (Wojcik 1995). According to Wojcik, punk style seeks to oppose the existing aesthetic order by embracing its opposite. Consequently, it celebrates that which is unschooled, unacceptable, undesired. In turning away from aesthetic value, punk culture attempts to bring our focus back to the violence in our culture. Rather than a decorative transformation of a violent act, the violence inherent in the piercing ritual is emphasized and magnified. The piercings are made to appear more directly as self-mutilations, as in the case of safety pins jammed into the skin. This undignified presentation, along with the wearing of ill-fitting and intentionally unattractive clothing and throwaway or taboo objects such as sanitary napkins, serves to illustrate the wearer's identification with the role of victim in a society that treats its children as trash, by not valuing and protecting their wellbeing. Wojcik's description of punk culture resembles Girard's vision of the sacrificial crisis in society: '[As] symbols of a society in a state of crisis and

disintegration, punks enacted their own drama of societal cataclysm, creating the overall impression that they were sacrificing their bodies on the altar of post-modern despair' (Wojcik 1995, p.11).

Punk style sometimes incorporates parodies of traditional gender styles to express rejection of sex roles, or the use of cross-dressing to amplify confusion of sexual identification. These attitudes suggest a subversion or rejection of whatever rites of passage to sexual maturity and adulthood exist in society. This may in part reflect a failure by the society to provide the young with a satisfactory view of the future in terms of meaningful work opportunities in a society worth living in. Passage to adulthood may be looked upon with despair. However, the extensive use in punk culture of piercing and other forms of self-mutilation traditionally seen in the context of rites of passage ceremonies suggests as well that there may be a need and a desire for such tangible rituals to mark the change between one life stage and another. A sacrifice is necessary, in the sense that sufficient payment in pain and suffering will produce rewards. Underlying the self-destruction and protestation of punk culture is possibly a magical wish for the transformation and purification of society through the voluntary and enduring practice of sacrificial rituals.

If the intent of punk style has been to dramatize the breakdown of civilization, a 'post-punk' style known as 'neo-tribalism' (Wojcik 1995) focuses on the positive personal struggle to rebuild an identity through 'individualization of the body' (p.33) in a dehumanizing world. A variant on the 'modern primitive' movement, neo-tribalism follows the conviction that the power to change one's own body becomes more important the more powerless the individual feels in being able to change the world: 'what is implied by the revival of "modern primitive" activities is the desire for, and the dream of, a *more ideal society*' (Vale and Juno 1989, p.4). In the example of neo-tribalist practices given by Wojcik, permanent changes to the body such as scarification, piercing and tattooing are used to achieve a sense of identity. There is value placed upon the endurance of pain in the process, not so much for the purpose of gaining attention, but to achieve personal goals of transformation. The tribal reference attempts to re-establish links with the primitive as an antidote to the dehumanization of civilization. This identification with the primitive involves a loose borrowing from cultural rites of passage ceremonies to create personally meaningful rituals of identity transformation. Neo-tribalism is an intent-

ional, self-transforming process that embraces an alternative aesthetic to mainstream style. Following a trend in twentieth-century art to merge and revitalize modern with primitive aesthetics, neo-tribalism as a body-modification practice seems to take a step further toward a more literal and magical appropriation of the primitive. By moving outside of the defined collective cultural space where art is held under protective custody, the 'primitive' aesthetic of body-modification arts may on an individual basis challenge established boundaries and assumptions regarding civilization, culture, and aesthetics: 'the last artistic territory resisting co-optation and commodification by Museum and Gallery remains the Human Body' (Vale and Juno 1989, p.5).

In the next section of this chapter, which deals with self-mutilation as subject matter and as a process in contemporary art, the permeability of the boundaries between art and life are exposed. In formal terms, this might be stated as the lack of a clear distinction between figure and ground; in psychological language, as a merging of self and object. When the body is used as a plastic medium in the creation of a landscape for example, there is an implosion both of the literal and the symbolic, and of the subject and the environment. One aspect of this discussion is the role of feminist performance art in posing questions about gender roles in art, specifically regarding the feminine body as a sexual landscape on display for the male viewer and consumer. The breaking down of distinctions and the blurring of boundaries, including the mixing of traditional gender roles and visual cues, are phenomena associated with the 'sacrificial crisis' referred to by Girard which was discussed at the beginning of this chapter.

Self-mutilation in twentieth-century visual and performing arts

Performance art

'The practice of performance art is a metaphor in itself. More precisely: a metaphor referring to a historical and social state when artistic work was a natural part of collective life and the daily efforts to humanize life in conflict with nature.' (Molderings 1984, p.173.) In primitive cultures, art is considered to be not separate from religious and magical practice. In attempting to achieve a goal of reintegrating art with daily life, performance art draws heavily upon 'primitive' influences, such as tribal rituals. It

is not surprising then that performance art frequently contains echoes of, if not overt references to, sacrificial rituals. When sacrificial-type rituals are incorporated, there is present in one form or another the violence that accompanies sacrifice. Performance art usually relies on the audience to witness the act, and on a subtle level may involve the audience as part of the act. Emphasis may be placed on the violence itself, often as forms of self-mutilation, while the audience as observers may be subtly manipulated to assume the role of the communal aggressor. Although a video recording is able to preserve a superficial account of the act, performance art is evanescent by nature and therefore aesthetic transcendence must occur in the visceral experience and symbolism of the action itself. This is different from the case of neo-tribal rituals, in which the violence and the ritual meaning of the art act is private while the resulting decorative scar or piercing endures as art that is transcendent and public.

Sacrificial references or parodies were central in the performances of the 'Viennese Actionists', a group of visual artists working in the early 1960s and inspired by the action painting of the time. Their performances included bloody crucifixions of animals, naked bodies covered with food or feces, and various sexual acts in an 'orgiastic mess of collapsed boundaries' (Carr 1998, p.67). The emphasis was on violence and licentiousness for shock value. One of these artists, Gunter Brus, used humiliation and victimization along with violence for shock effect. His performances incorporated self-mutilation with razors, public defecation, drinking his own urine, and masturbating on stage. In a larger context, Carr theorizes that these performances may have come about as a reaction to personal and communal traumas left by the experience of the Second World War in Europe. Carr finds that this explanation makes sense in the climate of today's art world, which is more interested in narrative and transcendence than was the case in the art milieu of the 1960s: 'healing seems to be the mission, powered by therapy – the story of your life that explains you to you' (Carr 1998, p.67).

Although he resisted being defined as a performance artist, Bob Flanagan was known for nailing his penis to a board in a public performance, and referring to himself as a 'hetero-masochist, in extremis' (Carr 1997, p.27). The aim of his acts of self-inflicted pain was less ritualistic than practical – as a means to cope with the chronic pain he suffered from cystic fibrosis. The practice of hurting himself to fight off

pain began in childhood, when he hung himself by the wrists or whipped himself, using a belt with pins stuck in it. In performances, he appeared literally as a victim of the disease in a hospital gown, connected to a catheter and oxygen tubes and lying in a hospital bed in the exhibition space. Flanagan's identification with the role of victim in performance was a seamless extension of his life experience: there was no boundary between his life and his art other than the nebulous one created by the presence of spectators – invited strangers – as witnesses in a space artificially separated from life. Flanagan arranged to have his dying process filmed throughout his final months of life. He has left the world with a vivid illustration of an instinctive human coping mechanism for fighting pain with pain, or sickness with sickness. The violence of the disease is met with the human capacity to separate from it through the willing submission to violence of one's own choosing.

The performance artist Stelarc also deals with the transcendence of pain, but vigorously denies the presence of any masochistic element in his work. In performances reminiscent of the sundance ritual, Stelarc has numerous hooks inserted into his naked flesh. These are connected to cables and pulleys that lift Stelarc into full suspension in mid-air for up to approximately 30 minutes. While certain of these poses clearly resemble crucifixion images, Stelarc disavows any references to religion. He states that his interest in transcending the body's limitations, specifically the constraints of gravity, is purely artistic. However, themes associated with sacrificial self-mutilation rituals permeate his discussions of his work. Like the neo-tribalists, his artistry is in the redesign of the body. The idea is not so much to escape the body's limitations, but to redesign the body to expand its capacities, in an attempt to induce change at a 'genetic' level. The emphasis on overcoming pain is aimed at developing physical strength, partly through effort of will. A familiar reversion to primitive values is apparent in the description of his events as 'a recovery of the primal spirit, developing the capacity to dominate the situation' (Paffrath 1984, p.13). Evolution of the body is necessary, Stelarc believes, because technology, brought about by the rapid development of the mind, has left the body far behind and, in its present form, 'obsolete'. Since no single mind, nor any single body, is able to contain all the technological knowledge that humans now possess, life can potentially exist without humanity, according to Stelarc. Like that of the neo-tribalists, Stelarc's

response to the dehumanization of technological society is to turn back to a terrain that can be controlled – the landscape of one's own body.

Stelarc spins layers of metaphors around the concept of his body as a landscape. The skin stretched by hooks delineates 'a landscape of gravity' that describes in graphic terms 'the physical penalty you pay for suspending your body' (Paffrath 1984, p.16). 'The stretched skin is both a manifestation of the gravitational pull and of resisting it, of symbolically overcoming it.' (p.29.) Payment in suffering allows the body to 'burst from its biological, cultural and planetary containment' (p.24). In a 1972 performance in Australia, Stelarc hung amid suspended natural objects such as large stones, effectively surrounded by an environment of his own creation. In later works, the hangings were moved outdoors or into other specific environmental sites. One of these, *Up/Down: Event for Shaft Suspension*, involved being lifted and lowered by hooks and cables in the space of an elevator shaft. In another, *Seaside Suspension: Event for Wind and Waves*, Stelarc hung suspended in the open air over waves crashing against a rocky shore. In this piece, a final merging of the body with the landscape occurred, where the body as landscape became just a detail within the larger landscape. Perhaps this merging with the natural landscape and natural forces symbolizes an ultimate transcendence of the limitations of the body container and its separation from the rest of nature. In *Event for Clone Suspension*, in which Stelarc's suspended body was 'cloned' by the casting of a portion of it in plaster, he described the separation from the plaster as 'the shedding of skin' (Paffrath 1984, p.115). There is in the symbolism of dissolution and transformation a similarity to sacrificial rituals that are aimed at purification and transcendence of human frailty or impurity through the immolation of the body.

Stelarc's denial of masochism in his artwork exposes another common undercurrent of sacrificial rituals. His argument against the portrayal of himself as masochistic follows a logic that women are not considered masochistic for choosing to undergo the process of childbirth. The pain is just part of the process of giving birth. The artist, in his view, must undergo pain as part of the creative process of giving birth to new ideas. The parallel between giving birth and creating art being acknowledged to the point of cliché, Stelarc's cloning event described above serves as an example of one of the more literal ways in which he simulates giving birth, through self-replication. The interest of male members of the society in

reproducing the pain of childbirth, as well as in the ability to produce menstrual blood, perhaps to match women in creative power, has been observed with frequency in cultural rituals of self-mutilation and sacrifice (Favazza 1987).

Stelarc repeatedly emphasizes the fact that he is only interested in art, not religion. This is an interesting paradox, in that the form in which he works takes its inspiration and impetus from a 'primal' culture in which art and religion are merged. As previously stated, performance artists expressly aim to reintegrate art into everyday living, in harmony with primal instincts. The element in Stelarc's performances that slides back out of the ethereal realm of aesthetics into the more primal space of ritual is strengthened by his later performances that move the event out of the gallery enclosure into the open atmosphere of the outdoors. The sacrifice of his own body through ritualized mutilations begins to dissolve the artificial barrier separating the artist from life. Along with the move outdoors is a diminished interest in being witnessed by an audience. These events are just as likely to occur in private, with no publicity or fanfare, indicating in them a heightened degree of ritual necessity on a purely personal level. In this respect, a similarity with the neo-tribalists' private approach to ritual is apparent.

Feminist theory in visual and performance art

Among women performance artists, there is also an interest in the symbolism of the body as a landscape. In this case, the gender issue of the feminine body as a landscape to be exploited, mined, or otherwise used for the furtherance of male accumulation of power and wealth is emphasized. The association of the feminine body with a landscape reflects cultural associations of femininity with nature in general. Wilderness and natural landscapes have been places of unknown to be feared, explored, conquered, and ultimately used and discarded as exhaustible resources. Nature is all encompassing, without a distinct voice or self. In order to establish a separate identity and a sense of control over the unpredictable forces of nature, humans have contrived to separate themselves from nature and to take an adversarial position toward it. In a feminist view, male domination of culture and gender has followed the pattern of mankind's dominating relationship with nature. Women as a gender group are seen by the

patriarchal culture as part of nature and therefore unpredictable and threatening, and, like nature, passively existing to be viewed and conquered. Women are invisible in the sense that they lack the sense of identity distinct and separate from nature that men as protagonists in the story of humanity have created. The rest of creation exists to nurture the protagonists' selfhood. Out of the landscape, come natural resources that are used, consumed, and then discarded back into the landscape, where garbage miraculously disappears from existence, or at least from awareness. After use, female bodies also lose value and tend to get discarded into

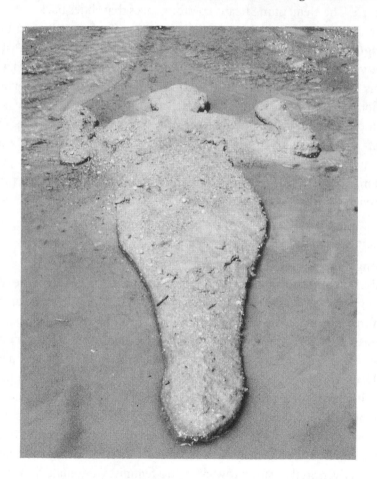

Figure 1.1 Ana Mendieta: Untitled (from the Silueta series), 1978. Courtesy of the Estate of Ana Mendieta and Galerie Lelong, New York

the disappearing garbage mound, metaphorically speaking. In art, a long tradition of female nude figures put out on display for the ostensible pleasure of mostly male consumers reflects the invisibility of women as selves with identities:

> In the art form of the European nude the painters and spectator-owners were usually men and the persons treated as objects, usually women. This unequal relationship is so deeply embedded in our culture that it still structures the consciousness of many women. They do to themselves what men do to them. They survey, like men, their own femininity. (Berger 1972, p.63)

The nudes are there to be seen and entered by the eyes of the viewer, as they passively rest within the surrounding landscape. In contemporary advertising, minimally clothed female and male nudes act as mute engines to fuel the desires of potential consumers. Sublimation of desire, by way of acquisition of products, fulfills the producers' goal. The identity of a model is irrelevant; she or he will soon land on the invisible refuse heap with all of the other stuff that no longer inspires desire for possession.

Women performance artists have addressed the issue of feminine invisibility or nonexistence by attempting to desymbolize the feminine by removing the distance between symbol and symbolized (Schneider 1997). This is achieved by a literal acting out of culturally entrenched symbolic meanings on the artists' own bodies, exposing the violence that may underlie layers of symbolism. For example, in Carolee Schneemann's 1963 work *Eye/Body*, the artist covered her naked body with materials such as grease and paint, and placed herself on view within an erotic environment of her own creation (Schneemann 1979). In so doing, she played both the role of passive object for the viewer's pleasure, and the role of active creator. By placing her own literal body in the place of a stereotyped passive female role, she created a parody of what she perceived to be her role as a woman artist among a group of male artists. This also effectively collapsed the distance between the entrenched symbol of passive feminine sexuality and the symbolized. Her usurpation of the male role as viewer, creator, and seducer transformed the stereotypically passive sexuality assigned to women into active, self-regulating erotic stimulation. Making herself visible in this fashion, she attempted to combat the

invisibility that she experienced in a profession where only men were taken seriously as artists.

Artist Ana Mendieta explicitly acted out the invisibility or vanishing of her female self by leaving impressions or outlines of her silhouette upon the environment. 'Tragic and beautiful' (Schneider 1997, p.119), these pieces were meant to express not desire but loss, perhaps loss of self, body, and potential. While Mendieta's sense of loss came in part from expatriation from her native Cuba, her interest in nature is influenced by primitive art:

> It was during my childhood in Cuba that I first became fascinated by primitive art and cultures. It seems as if these cultures are provided with an inner knowledge, a closeness to natural resources. And it is this knowledge which gives reality to the images they have created. This sense of magic, knowledge and power found in primitive art has influenced my personal attitude toward art-making. For the past twelve years I have been working out in nature, exploring the relationship between myself, the earth and art. (Mendieta 1993, p.41)

In Mendieta's images, the female body merges with the landscape, vanishing once again into the magical disappearing garbage heap. In one image in which her body seems to have sunk into a pool of mud, there is a literal representation of the figure merging with the ground (Figure 1.1). In another, a dug out form of her body is filled with gunpowder and set ablaze. Described as 'transformative' rituals of the 'body mutating into another substance' (Spero 1992, p.76), Mendieta's silhouettes embody the female in the act of sacrificing herself. In these artworks, the rage and erotic passion that are expressed in works such as that of Schneemann seem to dissolve into sadness and grieving in an identification with the victim. Nancy Spero, also a woman artist, summarizes these aspects of Mendieta's work:

> Ana did not rampage the earth to control or dominate or to create grandiose monuments of power and authority. She sought intimate, recessed spaces, protective habitats signaling a temporary respite of comfort and meditation. The imprint of a woman's passage eroding and disappearing, the regrowth of grass or the shifting of sands or a carved fragmentary relief, a timeless cycle momentarily interrupted, receiving the shape of a woman – a trace, such as the smudged body

print a victim of fire might leave, or a shadow, the recessive mark left
by a victim of the bomb in Hiroshima or Nagasaki. (Spero 1992, p.77)

The self-sacrifice of women was graphically acted out in Annie Sprinkle's
1989 performance *Post Porn Modernism* in which she invited viewers to
gaze at her cervix (Schneider 1997). Exposing the spread open body for
public consumption ritualized the cultural victimization of women. A
voluntary sacrificial act, it attempted to return power and authority to the
victim by arousing embarrassment and shame in the audience, who were
subtly drawn together in an identification with the voyeur/executioner.

In Schneemann's fertility goddess imagery and Mendieta's earthwork
silhouettes, the connection to primitive culture is either implied or overtly
stated. Schneider (1997) views the fascination with primitivism in women's
performance art as an intentional correlation designed to expose the
culturally imposed associations of the feminine with the primitive, and to
make explicit a parallel between the white colonization of primitive
cultures and a male 'colonization' of women's socially 'marked' bodies.
'Marking' is an assignation of difference, otherness, and possession. The
female body is seen as colonized in the sense that it becomes inhabited by,
and an extension of, the male ego. The popular embracing of primitive
icons such as goddess images may serve as a defiant challenge to the
dominant male culture, similar to the neo tribalists' intentional marking of
their own bodies to indicate proud adherence to an alternative culture.

The theme of women as sacrificial victims continues in the following
discussion of paintings by a New York visual artist, Patricia Smith. Like
Ana Mendieta, Smith is fascinated by the body as a medium and ritual
space for passage into non-physical realms, and by the imprint left behind
when transformation has taken place.

Patricia Smith

Dark Night, a series of paintings by artist Patricia Smith demonstrates how
the surface of the artwork may double as a reference to skin. This is more
or less a reverse of the concept of the body as an art surface. In *Dark Night*,
the painting surface is black rubber instead of canvas or linen. The size and
shape of the paintings suggest caskets, and each painting is a portrait of a
religious martyr, or, as Smith describes, 'containers for the remnants that
are left' (Smith 1994). The remnants consist of 'essential symbols', such as

Agatha's breasts, Joan of Arc's shoes, and Apollonia's teeth. St Lucy, habitually portrayed in religious paintings holding a dish bearing her eyeballs, appears here with safety pins piercing the painting surface in the position of the eyes, paint reminiscent of blood and tears dripping from the wounds.

Apollonia, who in legend had her teeth knocked out, is shown as two sets of teeth, the second set in the vaginal area – 'a concise portrait of a woman from a man's point of view', according to Smith. She discusses the sado-masochistic allusions in her paintings, particularly in reference to the black rubber that suggests skin with sexual connotations:

> …there's a lot of the S&M school of thought in the paintings…the tension between the obviously sexualized images in some of the paintings and the fact that it's on a kind of skin and it's a skin with sexual connotations and someone's been tortured and there's also piercing… (Smith 1994)

The artist's bodily identification with the artwork and its surface is literally expressed by the fact that she uses her own body against the rubber canvas to measure the placement of body parts. The painting surface to an extent represents a literal double of the artist's body surface. Her emotional identification with the artwork's content is expressed in the title, taken literally from the mystical text of St John of the Cross, *The Dark Night of the Soul*. Smith acknowledges that the title relates specifically to a personal crisis.

The disappeared bodies in Smith's paintings are reminiscent of Ana Mendieta's evanescent body images of unseen women. The images that are left seem to focus upon the violent aspects of martyrdom or, as Smith describes it, 'fetishistic body parts'. However, her stated interest in the remains is less about the violence that has occurred than about the transcendence that follows. There is a particular fascination with the power of transcendence that may be attached to fetishistic objects. For example, in the painting of the immolation of Joan of Arc, the saint has chosen to sacrifice her body rather than give up her symbol of power, the freedom to wear traditionally male clothing. Her metal shoes remain intact after the fire as testimony to her powers of transcendence not only of death, but more significantly of patriarchal authority.

The final painting of the series, *Catherine*, takes the symbolism to a more abstract, purified level. This image refers to a wheel that was supposed to rip apart the body of the saint as it spun. In the painting, this is represented by a row of spinning fireworks called Catherine wheels, and an actual spinning fan attached to the top of the frame. Patricia Smith explains that the seven wheels in the painting are lined up in the corresponding locations of the seven chakras of Indian religious tradition, or seven centers of energy in the body. The Sanskrit word for chakra means 'wheel' (Tansley 1984). Transcendence is represented here as spiritual energy moving upward through the body along the pathways of the chakras. The chakras may be characterized as spiritual centers, much like the stations of the cross or the progression of shrines along a pilgrimage route. As such, there may be a sense of erotic fetishistic adoration with each of these locations, just as the contact with sacred relics and fetishes at pilgrimage sites inspires spiritual devotion and ecstasy. For the artist, the significance of this piece, as well as of the entire series, relates to her understanding of the vital role of the physical body and corporal experience in spiritual transcendence.

In *Dark Night* as a body of work, the viewer, along with the artist, is taken on a journey through the process of victimization, suffering, sacrifice, purification, transcendence, and sanctification. Symbolic imagery moves subtly between varying levels of literal meaning, visceral impact, and abstraction. Merging of the figure with the ground occurs in different ways. Although the artist does not literally paint upon her body, as in the case of certain performance artists and practitioners of body modification arts, she does paint with her body parts in the sense that she uses her body as a literal template on the art surface. In the process, she is thus bodily fused with the artwork, or ground. Fusion of figure and ground is visually present in the lack of body outlines and in the blackness which seems to swallow up corporeality, just as the night obliterates the delineation of separate objects. The rubber ground, or paint surface, in its evocation of skin symbolically becomes the body.

Paradoxically, this merging is accomplished simultaneously with the separating out of specific body parts for mutilation, culminating in the Catherine story where the entire body is to be torn apart into fragments. This returns to a theme that was introduced earlier in this chapter, that of dualism in which good and bad violence, purity and impurity, and body

and spirit are separate but joined in the act of sacrifice. Across the range of examples discussed in which the body is subjected to violent treatment for various culturally meaningful reasons, the body as spiritual collateral is emphasized. Pieces of it or all of it may be given up to gain access to superhuman powers, blessings, purity, absolution, and transformation. The voluntary submission to the pain of giving up a part of the body or abstinence from bodily pleasures serve notice of the sincerity of the victim. For the involuntary victim, the experience of pain and dissolution of self is in itself a purifying experience that confers sanctity. Symbolically, sacrifice represents a passage from victimization to mastery. It is in this sense that sacrifice, or self-mutilation as a voluntary form of sacrifice, may be seen as a part of the process of healing. The next chapter will explore some of the ways that psychological theory explains this transformative process, as it plays out in the individual psyche.

Psychological Perspectives on Self-mutilation

Introduction

Defining self-mutilation as pathology

The preceding chapter discussed ways in which acts of self-mutilation or body modification may express certain cultural or aesthetic values. Some such practices may be viewed as socially deviant, depending upon the degree to which practitioners and acts are incorporated within or split off from the mainstream of society. However, they are rarely viewed as pathological, owing to the fact that they are in some way meaningful and valuable to a society or to a subculture within society. Self-mutilation is generally considered pathological when it becomes highly individualized, idiosyncratic, and lacks aesthetic value or ritual significance to the community. In these cases, it is often performed secretively, with a level of shame and discomfort indicative of an ego-dystonic activity. In other words, acts of self-mutilation are not comfortably incorporated into the person's acceptable view of themselves. Discomfort with the act on a personal level may be partly a reflection of absorbed cultural values that condemn acts of meaningless violence. It may also have to do with meaning that is not fully understood or integrated into the personality: the behavior may stem in part from unconscious motivations. Therefore, culturally sanctioned and pathologically defined forms of self-mutilation, although similar in appearance, may differ in the degree of conscious meaning with which they are performed. Yet, as the following discussion aims to demonstrate, it is possible that underlying meanings are similar in both types of self-mutilation. Pathological and culturally accepted forms of self-mutilation exist side by side, joined and separated like twins, one of

which is understood by the culture and accepted to a degree, and one that is not understood and consequently primarily seen as illegitimate. This duality resembles the splitting of violence into sanctioned and unsanctioned types for the purpose of maintaining order and meaning in society, as was discussed earlier with reference to sacrifice (pp.18–19). In each case, the culture creates boundaries to separate and contain violence.

One of the ways to reconcile this somewhat artificial split between culturally meaningful and pathological self-mutilation is to view them as separate and related, at opposite ends of a sliding scale. The 'gray area' between the two poles would then contain varying mixtures of culturally meaningful and personally meaningful acts of self-directed violence. While the gray area might allow for lack of clarity in the origins and significance of the act, the polar opposites (acceptable or unacceptable types of violence) would provide a rationale for the passing of judgment or for establishing distinctions. Favazza (1989) uses this model to distinguish 'normal' (defined as culturally sanctioned) from 'deviant' (defined as pathological) self-mutilation. The scale provides a context for his examination of culturally sanctioned forms of self-mutilation as a means for better understanding of the pathological type. He points out the social stigma associated with pathological forms of self-mutilation, and the difficulties that may be encountered by clinicians working with self-mutilating clients. Such morbid acts can be very disturbing to witness, and the exaggerated emotional reactions they engender in clinicians may interfere with the effectiveness of treatment. By coming to understand and appreciate certain violent and self-destructive acts as an intrinsic part of human cultural development, clinicians may become better equipped to empathize with self-mutilating patients.

Ironically, the stigmatization of self-mutilating behavior is similar to the taboo that has traditionally surrounded items and acts of a sacred nature. It is, in the view of Girard (1977), the violence that lies at the heart of the sacred that leads to this taboo. The urge to cut off our own violent nature from ourselves is a defensive gesture that plays out symbolically in our taboos and the sacred barriers we place around violence and morbidity. The shrouding of violence in a cloak of sacredness may be another way of coping with morbidity by giving it powers of transcendence and magical healing. Viewed as a form of sacrifice, self-mutilation may be transformed from a senseless act of self-destructive violence to a morbid

attempt at healing. The focus shifts from the violent and pathological to the constructive and transcendent. This parallels the transformation of a wound into a decorative scar, as seen in body modification arts, where a violent event gets diminished or concealed in aesthetic overtones.

Hewitt (1997) focuses on the volitional and transcendent aspects of self-mutilation, placing self-cutting and eating disorders on a comparable plane with tattoos and piercing. Self-directed changes upon the body are viewed as an attempt at spiritual transformation or 'religious conversion'. Such acts fulfill aims of 'self-expression', 'self-initiation', and 'self-evolution'. The idea of the body as a landscape is revisited, in this case as a 'territory for establishing personal, social and spiritual identity' (p.3). Hewitt recognizes body modification and self-mutilation as creative processes – attempts by practitioners to 'recreate themselves and write the story of their identity upon their bodies' (p.6). Upon this stage are re-enacted universal dramas of death, purification, and rebirth, played out in archetypal roles such as victim and aggressor, master and slave, or parent and child. Pain administered to the body is intrinsic to the process of transformation because the pain response provides a confirmation of existence, while endurance of pain produces evidence of the transcendence of bodily limitations.

Like the artist Patricia Smith, who views the body as the medium for gaining access to the spiritual realm, Hewitt describes the body surface as a boundary between internal and external dimensions. On this surface, ritualized acts may bring about magical entry of the physical being into the spiritual realm. As in performance art and body modification arts, a romance with primitive traditions comes into play where art, magic and religion fuse, and transformations of the body are believed to effect spiritual transformation. Body magic may be related to image magic, or 'imitation magic' (Frazer 1922). In the latter, an image is believed to possess similar powers to the original object or being, and for that reason may be considered taboo. Altering or affecting the image in some way may produce similar changes in the original. For example, to step on another person's shadow might cause harm to that person's body. The soul, a spiritual twin of the body, could theoretically be accessed and affected as well, via events and changes occurring within or upon the body.

Girard (1977) believes that symbolism grew out of the use of a double or substitute in the sacrificial act, and from this was developed all of

culture. Culture, in this view, is therefore an evolution of the practice of substitution that serves to protect society from its own self-destructive violence. In his paper 'The double as immortal self', Rank (1958) traces the concept of the soul to early and pervasive superstitions about twins and shadows. Twins were considered taboo because they were believed to possess supernatural powers of self-regeneration and immortality. The birth of twins meant that a person had brought the soul or immortal double into material being, which constituted a potential threat to the community. Therefore, twins and their parents were often either killed or banished to isolated communities. In hero myths, one twin is routinely sacrificed so that the other may live to accomplish heroic deeds, such as the founding of cities and culture. The hero myths reiterate the idea that culture is born of sacrifice. Rank proposes that both primitive and modern cultures have the irrational need for a belief in the supernatural to oppose biological processes that inevitably lead to death. In primitive man, the supernatural is represented in the taboos and superstitions that form cults, the extension of which becomes religion and all of the arts and culture in modern man. Through the power of symbolism, Rank suggests that culture represents a kind of collective soul, an immortal double that continues beyond the individual lifetimes of humans, and in this way transcends death.

What appears as pathological in self-mutilation may relate to a similar attempt at symbolization for the purpose of healing, transcendence, and survival. Something must die or be sacrificed so that the transformed self may live. Just as culture symbolizes life on an immortal plane, the transcendent self symbolizes victory over illness, morbidity and death. The fact that the body itself is used as the sacrificial substitute suggests that symbolization at a cultural level is not complete. The act is part real and part symbolic, primitive in the sense of being not quite rational or 'civilized'. It may be seen as a regression toward an undifferentiated state, where religion, art, and daily activities are fused.

In some cases, regression is intentional. In evoking primitive influences, some modern art and feminist performance art may consciously intend to desymbolize, for the purpose of exposing cultural and gender bias in ubiquitous symbols. Exposing the hidden violent or exploitative messages in symbols may be seen as a way to diffuse their unconscious power over culture and humanity. An interest in restoring primitive values and rituals

may also represent a reaction against the dehumanizing pressures of a modern society that is over-symbolized to the degree that it values rational thinking to the exclusion of irrational but needed spiritual beliefs. This may be one of the reasons for the continued use of self-mutilation rituals such as the Lakota sundance in modern North American native culture. While the body piercing of the neo-tribalist is intentionally primitive in its mixture of tangible pain and symbolism of transcendence, other acts of self-mutilation may attempt to fulfill similar functions of self-empowerment with less conscious intent. The degree of pathology accorded to the act of self-mutilation might then also have to do with the degree to which a person is able to separate the act from its conscious meaning. In other words, the degree of pathology may correspond with the ability to symbolize. This is given within the cultural view that the more completely symbolized, the more culturally developed and therefore more acceptable, normal, or healthy.

Varieties of self-mutilation labeled as pathological

Self-mutilation may take the form of any violence carried out upon one's own body that does not result in suicide. Although self-mutilation and suicide involve a similar self-destructive urge, it is generally observed that self-mutilation is distinct from suicide in that the intent is not to die. In other words, a failed suicide attempt may not be considered self-mutilation. However, self-mutilation has been given the term 'focal suicide' (Menninger 1938) to describe it psychologically in terms of a suicide that is neither fatal nor incomplete. This concept will be presented in more detail below (pp.51–53).

Cutting is perhaps the most common form of direct self-mutilation. This involves making superficial incisions of the skin with a razor, knife, or other sharp object. Cutting is often done on the arms, thighs, or other areas of the body that may be concealed by clothing, especially if the cutter wishes to keep the behavior secret. The skin may be intentionally burned, especially with lighted cigarettes. Abrasion of the skin is another possible form of self-injury. In all of these cases, the body may be additionally abused through intentional interference with the wounds to promote further pain and delay of healing. A less common style of self-mutilation is the insertion of sharp objects into body orifices. More

severe forms include severing body parts, swallowing or inhaling noxious substances, and constricting body parts, including self-strangulation. More primitive or regressed forms include biting or hitting oneself, or banging parts of the body against objects. These forms are considered regressed because they are forms of self-directed aggression that may be seen at the earliest developmental stages, and sometimes in developmentally delayed or brain-damaged persons.

There are also some behaviors that do not fit in the category of direct self-aggression that may indirectly result in damage and modification to the body. Anorexia nervosa reshapes the body, not through a direct cutting away of flesh but as a result of indirect wasting away accomplished by voluntary starvation. Bulimia and chronic overeating are other forms of bodily abuse that involve food and nutrition. These eating disorders may be subtly related to the more overt expressions of self-directed oral aggression represented by self-biting. Chronic abuse of alcohol and other legal or illegal drugs may ultimately lead to permanent damage to the body, which may be seen as voluntary wounding. Besides causing systemic damage, the administration of intravenous drugs by hypodermic needles involves a direct wounding of the skin. Although this is a byproduct of the drug-using activity, the process is similar to a direct self-mutilation such as cutting or piercing the flesh and possibly affords a corresponding degree of psychological gratification. Compulsively repeated cosmetic surgeries may also reach a level of indirect self-mutilation, according to Miller (1994).

Trichotillomania, the compulsive pulling out of one's hair, appears in the *Diagnostic and Statistical Manual of Mental Disorders* (American Psychiatric Association 1994) as a separate diagnostic category under impulse control disorders. However, self-mutilation of all types is seen across a range of mental disorders, and despite its morbidity factor, is often thought of as a symptom rather than an illness.

The remainder of this chapter will focus on some of the dynamics involved in self-mutilation, as seen from differing psychological perspectives. Some of the theory presented dates to the early part of the twentieth century. The following discussion includes both earlier and later ideas from the twentieth century; and these are not necessarily presented in a historical sequence since many of them are overlapping or may repeat themselves in various forms. As is true of many other mental disturbances,

symptoms of self-mutilation may be overdetermined by a plethora of motives. An open-minded clinician has the benefit of choosing from a variety of theoretical points of view, or combinations of these, to gain insight into each case in its complexity.

Psychoanalytic and psychosexual approaches to self-mutilation

Early psychoanalytic approaches to self-mutilation interpret it within the framework of aggressive and erotic drive energies that are theoretically connected at an instinctive level. In this view, it must be assumed that self-mutilation is a painful experience. From there, an interpretation may be drawn regarding the degree to which pain may be experienced as pleasurable, or sexually gratifying. Self-inflicted pain and suffering, seen as driven by an ultimate goal to achieve pleasure and satisfaction, is therefore considered a form of masochism. In accordance with psychoanalytic views on masochism, self-mutilation may be a useful defense to punish guilt feelings associated with inner conflicts, not confined to, but particularly associated with, anxieties revolving around Oedipal fantasies. During this discussion, an attempt will be made to follow the thread of reason and evidence begun in chapter 1, linking self-mutilation with ritual sacrifice.

Masochism

From a psychoanalytic perspective, self-mutilation is usually seen as related to, and included in discussions of masochism, which by strict definition involves sexual gratification. In the paper 'Three essays on the theory of sexuality', Freud (1905) theorizes that masochism is a component of the instinctual drives present in everyone. Defined more narrowly as a sexual perversion, it refers to a requirement of pain for adequate sexual arousal and gratification. Although it is classified as a perversion in psychoanalytic terms, the person engaging in this type of sexual behavior may be quite comfortable with it, and likely to function in other aspects of life no differently than anyone else. A broader definition of masochism embraces behavior that is pervasive throughout the personality as a generalized gravitation toward suffering and pain, from which is derived pleasure and satisfaction. This is referred to as moral, or characterological masochism.

Masochism and sadism are natural partners. In 'Three essays on the theory of sexuality', Freud observes that masochism and sadism are invariably found together within the same person. In this early view, sadism is described as the sexual or erotic drive mixed with aggression to a disproportionate degree. Masochism is seen as a passive form of sadism or, in other words, as sadism turned inward upon the self. In the same person, according to Freud, aggression might be expressed at different times either passively or actively, as masochism or sadism. In relationships, this might play out as one partner invariably playing the role as masochist to the other's role as sadist, or as both reversing roles from time to time. In the masochistic pattern, sadistic urges may find indirect gratification through passive submission to punishment at the hands of an aggressor- sadist. In this view, gratification is thought to come when the aggressor is made to suffer guilt feelings for having abused the victim.

In moral masochism, pleasure and pain are connected, but sexual arousal is not the overt aim. The search for suffering is aimed at relieving unconscious guilt feelings, for sadistic as well as sexual urges. This may be accomplished unconsciously as well – for example, through frequent accidents or chronic failure. At a more conscious level, behavior that can be described as moral masochism may have a cultural value. In the case of religious ascetics or martyrs, punishment may be either self-inflicted or passively accepted at the hands of persecutors. Describing the psychological dynamics of martyrdom, Bradford (1990) feels that the martyr denies his or her anger and projects it on to a god who then is assigned the role of punishing the martyr's persecutors. As the martyr passively embraces death or punishment, the god in turn embraces the martyr, thus absolving him or her of guilt feelings associated with sadistic urges. Sadistic wishes are indirectly gratified through the induction of guilt feelings in those identified as persecutors. Asceticism and other forms of self-negation and martyrdom all may focus upon bodily suffering as a means of communication and influence, simultaneously gratifying and defending against sadistic impulses. For example, nonviolent protests such as hunger strikes may have dramatic and effective results in terms of furthering altruistic causes through the inducement of guilt in persecutors. Self-mutilation may follow a similar pattern of aggression toward others redirected upon the self in dramatic displays of suffering (Asch 1971;

Woods 1988). This idea will be further explored in the discussion of object relations later in this chapter.

Eventually, in 'The economic problem of masochism', Freud (1924) refined the theory of masochism to include life and death instincts. Here the urge to self-destruct is seen as a fundamental drive, and masochism is described as 'erotized' (mixed with erotic feelings) self-destruction caused by the interplay of the dual instincts. Life and death instincts represent constructive and destructive tendencies of personality that are in constant conflict. The life instinct, a constructive force represented as sexual drive toward procreation, functions to neutralize the destructive force of the death instinct. Emotionally, these instincts manifest as love and hate, with love having the power to inhibit destructive impulses associated with hate. For example, sufficient love can theoretically neutralize a wish to kill, so that the latter no longer results in murder or destruction. Menninger (1938), following Freud's dual instinct theory of masochism, explains that with the addition of enough positive feelings of love, hostility may be transformed into constructive, creative efforts. This may be expressed as sexual biological procreation, however it can as well take the form of 'upward deflections' or creative sublimations. Forms of symbolic and aesthetic expression would fall in this category. Menninger is careful to distinguish sublimation of the destructive urge from its 'lateral displacement', occurring when aggression is simply displaced to a substitute such as, in his example, the destruction of a deer instead of a hated family member. If love is insufficient to neutralize hostility, the result may be a defensive redirection of aggression on to the self. When this is carried out partially, not to the extent of annihilation, it is erotized self-destruction, or masochism. Menninger elaborates on various aspects of self-destruction, based upon Freud's theory of masochism. Because Menninger addresses self-mutilation at length in reference to sacrifice, his ideas will be presented in detail in the next two sections of this chapter.

Suicide and self-mutilation

Self-mutilation is generally distinguished from attempted suicide, and seen as a separately motivated process. Continuing in the vein of the life and death instincts model, Menninger explains how self-mutilation and attempted suicide, although distinct in degree of severity, both have

survival wishes as underlying motives. The following is a brief summary of Menninger's theoretical approach to suicide, including 'chronic' and 'focal' suicide. When the aggressive hate instinct, or the 'wish to kill', is combined with an unconscious 'wish to be killed' and a 'wish to die', suicide may be carried out fully. The wish to be killed theoretically stems from unconscious guilt feelings that may arise from the unconscious wish to kill. This submissive wish to be killed may also have a morbid exhibitionistic component, as in the case of the religious martyr, and may serve unconscious motives of masochistic sexual gratification. The conscious wish to die is different from the unconscious death instinct. Paradoxically, the conscious wish to die represents an underlying unconscious wish not to die. This is indicated by the vast number of unsuccessful suicides, in which an unconscious wish not to die weakens the death instinct and unconsciously hinders the suicide plan so that it is carried out ineffectively. The unsuccessful suicide may feel like an actual triumph over death, when the person is miraculously restored to life after having consciously given it up. Whether successful or not, suicide may represent a premature death that attempts to take control of one's destiny from the hands of fate. By actively and consciously causing one's own death, death is paradoxically vanquished.

In the case of asceticism, the life instinct struggles against the death instinct in a slow but steadily losing battle. This is seen as 'chronic' or 'partial' suicide: a slow death brought on intentionally by self-deprivation that lasts indefinitely. Menninger vividly describes this condition as a 'living death'. Individual characterological motives for suffering – namely, erotization of pain, unconscious destructive drive, and guilt – may be supported and encouraged by cultural values that in themselves may be destructive. What is viewed as appropriate and laudable in one time and place in history may be seen quite differently in another.

According to Menninger, self-mutilation falls in the category of 'focal suicide' and accomplishes atonement for guilt. This theory incorporates the later Freudian view of masochism as a defensive negotiation by the ego, in which passive submission (to the father) defends against castration fears associated with Oedipal fantasies (Freud 1924). Focal suicide follows the rule of a part substituting for the whole. A part of the body is offered in exchange for life of the body as a whole, sacrificed with the hope of redemption for transgressions. Clearly, death is not the goal. Survival is the

goal, and the life instinct wins, at least temporarily. The economics of pain parallel those of religious sacrifice: a lesser pain put away in the savings account serves as insurance against more devastating losses. The bargaining is done at a structural level by the ego, determined to protect itself from the pressures of erotic and aggressive id drives, particularly Oedipal wishes, clashing with a punitive or stern superego. This may be restated as the conflict between inner demands and outer expectations of conformity to social restrictions, internalized in the form of the superego. The skin boundary between inner and outer realms is again emphasized, where much of self-mutilation takes place. The body surface becomes a sacrificial altar or landscape, where pain transactions take place. Hewitt (1997) refers to this zone as the 'boundary crossing' between physical and spiritual realms, a place where there is the 'potential for magic'.

Self-mutilation as the 'fundamental form of sacrifice'

In discussing self-mutilation, Menninger refers to a common belief that 'some kind of self-mutilation upon the genitals is the fundamental form of all sacrifice' (Menninger 1938, p.254). This is based on the idea that dedication to religious life traditionally requires the renunciation of sexual life, and self-sacrifice of the genitals insures the sincerity of the commitment. A symbolic substitute for the more extreme form of genital mutilation is circumcision, a practice that in this view employs the philosophy of the part as substitute for the whole. Circumcision is not usually a self-mutilation in the strict sense, because it is most often administered by others and submitted to voluntarily or unknowingly (as in the case of babies). It may take the form of a rite of passage, not for the complete renunciation of sexual life, but in payment for the sexual privileges of adulthood, within prescribed limits. In Menninger's opinion, it also serves the function of defending against Oedipal conflicts. In this case, fear of castration by adult authorities in retaliation for Oedipal fantasies are resolved through the sacrificial payment of circumcision.

Because many women engage in self-mutilation, there is a question of how a theoretical approach to self-mutilation based on castration fears might apply to women. Expanding upon controversial views of Deutsch (1930) regarding a feminine 'castration complex' and its associated 'rape-phantasy', Rado (1933) explores the issue of castration anxiety in

women. He uses several case examples to illustrate the point that some young girls suffer intense narcissistic wounding on becoming aware that they lack a penis, specifically if this event coincides with their own discovery of masturbatory pleasure. If the young girl is left with the impression that she is deprived of the degree of sexual pleasure afforded to boys, she may replace her enjoyment of genital pleasure with an alternative fantasy of pleasure in suffering, specifically related to the pain and violence of castration. Rado uses the term 'genital masochism' to describe this defensive fantasy. The fear of castration and the denial of 'genital masochism' occur as defenses against these masochistic feelings, along with the fantasized possession of an 'illusory penis'. As the girl matures, the illusory penis submerges into the unconscious, but may find unconscious representation in some other place or places upon the body. Such substitute areas may become sensitized, or invested with erotic significance. Among different defensive reactions against 'genital masochism' mentioned by Rado is the 'choice of a lesser evil'. This is a last defense, and represents a 'partial submission' to the repressed desire. Self-injury, accident proneness, and frequent submission to surgical procedures are among the possible manifestations of this defensive response. It can be reasoned that this response would simultaneously serve to defend against the more overt fears of castration, in the sacrificial manner described with reference to Oedipal anxieties. Therefore, sacrificing a part, or a substitute, might defend against the fear of complete loss of the illusory penis, as well as defending against complete submission to a repressed desire. In women, Rado believes, there may develop an underlying wish to take the father's penis away from him, for fear that he will not give it to her. Oedipal anxieties may stem from fear of rejection, reprisal, and guilt for hostility toward the father.

Following the idea that self-mutilation of the genitals may be the fundamental form of sacrifice, and that circumcision may serve as a symbolic substitute for the entire genitals, it can be surmised that symbolic representations of the genitals may be displaced to other parts of the body as well. This accounts for the possibility that, at some level, self-mutilation in general may represent a sacrifice of the genitals, aimed at resolution of guilt for prohibited drive fantasies and the soothing of castration fears. A lesser punishment is intended to avert a more severe one. This is particularly suggested in the mutilations that involve cutting of the skin. The

symbolic displacement of the genitals to other body parts may involve an erotization of the substitute body part. In the case of fetishism, this may be an erotized body part or an object pertaining to another person. At least with male fetishists, the fetish is thought to function as an unconscious representation of the castrated phallus of the mother (Freud 1927). The fetish is needed for sexual arousal, to soothe castration anxieties related to underlying fears that the mother has been castrated. In other words, the fetish represents an unconscious denial of the mother's castration.

Just as a body part may function as a fetish, it is possible that a self-mutilator's wound may also become an object of erotic fascination and fixation. Again, the symbolic displacement of the genitals to another body part may be related to castration anxiety, or as stated with reference to women earlier, a defense against genital masochism. It may also be related to generalized anxieties about sexual urges, including mastur-batory urges. Anxiety brought on by the repression of these urges may seek release through the autoerotic activity of manipulation of substitute erotized body parts. For example, cuts on the skin may be opened and erotically stimulated in an unconscious association with the female genitals (Siomopoulos 1974). The pain involved in the cutting may serve as a substitute gratification of sexual aims. It may also serve as a sharp punishment intended to put a stop to unwelcome feelings of sexual arousal. The possibility that displaced symbolic genitals may in fact generate erotic sensation is supported by Freud's (1905) suggestion that any area of the skin or mucous membrane may be experienced as sexually stimulating. The erotogenicity of the skin may be further conditioned by spanking (Asch 1988).

Sexual ambivalence may be another factor involved in self-castration urges, and this phenomenon seems to be common among those that mutilate themselves. Self-castration may be not only a punishment for sexual feelings or a renouncement of sexuality, but may also represent a rejection of one's gender or sexual identity. This might involve direct genital mutilation, or take the form of symbolic substitutes. A common effect of anorexia nervosa in adolescent girls is the delay or prevention of the onset of physical maturation. While this may be due to an attempt to resolve Oedipal conflicts that resurface in early adolescence (Haeseler 1991), the indirect carving away of the body may result in a body that is more masculine in appearance.

The discussion has so far centered on ideas about self-mutilation emphasizing masochistic elements, where pain and some form of sexual gratification are connected. Self-administration of pain theoretically functions to appease guilt for erotic and sadistic urges. Some gratification of the initial urge is accomplished in the pleasurable erotization of pain. The ego accomplishes this economic adjustment of pain payments to maintain its own integrity within the warring climate of conflicting id and superego demands. The bargaining table where the exchange takes place is most likely the skin surface or mucous membranes of the body, where the outside world enters inner consciousness in sensations that may be perceived as either painful or pleasurable. Guilt connected to instinctual urges may underlie intense fears of castration as punishment, therefore a sacrificial substitute of some other erotized body part is offered in payment to prevent the dreaded outcome. Self-mutilation in this case may represent a choice of the lesser of two evils. If there is an overabundance of sadistic or destructive urges redirected against the self, erotic gratification from smaller doses of pain may be insufficient to stave off complete destruction of the body, and suicide may occur. Seen as a microcosm of society, the body as an entire culture may perish if the destructive drive is too great for ritual self-mutilations or other forms of sacrifice to satisfy the general appetite for violence.

The sacrificial drama thus far discussed for the most part involves and depends upon the presence of an internalized conscience, without which there could be no guilt feelings. In the next section, theories about self-destructive behavior that involve pre-Oedipal dynamics where the superego has not yet developed will be explored. As in the previous section, masochism is a central part of the discussion, but especially with regard to masochism as a pervasive characterological phenomenon. The guilt feelings associated with instinctual drives are de-emphasized, and primary object relations concerns become important. While the erotic drive and associated Oedipal and castration fears are not as stressed, there continues to be an erotic component in early painful experiences associated with touch and the skin surface. Wounds and scars as transitional objects to facilitate separation and individuation form an important aspect of self-mutilation viewed from the perspective of object relations theory. Included in the discussion will be related ideas of Heinz Kohut (1977) regarding a self-psychology approach to self-destructive behavior.

Object relations theory and self-mutilation

The preceding discussion focused on the possible psychological under-pinnings of self-directed aggression that might serve to relieve anxiety associated with conflicts between various psychic forces within a person: specifically, sexual tension and guilt feelings engendered by drive energies. Self-mutilation was observed in this context as a personal form of sacrifice. The purification of the self from guilt feelings and the restoration of order within the self may be seen to parallel the functions of sacrifice on a community level, as discussed in the last chapter. As in cultural rituals that aim to preserve aspects of life within the community, individual acts of self-mutilation may also have self-preservation as an aim. Turning now from the pressures of intrapsychic demands, this discussion will focus on self-preservation in the context of the self in relation to others.

Perversions of aggression

Self-directed aggression may be seen as a defensive gesture against aggression that has as its target the primary caretaker during the earliest years of life (Berliner 1958). Anna Freud discusses aggression as a part of sexual development and nature:

> ...long before the beginning of independent analytic studies of aggression, the aggressive nature of infantile sexuality was taken for granted, as evidenced by the cannibalistic tendencies and fantasies on the oral level; the sadistic tormenting, possessive attitudes charac-teristic of the anal stage; and the domineering, thrusting qualities of phallic sexuality. (Freud 1972, p.164)

Eventually, the child learns to modulate its aggression through the growing ability to delay gratification of urges, and through the develop-ment of 'playful', rather than 'hostile', aggression toward the primary caretaker (Galenson, 1988). In Galenson's view, if the primary caretaker is particularly uncomfortable with the infant's expressions of aggression and harshly restricts them, the child may experience a buildup of hostile aggression turned in toward the self. Head banging, hair pulling and self-biting are common forms of self-directed aggression in the earliest years of life. Self-preservation at this level of dependency may demand that the child accept self-inflicted pain if necessary to maintain a relation-ship with the caretaker. This choice represents the lesser of two evils, pain

as opposed to loss of love and abandonment. The inhibition of aggression toward others, developed from an early age, may become part of an overall passive personality type occasionally manifesting in self-mutilation. It is to be expected that, beyond early childhood, episodes of self-mutilation might occur during times when a person anticipates abandonment by a loved one. This fear, rooted deeply in the past, might easily promote regression to early and primitive defensive modes of functioning.

The association of love with pain may also occur at this early stage of development, particularly when the relationship with the primary caretaker is experienced as painful (Bernstein 1983; Glenn 1984). This may be caused by an aggressive style of holding, or by a punitive, rejecting parent. The child may come to associate touch and physical holding and affection with painful experiences, simply because that has been his or her primary experience. Surgical procedures and some medical conditions such as eczema (Gedo 1988) may also cause painful skin contact in early life that become associated with pleasure and affection.

Physical conditioning may be one aspect of the libidinization of pain, but psychic factors may also play a role in the transformation of an experience from something bad into something good. Self-preservation may instinctively demand that the caretaker always be perceived as a good object, dedicated to the protection of the dependent and defenseless child. When the caretaker fails to meet this expectation because of excessive neglect or lack of empathy, the child may in fantasy 'split off' the bad part to keep it from taking over and tainting the 'good' caretaker (Meyers 1988). In this view, the child assumes control of the bad part by taking it into itself via a defensive 'identification with the aggressor'. The now internalized aggressor, derived from a punitive or aggressive caretaker, then carries out its punishments upon the 'bad' child. In this way, a drama of pain and punishment is carried out by the self upon the self, to protect and purify the idealized 'good' parent object. This interpretation of the defensive use of 'identification with the aggressor' varies from the original use of the term by Anna Freud (1946) in which aggression is projected outward instead of inward. According to Anna Freud, identification with the aggressor is a preliminary step toward the development of the superego, the conscience that functions to redirect criticism and blame upon the self. However, the internalization of an extremely harsh or

nonempathic parental figure may create the circumstances for extreme forms of self-punishment.

Difficulties with separation and individuation

It has been observed that many young women patients that mutilate themselves have in common 'early developmental difficulties in differentiating from a disturbed/withdrawn mother' (Kwawer 1980, p.203). Galenson (1988) sees the child's inability to cope with aggression due to the caretaker's inability to tolerate the child's anger as interfering with the normal separation and individuation process. In this case, if the child becomes too angry toward an aggressive caretaker, she may submit passively and become regressed, clingy, anxious, and passive. This may develop into a chronic interdependent sadistic and masochistic type relationship between caretaker and child. Another possible reaction to an aggressive caretaker, according to Galenson, is the formation of a 'stimulus barrier' to block out unpleasant sensations. She cautions that if this prevents other necessary experiences from entering the child's awareness, development may be severely impacted. Desensitization might also be presumed to lead to an unclear sense of the skin boundary – where the self ends, and the objects of the outside world begin. The anal sphincter represents another locus of control, regarding passage of material from inside to outside of the body. Deprived of healthy aggression, the child may have difficulty mastering this function, and anal phase tasks of separation and individuation may also suffer.

When separation and individuation do begin to occur, the process is necessarily a painful one, because separation is experienced as a narcissistic loss of magical omnipotence (Cooper 1988). To counteract the loss in self-esteem brought about by this predicament, an attempt may be made to master the experience of pain through its denial and conversion into pleasure. Mastery of pain may also take the form of assertion of power (as in the defensive identification with the aggressor), through the self-administration of pain. This was illustrated in the example of Bob Flanagan in chapter 1. To maintain a sense of dignity, suffering can become a preferential mode of feeling, rather than a form of victimization. Pain may also become familiar, and the familiar can be felt as pleasurable. Therefore,

the self-administration of pain can be a method of coping with the greater pain of loss of self-esteem associated with separation and loss.

Self-administration of pain may be positively employed as a means of initiating separation. Autotomous healing is achieved with the painful splitting off of an unhealthy part of the body. Certain types of self-mutilation – such as pulling on the cuticles, tearing out the hair or nails, tearing off scabs, or scraping and rubbing away the skin – may represent an unconscious wish for 'separation from someone who was formerly part of the ego' (Hermann 1976, p.31). The self-inflicted pain and wounding is not an end in itself, but an attempt to promote healing and the achievement of a healthier and more autonomous state of functioning. It might also serve to delineate the skin boundaries of the self, as well as the body image. This was illustrated, at a conscious level, in chapter 1 in the example of the neo-tribalists' attempts to modify the bodily self and identity through heroic feats of suffering and the exhibition of scars and piercings. The discomfort of separation may come to be seen as a good thing, in that it can represent separation that has become to a degree self-regulated. It is also to be noted in reference to the connection between healing and self-mutilation, that when sado-masochistic mother and child pairs such as were described earlier are gradually separated in therapy, temporary depression and self-mutilation often appear as side effects to the healing process (Galenson 1988). For masochistic patients in therapy, difficulties with setting boundaries and fears of merging with the therapist may necessitate self-hurting behaviors for a period of time in order to establish autonomy (Meyers 1988).

Self-mutilation and transitional objects

While the pain of wounding and the act of cutting may serve to emphasize and promote the separation process, body parts and features of the ritual may take on the function of transitional objects to ease the pain of separation. This may partly depend upon the erotization of the 'sore spot' that is the site of self-inflicted pain in masochism (Hermann 1976). The wound may become invested with some of the love and connection that is transferred during separation from the mother, or from the original object of affection. A libidinal attachment may develop toward a part of one's

own body, where the ambivalent process of separation and individuation gets acted out in intermittent attacks and subsequent healing.

Wounds, blood and scars are common examples of self-mutilation phenomena that can be used as transitional objects. The products of self-initiated violence may be invested with meaning, just as the blood and ritual objects used in sacrificial rites become imbued with sacredness. A self-mutilating adolescent girl described the blood flowing from her wounds as 'a security blanket' (Kafka 1969). The blood is a 'permanently available, efficiently stored, and readily released source of warm and brilliant envelopment' (Simpson 1980, p.270). The appearance of blood on the skin surface may help to clarify the sense of boundaries between inside and outside the body, and thus serve to strengthen self-integrity. Another patient, describing her skin as having zippers in it, mentioned that she saved the blood in jars and considered painting with it (Simpson 1980). The creative urges inherent in self-mutilation are apparent here. For example, a self-mutilating patient dreamed of shedding her skin, and spoke of her fascination with the ability of segmented worms to regenerate severed parts (Kafka 1969). The scar tissue that forms over the surface of the skin creates another layer to the body – a 'second skin' – that in a sense may provide a measure of extra containment and protection. The scars provide evidence of the worthiness of the individual, in overcoming painful tests of courage on the path to growth and healing. Like medals of honor, the scars tell stories of hardship, suffering, struggle, and heroism. The altered, battle-scarred body exists as a living witness to the power and triumph of the mind and spirit over suffering.

The skin is the primary container of the body, and the degree to which the body and its contents feel good may depend upon the earliest experiences of touching and holding (Deri 1984, pp.247–250). Communication with the outside world occurs through sensations of the skin; if the primary caretaker is able to communicate feelings of love and acceptance through touch and holding, the infant will be more receptive to positive internalizations from the world. A 'good' experience of being held promotes trust, and a sense of unity and wholeness. With a 'bad' holding experience the skin may fail to contain the body, and deep distrust may combine with feelings of disintegration, and the terrifying sensation of 'falling into the abyss'. To cope with the terror of disintegration,

compensatory structures may develop as forms of substitute or meta-phorical containment, tantamount to a 'second skin'.

Bick (1986) uses the term 'adhesive identification' to describe a way of relating to another person as if stuck together, joined together super-ficially in two-dimensional space. In order to separate from the person, ritualized behaviors may develop to bridge the gap or the abyss of separation. Bick describes these as self-stimulating behaviors (such as humming, scratching, tearing at the skin, rocking, etc.) or repetitive, ritualized movements intended to create an unbroken chain between the self and another person. According to Bick, a type of personality may develop that is characterized as 'pseudo-independent' with a tendency toward disintegration or falling apart under stress. A popular stereotype comes to mind of the tough-skinned individual with a soft interior. The scar tissue created by cutting, burning, or tattooing the skin is in reality a 'second skin' that may provide a symbolic function of adding protection and extra containment to the self. The idea that extra armor is desirable is particularly suggested in punk culture, which combines scarification and tattooing with protective armor in the form of aggressive jewelry adorned with steel spikes and sharp, spiked hairstyles.

Many self-mutilating patients, especially those that cut themselves, use self-mutilation in a ritualized fashion to end episodes of depersonaliz-ation, states of numbness, and feelings of fragmentation. The appearance of blood upon the skin surface is said to provide relief in terms of delineating the skin boundaries of the body, and giving reassurance of existence, through the sight of the lifeblood. Since pain sensations are often diminished or absent during these episodes, the shocking sight of the blood becomes an important visual clue of existence, whereas another person might be able to 'pinch themselves' to prove they are alive. According to Pao (1969), the cutter may experience a type of amnesia or denial having to do with the repression of memory – the mutilation unconsciously representing a cutting off of thoughts. Yet, at a more profound level the tendency toward feelings of fragmentation and non-existence may have at the root serious disturbances in the development of the self from the earliest years.

A self-psychology view of self-injury

The development of a cohesive and continuous self depends upon the sufficient provision of parental empathy (Kohut 1977) during the beginning stages of separation and individuation. Kohut explains that from birth the child is equipped with a healthy assertiveness (distinct from the aggressive instinct) that actively exerts a healthy exhibitionistic self. If the parent is able to mirror sufficient acceptance and appreciation for the developing self, the child develops enough self-esteem to withstand the disappointments and frustrations that must come its way when the reality principle or loss of magical omnipotence sets in. If, however, parental empathy is insufficient, the child may suffer a sense of nonexistence and annihilation. In compensation, the child may resort to substitute forms of self-stimulation, such as those mentioned above: rocking, humming, scratching, tearing at the skin and rocking. These efforts are aimed at creating or restoring a sense of containment and unity for the fragments of self that have not coalesced into a cohesive whole. As a manifestation of the fragmented self, the child may develop an attachment to and fascination for isolated fragments of the body, thus developing a tendency toward fetishism. Kohut finds that fragmentation of the self is at the core of the low self-esteem and vulnerability of the narcissistic personality, which has not received sufficient empathy to develop a cohesive sense of self. In this case, the fetish operates as a kind of self-object, libidinized with the love of the desired parental object.

Fetishes

As self-mutilation has been connected loosely to the use of transitional objects as a means to aid separation, there may be a subtle relationship between the use of fetishes and self-mutilation. Phyllis Greenacre (1969) identifies similarities and differences between fetishes and transitional objects. The following discussion summarizes some of the ideas of Greenacre, presented in three different papers on fetishes and fetishism, and draws parallels with self-mutilation.

Greenacre (1953) refers to 'castration hypochondria' in connection with fetishists, in which there exists a generalized fear of various parts of the body being cut off or falling off, particularly fingers, toes, arms, legs and teeth. Greenacre explains that such disturbances of body image may

develop because of traumatic conditions during the first four years of life. Severe or chronic disruptions in the mother–child relationship may result in prolonged clinging behaviors, as the child identifies with the mother as part of itself. It may also develop an overemphasized fascination for touching and smelling, associated with the genitals and the stools as pieces of the fragmented self. The sense of sight may be emphasized, as a form of clutching or clinging with the eyesight related to an intolerance of losing sight of the mother. According to Greenacre, fear of castration may come about owing to the fact that the genitals in the early stages of life are either not visible to the child, or may appear and disappear according to the position of the belly. Viewing the genitals of others such as siblings and parents, particularly those of the opposite sex, may cause traumatic or confused reactions. Traumatic incidents witnessed by the young child, such as miscarriages, births, and surgical operations, may intensify fears of castration, especially when blood is present. Young children that undergo surgical or certain hospital procedures in which the body is invaded or altered in some way are especially vulnerable to disruptions in the development of a cohesive body image. In these cases of confusion of body image and feelings of disintegration or fear of the loss of body parts, Greenacre finds indications of the tendency toward fetishism to restore lost body parts or to magically ward off their threatened loss.

Greenacre further discusses the connection between aggression and fetishism. She explains that early traumatization involving perceived threats to bodily integrity generates a flooding of aggressive stimulation. This leads to the loss of defenses such as impulse control, sublimation, symbolization, and the ability to delay gratification. In her view, the tendency toward acting out and impulsivity that is associated with fetishists may be linked to an overstimulation of aggression and fear. The need for a fetishistic defense to restore body unity, linked with an overabundance of aggression and impulsivity may lead to a redirection of violent urges upon the self. Here the link between self-inflicted wounds and fetishized body parts is implied. The self-mutilator's attempts to take control of the alteration and re-creation of the body image through self-directed carving and healing parallels the fetishist's attempts to restore lost body parts to achieve body unity and integration. Linking both activities is an underlying reference to self-mutilation as the primary form of sacrifice and its double purpose: to magically ward off castration

fears and to simultaneously restore the lost phallic object to the mother. For girls, the traumatic 'loss' of the phallus may refer directly to themselves, causing similar anxieties around the confusion and sense of incompleteness of body image that is associated with the need for restoration and repair.

Just as some self-mutilation phenomena have been seen to function as transitional objects, a connection has also been drawn between fetishes and transitional objects. Greenacre (1969) writes that the earliest transitional object, usually a soft or silky object such as a blanket or the silk trim on a blanket, recreates a sensation of connection to the mother's breast. The transitional object comes to represent the mother–child relationship in a generalized way, and helps to facilitate separation and individuation by providing an illusory framework of the original relationship even while the mother is absent. Eventually the transitional object will diminish in size and importance, and in most places be replaced by a toy. However, the safety of the mother–child relationship may continue to be accessible to a person, at least in the illusion of fantasy, throughout their lifetime during periods of stress or regression.

Conversely, the fetish may re-create combinations of the breast, genitals, and anus of the mother, and arises in situations of trauma, physical illness or surgery, and disturbances in the mother–child relationship. In Greenacre's view, the fetish differs from the transitional object in that it does not provide an illusory safe relationship, but serves to restore or fill in a part of the body that is felt to be missing or threatened. Use of the fetish may appear at later stages in life, such as latency or adolescence, particularly when castration threats may be felt. The preponderance of black silk, leather, and fur in the fetishes used by adults is surmised to be an association with the mother's pubic area: silk underwear, skin, pubic hair, and so on. The association of disturbances in the development of the aggressive drive, along with overabundance of aggression connected to early trauma, with the formation of sado-masochistic object relations is recalled. The use of black leather, fur, silk, lace, etc. is also strongly associated with sado-masochistic rituals, as are various forms of self-punishment and bodily wounding. The paintings of Patricia Smith described in chapter 1, associating black rubber and images of mutilation and martyrdom with sado-masochism, serve as a succinct symbolic representation of these complex but related phenomena. Perhaps the connecting link is a

core of violence that is either experienced or fantasized, and is essential for the sacrificial and creative double act of prevention and restoration.

Greenacre (1970) notes that the use of the fetish as a sexual perversion may often appear during latency, at a time consistent with the disappearance of the transitional object. In healthy development, the abandonment of the transitional object as no longer necessary would indicate that this stage of separation and individuation has been completed successfully. The fact that the use of the fetish may likely persist throughout adulthood indicates that the separation and individuation process that was disrupted early on is never completely realized or fully integrated within the personality. Self-mutilation may follow a similar process. Certainly not all forms of self-mutilation are related to problems with separation and individuation. In some cases, however, the self-mutilation acts may represent attempts at separation and individuation where, because of early traumas and disruptions in self-cohesion, the transitional object becomes imbued with ambivalence, aggression, and violence. Much of the self-mutilation that appears during adolescence may be related to the recurring crisis of separation and individuation that occurs at that stage in life. The fact that self-mutilation and its related indirect forms, such as anorexia, often diminish and subside at some point during adulthood after their initial appearance in adolescence, suggests that the separation and individuation crisis of that phase has finally been completed or resolved to some degree.

Despite the degree of morbidity involved in self-mutilation, there does appear to be present an active urge toward separation and change that is not apparent in the use of the fetish. Like the sado-masochistic behavior that is confined to sexual practices, fetishistic behavior is not usually ego-dystonic. That is, the behavior is incorporated and accepted into the personality, and does not interfere with functioning in other areas of life. It is in fact a compromise that fulfills its function smoothly and continuously. However, as has been discussed, the self- mutilating person is often concerned with personality change, and with taking control over his or her body. While the self may be split between victim and aggressor identities, there is an attempt to move from a passive to an active position, such as in the 'identification with the aggressor'. Taking control by the self, even in rudimentary and impulsive forms, is a manifestation of an attempt at separation and individuation.

Secrecy

Gestures of separation and individuation from a parental authority may be secretive acts, as 'pathological' forms of self-mutilation often are. Secrecy may be a necessity to prevent retaliation for the initiation of separation. However, secrecy may also help to promote separation and individuation through the creation of a boundary. Secrecy may enhance feelings of self-esteem through the inference of privilege, because of the possession of something to which others do not have access. On the other hand, self-mutilation may become a public act of individuation and defiance of authority, as was seen in the case of punk and neo-tribalist culture. In this case, identification with a marginalized group or subculture provides a provisional sense of autonomous identity and functioning. The idea of wresting power from an oppressive, pervasive political and cultural order through taking violent control over the appearance of the body is not appreciably different from the dynamics involved in secretive acts of self-mutilation to demonstrate a similar violent possession of the self.

Creativity and transitional phenomena

Winnicott (1953) developed the ideas of the 'transitional object' and 'transitional phenomena' to refer to an 'intermediate area' where subjective and objective experience meet and interact. He also describes this as a means by which 'inner and outer realities' are kept 'separate yet interrelated'. Usually a soft or silky object, such as a baby blanket, the transitional object serves to soothe the child while the mother is not present. A transitional object not only helps to connect the infant to its mother or caretaker in fantasy, but also represents the child's dawning acceptance of separate objects and outside reality. Although the child partly creates the object by projecting its fantasies upon it and imbuing it with mother-like qualities, the child also chooses the object from the outside environment. This represents a partial acknowledgment of objective reality. Attributes projected onto the object, such as love and affection, transform it into an object capable of providing comfort, in the child's fantasy. In this way, the child obtains nurturing needs through a creative relationship with the environment. It is through creative relationships that we begin to understand and accept the reality of the outside world.

In primitive cultures, the use of magical thought processes may be similar to the magical thinking of the young child. For example, in animistic beliefs, inanimate objects may be imbued with a soul or spirit, including human properties such as feeling and sensing (Zusne and Jones, 1989). This may be related to the human need to exert control over the environment, however illusory, and may be seen to correspond with the child's fantasies of omnipotence in the normal narcissistic phase. In either case, the ability to form such projective illusions is preliminary to the development of the ability to create, in its widest sense. Modell (1970), in the context of paleolithic cave art, explains how early art forms may be analogous to transitional objects. In cave art, the use of existing natural forms to suggest subject matter, in combination with added embellishment from the artist's imagination, parallels the child's interpretation or embellishment of an inanimate object from the environment with subjective meaning. Following Winnicott's assertion that the transitional object represents a provisional adjustment to objective reality that is beyond the child's control, Modell sees the art object and other cultural forms as only partially 'self-creative', and subject to a 'certain limitation upon narcissism'. According to Modell, the external environment, upon which the human being is dependent, represents, at a psychological level, the mother. Just as the transitional object helps to maintain a relationship with the mother, created cultural forms also serve to keep alive a relationship, analogous to that with the mother, with the environment and with existing cultural traditions.

In religious practices and rituals, sacred objects become imbued or animated with aspects of the divine. Serving to maintain a connection to the divine, these objects may also resemble transitional objects. However, whereas the transitional object eventually fades out of use with the achievement of separation and individuation, the sacred object is probably not intended to promote independent functioning. Instead, it is used according to unvarying prescribed ritual. The sacred object seems to be more akin to a fetish than a true transitional object, as differentiated by Greenacre. Religious relics, especially those that resemble (or are said to be) actual body parts of saints or other sacred personages, bear a distinct similarity to body part fetishes. In both religious relics and fetishes, the object is imbued with the power to induce an erotic or ecstatic reaction. While the fetish may provide an unconscious connection to the mother

and serve to restore the parts of a fragmented self, the religious relic may generate a magical connection to a supernatural protective being. When art was undifferentiated from religious or sacred practice, it may have fulfilled the functions of a relic. However, at some point artistic creations became transformed into objects of value beyond their ritualistic use. Aesthetic value confers meaning to an artwork, infusing it with transcendent powers of communication and connection to the culture. The art object comes to occupy a position of independence and meaning separate from ritual uses, and in this sense resembles a transitional object more than a fetish.

On the other hand, the creative drive toward restoration and repair of early wounds or traumas (Niederland, 1967), resulting in restorative works of art bears similarities to the dynamics of fetishism. As the fetishist is rarely interested in giving up the fetish, neither is the artist as a general rule interested in a 'cure' that might interfere with the drive to create. If the creative drive is linked to a wound or trauma, even unconsciously, the artist's self-nurturing of creativity would likely bleed into an erotic attachment to the wound as well. The cultural stereotype of the 'starving artist', when viewed from the artist's perspective of sanctified suffering, glorifies the creative drive and minimizes the importance of basic survival needs. This stereotype represents a variation on asceticism that may be carried to the extreme of 'fear of success' described by Menninger (1938) or being 'wrecked by success' discussed by Schafer (1988), both in reference to a style of moral masochism. As an example of the artist's reluctance to relinquish the original wound driving the restorative creative urge, Niederland (1967, p.13) quotes the artist Giacometti as saying that 'to succeed is to fail'.

Self-mutilation, involving an erotization of a part of the body and a subsequent destructive and creative relationship with that part, bears similarities to the use of both fetishes and transitional objects, as has been discussed. As the child's transitional object is treated with both affection and rage, subject to aggressive attacks from which it must survive – 'the object is affectionately cuddled as well as excitedly loved and mutilated' (Winnicott 1953, p.91) – the self that is the object of mutilation must also be expected to survive. As the surviving transitional object helps to maintain connection and establish separation, the wounding and healing involved in self-mutilation may be aimed at a similar sense of connection

and separation. Yet, as with the fetish, the object of affection remains fused to the body, therefore neither separation nor relationship can occur. The self, the act, and the object are all as one, merged in an undifferentiated state. A repetitive, ritualistic act continues – until some form of aesthetic transformation takes place with the introduction of cultural and artistic meaning to mediate between the self, the act, and the object.

Trauma and self-mutilation

In recent years, the connection between later self-injurious behavior and traumatic childhood histories involving physical and sexual abuse, severe neglect, and repeated surgery has been documented and widely discussed (Favazza 1987; Hawton 1990; Herman 1992; Miller 1994; Pao 1969; Yaryura-Tobias, Neziroglu and Kaplan 1995). Self-cutting in particular has been associated with incest (Richards 1988; Shapiro 1987). Van der Kolk, Perry and Herman (1991) concluded that while childhood traumas predict the initiation of self-destructive behaviors, lack of secure attachments (caused by severe neglect such as prolonged separations from caregivers) serve to maintain it. With secure attachments and appropriate support systems, children are more able to cope with the effects of trauma.

Much of the trauma literature explains self-injurious behavior as an unconscious attempt to act out traumatic experiences upon the body. Miller (1994) refers to this process as 'trauma reenactment syndrome', a self-generating cycle involving self-abuse, shame for the behavior, and more self-abuse to punish the shameful behavior. One of the reasons for acting out the behavior, she suggests, is the unconscious need to communicate what has happened when verbal communication is inadequate, because of memory loss or repression. Van der Kolk (1996) suggests that repetitive self-abusive behaviors may be related to Freud's idea of a compulsion to repeat in the present emotionally charged experiences from the past that are unintegrated and repressed from conscious memory. However, van der Kolk (1997) disputes the idea that repetition of abuse may lead to mastery or integration of the experience. In fact, as Miller also states, re-enactment may cause retraumatization of people whose bodies are already hyperaroused and sensitized to abusive situations.

Dissociation

One of the ways that trauma survivors cope with chronic abuse is to split themselves so that a detached part of the self observes the event from above or from a distance. The traumatic event then seems unreal and separated from the self. This ability to enter into altered states of reality may go too far and persist long after the abuse, causing intensely unpleasant episodes of dissociation. Characterized by feelings of numbness, deadness, or disintegration of self, these episodes are often triggered by feelings of loss or threatened abandonment and may precede acts of self-mutilation, especially cutting (van der Kolk 1996). Although pain sensations may initially be numbed, the shock of cutting and the appearance of blood may help to bring unpleasant episodes of depersonalization to an end. The mutilation eventually brings relief and calm, as though the administration of physical pain quiets and soothes emotional pain (Herman 1992). This use of one type of pain to counteract another less desirable kind of pain is similar to the idea of violence as an antidote to violence. Just as the 'sacrificial crisis' of chaos, loss of boundaries, and uncontrolled violence is brought under control through the legitimate violence of sacrifice, the self-mutilator's act of self-directed violence may help to restore calm and order to an inner state of chaos and disintegration.

Hyperarousal

The numbing of bodily sensations that accompanies dissociation and occurs frequently in people with histories of trauma may be a defensive response to the body's overreaction to stimuli. As a result of the tendency for traumatic experiences to be relived over and over, the body may become accustomed to being in a state of hyperarousal, and may lose the ability to distinguish minor environmental stresses from actual dangerous situations (Miller 1994; van der Kolk 1996). According to van der Kolk (1996), the traumatized person tends to respond to all stressful stimuli with an equally high level of fear and anxiety, causing such responses as fight or flight reactions or simply shutting down. The stimulus–response pattern occurs instantly, meaning that there is no time for reflection or thought to modulate the reaction. The inability to modulate affects such as anger and fear contributes to the traumatized person's tendency to engage in self-destructive activities. Overwhelming feelings and anxieties tend to

be acted out upon the person's own body as the safest and most easily accessible target. If not acted out directly, affects may be repressed and unconsciously converted into indirect attacks upon the body, such as somatic complaints, eating disorders, substance abuse, or accident proneness.

The state of excitement and arousal that accompanies traumatic experiences may be a cause in itself for repetitive re-enactment of abuse. In contrast to the numbing that simultaneously occurs, hyperarousal may impart a sense of aliveness. An addiction to pain or danger may develop, as these become associated with excitement and the feeling of being alive. Psychologically, the excitement and pain of ongoing trauma may prolong and maintain a sense of being connected to an abuser, with whom there is often an ambivalent relationship. Particularly in cases of early childhood trauma involving parental neglect or abuse, the child may become conditioned to associate love, connection, and even protection with pain and abuse. Sexual abuse and incest may involve the arousal of pleasurable sexual feelings, as well as feelings of closeness and being special to the abuser, and re-enactment of the abuse may promote a return to these feelings along with pain. Pain may be seen as a special friend for an isolated and unprotected survivor of abuse: 'cutting takes her to a place of excitement and peace simultaneously…cutting taking on the form of a wizard with strange and mysterious magic' (Miller 1994, p.68).

Shame

The social isolation experienced by many survivors of trauma, besides reflecting an overall impairment in object relating, may also be connected to the need to maintain secrecy about the abuse. Sexual or physical abuse is usually either hidden from other family members or kept secret within the boundaries of the family, to maintain appearances of normalcy. Shame, on the parts of both victim and abuser, feeds into the need for secrecy. Shame and secrecy may lead to the development of a 'false self' (Miller 1994), with a facade of good behavior used to defend against a negative inner self-image. According to Miller, patterns of secrecy and shame begun in childhood may extend into adolescence and adult life. For example, ritualistic acts of self-mutilation performed in secret to private areas of the body may be an extension of such patterns. The self-abuse, while keeping

alive a secret relationship with the abuser, may also serve the need to punish the bad self that secretly enjoys the abusive experience. Miller describes the body of the trauma victim as a 'battleground'. In the language of human sacrifice, self-mutilation may symbolize a ritual killing of the bad self to purify and raise the 'false self' to a position of dignity for the sake of survival and inner peace. With sacrifice, the ongoing conflict between the bad self and the false good self is temporarily silenced. The body is both sacrificial victim and 'battleground' for the resolution of the conflict. It is, as has been stated already, the bargaining table where exchanges between inner and outer worlds are negotiated. With the killing off of the bad self, the shameful gulf between inner and outer selves is temporarily wiped away. In a sense, the two selves may be seen to switch places, as purification allows the inside to feel more peaceful while the bad self becomes externalized as markings, scars, or other images of violence upon the surface of the body. The transformed self has made a symbolic attempt to create balance and exchange between inner and outer worlds, that at least in a small way may help to ease feelings of isolation.

Protection of boundaries and bodily integrity

The splitting up of the self owing to problems of shame as well as dissociative defenses wreaks havoc upon the body image. With traumatic and abusive experiences comes a repeated violation of the boundaries of the body and the self, so that a sense of bodily integrity may never develop. There may be no clear sense of where the self ends and the world and others begin. The fear of invasion, grounded in real experiences of violation, coupled with a fear of engulfment due to unclear boundaries, may contribute to the need for distancing and isolation. Disfigurement of the body through self-inflicted violence may achieve the result of repulsing and driving away others for the underlying purpose of self-protection. Scar tissue may serve as a double layer of protection, as a symbolic 'second skin', and as a repulsive 'mask' used to frighten away possible intruders. The ability to alter and manipulate the body image through actual carving and reshaping may help to enhance feelings of personal power for the disempowered victim of traumatic abuse. An improved sense of control over the body may help to reshape and restore fragments of self into a more cohesive whole. The idea of the body as a battleground blends with

the idea of the body as a creative medium, both of which were seen in examples of performance art discussed in chapter 1. Survivors of traumatic invasions of the self, including surgeries performed in the earliest years of life, may feel the body to be essentially damaged. Subsequent self-mutilations may represent unconscious attempts to reform and repair a damaged body or to rearrange and restore missing parts to a self that is felt to be incomplete or disintegrated.

Communication styles and self-mutilation

Separating and connecting function of symbols

Part of this discussion has focused upon self-mutilation as a symbolic attempt to separate from an enmeshed or troubled relationship, associated with feelings of inner chaos and loss of boundaries. The violent act may function in a similar fashion as a sacrificial rite of passage or castration ceremony to rid the self of unwanted or impure elements, to locate and mark boundaries between self and other, to establish a transcendent self, and to restore a sense of order and calm. On a concrete level, the morbidity of self-destructive acts may drive others away in fear or repulsion. Creating distance from other people in this manner may accomplish a temporary or illusory separation, one without true independence.

Paradoxically, the act of self-mutilation may simultaneously function to create or maintain connections with others, however illusory or unfulfilling. Various examples of this have already been explored. To summarize briefly, self-mutilation may operate defensively to preserve an attachment by redirecting aggression toward another upon the self, in order to avoid retaliation and possible abandonment or loss of love. It may also serve to maintain a sense of connection to an abusive caretaker or loved one, through the unconscious association of pain with love and caring. Self-mutilation may create connection to others in certain circumstances by representing membership of an elite group such as a street gang, a tribal warrior class, or a subgroup within an institution. Tattoos or scars of self-mutilation may be displayed as emblems of initiation and belonging, while establishing an identity separate from the mainstream of culture. Finally, scars and rituals associated with self-mutilation may function as substitutes, maintaining connection to another while facilitating the beginnings of separation. In this aspect as primitive or pseudo

transitional objects their function is to bridge the gap between self and other, to cross or patch over the unbearable abyss separating self and other. The dual intent to create both connection and separation is central to the discussion of self-mutilation in relation to communication and the capacity for symbolization.

Symbolization

Communication involves the use of symbols to bring about interaction between separate beings. In this sense, symbols perform a 'bridging over' function, serving to connect that which is separated by distance. Conversely, without distance between separate beings, there is no space, nor reason for symbolization to occur. Schaverien (1995, p.146) describes this concept: '... an undifferentiated state is just that. There is no name for it, no symbolic representation and so no separation.' However, symbols also help to create distance and separation by organizing perception into recognizable gestalts within an undifferentiated field of stimuli. Deri (1984) states: 'Without adequate separation, there is no "other" and consequently no symbolization. At the same time, however, symbolization is a means toward separation' (p.166) and 'an innate weakness in the symbolizing capacity may itself prevent wholesome separation' (p.167). It is the mental symbolic representation, what Deri terms a 'matching half' analogous to something in the outside real world that effects a separation between inner and outer worlds. In other words, a 'double' is created, to represent that which is separate but related. Doubles are divided but related, so may be interpreted either as difference or similarity. For recognition to occur, the mental image is doubled or 'paired' with an outside pattern, thereby acting as 'a guide toward the missing half that will complete a gestalt' (Deri 1984, p.51).

The language of doubles and pairing refers back to the discussion in chapter 1 around the appointment of a 'sacrificial substitute' to serve as a scapegoat for communal aggression. Girard (1977) draws a connection between the origins of sacrifice and the development of all aspects of culture, based on his theory of the sacrificial substitute as the basis for the development of symbolization. Although this may be an oversimplification of the derivation of symbolization, Deri (1984) also emphasizes the parallel between language and magic rites as originating in 'the wish to

reach across a boundary to some invisible power believed to exist in another realm' (p.46). Sacrificial rites, through the striking down of a substitute victim and the subsequent setting up of a deity, are intended to reach magically across boundaries between physical and non-physical worlds. Underlying the function to put a stop to violence caused by a chaotic and undifferentiated blurring of boundaries, the transcendent purpose of sacrifice is to separate the pure, or spiritual, from the impure, or material, while simultaneously creating a passageway between these two worlds.

Impairment in the capacity for symbolization

Many self-mutilating patients have difficulty with verbal communication. Verbalization of emotions, especially anger, is particularly difficult (Simpson 1980). Doctors (1981) describes the 'inarticulateness' of self-cutting adolescent girls, and relates this to difficulties with trust in the environment to respond to basic needs. Their 'lack of access to the use of symbols' (p.448) leads to a tendency to express feelings of frustration through 'motor expression', such as self-cutting. Trauma, common in the histories of people that self-mutilate, may result in 'speechless terror', due to the shutting down of areas of the brain that make verbal recognition of emotional and internal experience possible (van der Kolk 1996). For these people, action replaces symbolic representation. In other words, the capacity to use symbolization for soothing anxieties and delaying gratification of urges may be quite weak. Instead, impulsive actions to end or alter states of anxiety are used. This may also be viewed as impairment in the ability to symbolize.

Taking place within the space between desire and gratification, symbolization allows for the healthy toleration of anxiety associated with separation from the desired object. Klein (1930) emphasizes the necessary role of anxiety in the development of symbolization. She theorizes that anxiety produces the desire and pressure to create internal mental representations, precursors of symbolization, to maintain a hopeful connection to the desired object. Part of the anxiety aroused by separation from the desired object may be caused by sadistic fantasies toward it, and by feared retaliation. The fear is that the same weapons used in fantasy to attack the desired object may be turned back against the self. In learning to handle

anxiety related to sadistic impulses, the infant ego learns to turn to substitute objects within the play space upon which to discharge destructive and aggressive urges. According to Klein, as play objects become invested in fantasy with the attributes of the desired object to such a degree that they become threatening, the infant may discard them and search for new substitutes. This step-by-step process of investment, destruction, and moving on to the next substitute, is the process by which distancing from the desired object occurs. At a higher level of abstraction, a substitute may evoke, but no longer directly stand in for, the desired object. At this point, symbolization begins to occur. Since abstraction is more versatile and directly accessible, symbolization becomes a more economical means to handle anxiety, particularly through the ultimate development of language and communication skills.

Returning to the theme in chapter 1 of the use of a sacrificial substitute to handle aggression, it becomes clearer how the concept of sacrifice may relate to the development of symbolization. The process that Klein describes, in which the infant destroys one substitute after another to escape his or her own destructive aggression, is essentially a sacrificial process, using the device of a sacrificial scapegoat. In Klein's view, this process ultimately leads to the development of symbolization. Girard (1977) theorizes that sacrifice may be the foundation of symbolization and thus culture in general. Parallel to this is Klein's theory that 'symbolization is the foundation of all sublimation and of every talent, since it is by way of symbolic equation that things, activities and interests become the subject of libidinal phantasies' (Klein 1930, p.97).

The degree of anxiety experienced by the infant is crucial to the unimpeded development of symbolization. Too little or too much anxiety can interfere with the process. Trauma in the earliest months and years of life, especially involving neglect and abuse, can result in far too much anxiety, which then may inhibit the capacity for symbolization. This may result in the previously mentioned 'speechless terror' of which van der Kolk (1996) speaks. When the separation between infant and caregiver (or the delay in the caregiver's response to the child's needs) is experienced as optimally stressful, then symbolization may develop. Gratification would ideally be neither immediate nor delayed to the point of annihilation of hope. The balance between separation and connection is delicate: 'Children first have to experience a space separating them from the mother

before they can turn that space into a "connecting space" by symbolic play, or language.' (Deri 1984, p.166.)

According to Deri (1984), if the caretaker remains absent for too long a period, the transitional object used to comfort the child during the absence may 'deteriorate into a rigidly frozen fetish' (p.257). The child may become fiercely attached to such an object, refusing to let go, and thus never becoming able to 'move into the intermediate transitional space where symbolic, creative imagination reigns' (p.257). The tendency for the fetish object to become imbued with magical holding powers may ultimately lead to fixed delusions – an obvious impediment to the formation of 'good symbolization' and effective communication. At the earliest stage of development when the self and desired object are indistinct, object loss may result in feelings of body incompleteness, and parts of the infant's own body may be used as fetish objects. In Deri's view, the energy that is lost to repetitive, self-stimulating behaviors such as hair-pulling or compulsive autoerotic activities becomes unavailable for the development of more creative uses of symbolization. In fact, she states that the salient indicator of 'deficiency in symbolization' is 'stereotyped repetitiveness' of behavior or fantasies. Such a deficiency of symbolization and corresponding rigidity of thinking or behavior is highly undesirable in that it severely limits a person's freedom of choice, as well as ability to form satisfying relationships through the connecting pathways of creative interaction.

Adolescence and gender

During the period of adolescence, when the separation and individuation process is renewed, symbolic and verbal capacities may undergo regression. The tendency toward action and acting out interferes with the secondary cognitive processes necessary to 'thinking as trial action' (Blos 1962, p.125). The common occurrence of eating disorders, along with more direct forms of self-mutilation, may be related to a regression or arrested development at the separation and individuation phase (Haeseler 1991). At this point in development, Haeseler observes that there is lacking 'language with which to symbolize their inner world; instead, they communicate through their bodies and motility'. Sarnoff discusses masochism in the context of development, referring to a stage beginning

at the end of the first year, in which parts of the body are used as 'protosymbols' to represent affects, other body parts, or parents. Aggression related to separation and individuation pressures may be acted out passively upon the child's own body parts. During adolescence the tendency to use body parts to act out masochistic fantasies recurs, when toys and play symbols are no longer able 'to serve as substitute objects and tools for the discharge of drives and mastery of conflict' (Sarnoff 1988, p.209).

Gender may also have an affect upon the depression of verbal communication during adolescence. Adolescent girls tend to verbally withdraw at this age, having received cultural messages that their feminine values are unacceptable and therefore their voices will either hurt others or be ignored (Gilligan 1982). This 'silencing of her own voice' (Gilligan 1982, p.51) is reflected in the 'wispy' voices characteristic of anorexic clients (Haeseler 1991), most of whom are young women. Gilligan uses the Persephone myth to illustrate this concept, describing the 'disappearance of the female self in adolescence by mapping an underground world kept secret because it is branded by others as selfish and wrong' (p.51). The image of the disappearing or invisible feminine self is graphically apparent in the evanescent silhouettes seen in the artworks of Ana Mendieta, described in chapter 1. Although there is no firm evidence that the majority of self-mutilating clients are women, research studies often do focus upon women, particularly with respect to self-cutting clients.

Conclusion

As has been shown, self-mutilation may serve various purposes, and a single such act may accomplish a multiplicity of functions. In this respect, it resembles symbolization. The versatility of a symbol is based on its ability to convey multiple, even contradictory meanings. This is opposed to a sign, which stands in for something else, thus having just one significant meaning. In more visual terms, both symbol and sign are based on a concept of doubling, or splitting into equal halves. A sign would appear as a more literal equal, with emphasis on salient features for recognition but little room for variability in interpretation; while a symbol might represent equality through a variety of abstractions of intrinsic qualities of the original. As a symbol becomes more abstract, it loses

density and gravity with respect to its connection to the original counter-part. Thus, as in a highly complex and abstract symbol system such as language, symbols can freely combine and interact to reflect experience on a multiplicity of levels with efficiency and precision. In this sense, symbolism makes possible expanded flexibility and creativity. It also makes possible a more flexible use of the space between self and others. Through its simultaneous separating and connecting functions, it facil-itates an elastic degree of control over this space, ranging between distance and intimacy.

Human sacrifice relies on the use of a material substitute. However, according to Girard (1977), the sacrificial substitute must represent that which is both like and unlike the original. Therefore, while staying relatively close and connected to the original form literally, it begins to take on some of the ambiguity of a symbol. Self-mutilation, seen as a variation on human sacrifice, also seems to represent some intermediate position on a scale between sign and symbol, or concrete substitution and abstract symbolization. The cultural context in which it appears and the degree to which it is consciously performed would determine how effectively it functions as a symbol, liberated from literal meaning. For example, the compulsive repetition of some self-harming acts performed in secret might represent quite literal representations of past abuse, providing temporary relief from anxiety symptoms, and promoting a temporary sense of control. Yet in terms of empowering the individual toward more flexible and creative relationships with others, involving self-regulation of intimacy and distance, these repetitive acts would be relatively inefficient. On the other hand, the consciously planned self-mutilation of a sundancer might have a more stable and lasting effect upon the warrior's range of expression and power within the context of his culture.

A similar view is held by others (Favazza 1989; Hewitt 1997) that various forms of self-mutilation can be located on a scale ranging between culturally sanctioned and pathological, with the latter representing a morbid attempt at healing. The advantage of such a scale is to interpret self-mutilation as a common human practice despite the fear, contempt, or revulsion that it may elicit. By understanding self-mutilation as an ancient and universal human practice, it is hoped that it can be addressed from a position of empathy. The model suggested here does not contradict the

view of Favazza; rather it focuses the attempt at healing more specifically in the realm of symbolization, as a means ultimately to provide both separation and connection. By looking at self-mutilation as an attempted form of symbolization, for the purposes of connection and separation, the morbid and pathological aspects of it become peripheral. In terms of a therapeutic approach, the suppression of morbid symptoms would not be a primary goal. Rather, treatment would focus upon empathy and support for developing more creative and flexible symbolic capacities.

Seen as a process with healing intentions, the morbidity associated with self-mutilation can be related to the destructive elements involved in the act of creation itself. As a suicide attempt may be in reality a masked attempt to defy and survive death, creation from the disassembled parts of a pre-existing structure may also represent transformation and resurrection. The act of creation, whether through the sexual reproductive act or the symbolizing process of culture formation, represents an attempt to cope with death through the sacrifice of the dying generation, and the dying god, for the regeneration of life. Sacrifice achieves the transformation of mortality into immortality. Just as art cannot be purely imaginative, neither can it be purely a rote re-enactment of traditional rituals; where creation occurs, a chaotic and violent disorganization of existing elements opens the way for new forms to develop. A certain amount of discomfort – the morbidity factor – is necessary for change; as is hope. When the erotic drive slightly exceeds the destructive drive, creativity flourishes.

The remainder of this book focuses on the treatment of self-mutilating clients from the perspective of art therapy, a modality that incorporates both destructive and creative elements at a tangible and concrete level, particularly keeping in view a goal of supporting the expansion of creative and symbolic capacities. In the case studies that follow, art therapy was used in an integrative treatment approach, as one part of the overall treatment plan for each patient. Following the case studies will be a general discussion of aspects of art therapy that may be useful in the treatment of self-mutilating clients.

Transformation and Self-assertion in the Case of Mary

Introduction

This case study focuses upon Mary, a 16-year-old girl with a history of suicide attempts and self-mutilating episodes. Mary received art therapy in addition to verbal psychotherapy; the art therapy narrative in this chapter covers her first nine months in treatment. As the narrative will show, self-destructive urges surfaced in the art therapy sessions, in both the working process and the content and appearance of the artworks. Because Mary was not verbally communicative, art therapy as a nonverbal alternative modality in her overall treatment plan was felt to be crucial to her progress in therapy. This case details the journey and the progress that Mary made over nine months within the limited arena of the art therapy studio.

Art therapy process

The case study of Mary, as well as the cases in chapters 4 and 5, will include detailed descriptions of the art process. Although the content and appearance of the finished artwork is important, it is through the active working process that the subtle aspects of a client's behavior and thought processes unfold. Often, the art therapist's most effective interventions occur during the process. For nonverbal clients, or those that are resistant to verbalization, it may be nonverbal behaviors within the session, along with the therapist's nonverbal interventions that make up the therapy. It is around the concrete details of the working process that dialog between the client and the therapist usually begins. The art therapist's empathic facilitation of the creative process lays the groundwork for a therapeutic

relationship to develop. In the early stage of therapy, especially with severely traumatized clients, there may be considerable discomfort and resistance to directly discussing issues that emerge in the artwork. Verbal reliving of traumatic memories may be retraumatizing at this stage. Whether the client chooses to talk about his or her deeper associations to the artwork or not, the art therapist continually monitors the creative process for information on how the client acts out conflicts unconsciously. Careful examination of both the process and the product helps the art therapist to avoid forming hasty and superficial conclusions. A case study that focuses exclusively on interpretations of art products is therefore incomplete, and may do an injustice to the client and the practice of art therapy in general.

It was in witnessing the creative process, and subsequently describing it in detail, that I began to develop formulations about the sacrificial nature of Mary's process. Parallels to self-mutilation appeared in the process and in the artwork, which prompted me to explore further the possible connections between the creative process and body modification. In the discussion of the art therapy process that follows, I will refer to subtle and overt ways in which the dynamics of sacrifice may enter into art therapy sessions.

Clinical history

Family history and childhood

Details of Mary's early years are sketchy. She grew up in a city in the midwest, where she attended day care at an early age. It was observed that she sucked her thumb for a long time. Mary's father and mother separated when she was about four years old, and she claimed to have no memory of her father. Her parents had no other children together, but 15 years prior to Mary's birth her mother had given birth to a son with a different partner. Mary's father adopted the son, so it may be presumed that in the first few years of Mary's life, her teenaged half-brother lived with the family. However, by the time Mary was in her teens, her half-brother had moved out to live nearby. It was reported that Mary had mostly lived alone with her mother. Her brother was married with two children. He and his wife were both substance abusers, for which he was reported to have begun treatment.

Mary remembered having been beaten as a child by her mother, but she denied having experienced any other physical or sexual abuse. She began having anxiety attacks in the fourth grade, and hurt herself for the first time at age 11. In this incident she slashed her face with a razor. At the time it happened, she claimed the injury came from an accidental fall, but later she admitted that she had injured herself intentionally to gain her mother's attention.

Adolescence and first psychiatric hospitalization

At 15, Mary appeared older than her age. She was tall and quite obese, an imposing figure among other girls her age. She had acquired by this time a complicated history of depression, self-destructive behavior including suicide attempts, and somatic complaints. Her physical ailments prompted frequent visits to medical doctors. She was diagnosed with diabetes. In reaction to this news, she began to cut her feet in anticipation that the cuts would become infected. Other self-destructive incidents occurred at age 15. Although she denied using illegal drugs or alcohol, she was twice taken to the emergency room for ingestion of pills. She took pills approximately eight times, cut herself with razors, and burned herself all in the same year.

During these episodes, Mary had begun to date a 22-year-old man. Mary's mother disapproved of this relationship because of the difference in their ages, and forbade Mary from seeing the man. Mary was compliant with these orders and stopped seeing the man; but when she admitted to having had sexual relations on one occasion, her mother became hysterical and took an overdose of pills with an excess of insulin. The following day, Mary copied her mother's actions by taking a combination of Demerol, Tylenol, and codeine. Mary later learned that her mother had become sexually involved with the man that Mary had been dating, and continued to see him. Mary's situation became public knowledge, and she suffered ridicule at school from peers. She was so distressed by this time that she moved in with her half-brother, and began to cut and burn herself on the arms. Later, she remarked: 'I tried to kill myself with a razor, but it wasn't sharp enough. I asked my mother to promise not to tell anyone.' Mary's self-injurious behavior prompted her first psychiatric hospitalization, which lasted approximately two months. Mary's half-brother

intervened to have his mother hospitalized as well. Consequently, both Mary and her mother happened to be in inpatient wards at the same hospital at the same time. During her stay at the hospital, Mary continued to cut and burn herself. When Mary was released from the hospital, she was referred to a day treatment program. In the program, where Mary received treatment until her graduation from high school, she attended special education classes with other emotionally disturbed adolescent girls. In addition, she received weekly verbal psychotherapy and individual art therapy sessions. Her mother participated in regular family therapy sessions at the same facility.

Emotional and mental profile

Mary was of average intelligence, according to cognitive evaluations. She was relatively academically inclined, consistently completing her assignments and receiving good grades. She was able to concentrate and focus on her schoolwork, but kept to herself socially. Rarely speaking to others, Mary seemed particularly preoccupied with her own depressive state. Her introspective nature was not entirely negative; it also manifested as a capacity for insight and self-reflection. Unfortunately, her intellectual and perceptual strengths easily fell apart when she was under emotional stress. At these times, which occurred frequently, her thinking would shut down such that she had difficulty processing information and solving problems. She lacked the internal thought processes and mental self-soothing strategies to cope with tension, and overreacted to her overwhelming feelings with impulsive exaggerated actions such as suicidal gestures. In these states of heightened sensory arousal, Mary lost her ability to reflect, thus collapsing the distance between her anxiety and her desperate response to it. This left no time or space to ponder, imagine, and plan alternative coping strategies. To make matters worse, she was highly susceptible to environmental stimuli, reacting with equal alarm to very severe and relatively slight stressors.

Because of her inability to cope with situations of emotional arousal, Mary had developed defensive strategies to avoid getting into such situations. She shied away from social interactions, keeping to herself in nearly wordless silence. Her obesity and depressed affect contributed to her isolation by eliciting reactions of rejection or indifference from her

peers. Outwardly, she seemed to accept passively her position as a social outcast. On the other hand, she mourned the lack of connections and closeness in her family. Psychological test reports ascertained that Mary viewed her family as rigidly disengaged and wished that it were more intimately merged. In reality, both disengagement and chaotic merging patterns appeared within her family, particularly as demonstrated by the types of behavior and communication styles displayed.

Although Mary was intellectually intact and her sense of reality was never in question, she did experience isolated conceptual distortions. In particular, she suffered from severe anxieties related to her body, which she seemed to experience as damaged and defective. This led to chronic somatic complaints and symptoms. She also had intense feelings of being misunderstood by others. Like other adolescent girls and boys, she craved acceptance from her peers, but reacted to the loss or withholding of acceptance with severe depressive and suicidal gestures. Her cognitive strengths of sensitivity and self-reflection were easily subject to reversal against herself, resulting in self-critical attacks that left her deeply depressed and sometimes physically mutilated.

It would probably be inaccurate to say that Mary felt hopeless about her condition. In fact, her self-directed attacks, though related to her depression, also served expressive and connective functions. According to her own admission, her attacks upon herself were directly aimed at gaining attention and comforting from her mother. Mary and her mother appeared to communicate with each other in similarly nonverbal and impulsive self-destructive actions. These self-victimizing acts seemed to carry considerable weight in terms of effecting responses from each other. The fact that the responses Mary received from her mother probably, in most cases, failed to bring comfort must have contributed to her feelings of being misunderstood. Yet some degree of satisfaction seemed to be derived from her frequent states of victimization. This was possibly related to a psychological gain associated with the power to induce guilt feelings in her mother.

Another possible gain derived from Mary's self-destruction, in terms of effecting a connection with her mother, may have been accomplished unconsciously and through direct impulsive behaviors. The emphasis on nonverbal interaction in their relationship underscored the lack of psychological distance between them. Such a propensity for impulsive action

left no space for reflective, mediating dialog. In this sense, Mary and her mother could be described as attached to the point of merging. The chaotic lack of boundaries between the two of them was visible most graphically in the sharing of the same man for sexual purposes. Equally dramatic in coincidence and style were the ways in which Mary and her mother merged in identification with each other. The copying of one another's behavior, such as consuming the same pills, and eventually finding themselves simultaneously in the same hospital clearly suggested an exaggerated style of identification. In lieu of dialog, congruent violent actions and reactions formed a bridge that connected and united them. Furthermore, the threat of violent action became a useful tool to inhibit gestures of healthy separation. At an unconscious level, the violent impulses may conversely have conveyed an opposite intent: a healthy urge toward separation (via destruction) from an overly fused state.

It is significant that Mary at one point stated feeling disconnected and distanced from her family, while the facts and incidents revealed an overly merged relationship with her mother. In fact, she also remarked about the same time that her mother was overprotective of her, jealous, and intrusive. The juxtaposition of these thoughts indicated Mary's strong ambivalence toward her mother, with conflicting desires and fears of separation. This ambivalence was almost certainly not one-sided on Mary's part. Her mother also appeared to operate from strong feelings of ambivalence toward Mary. Her mother at times consciously acted in her daughter's and her own best interests. This was borne out by her cooperation with her daughter's treatment and her own past attempts to resolve personal issues in therapy. Yet she openly engaged in behaviors that were destructive to both her own and her daughter's wellbeing. Her physical appearance, not unlike Mary's with respect to obesity, was strikingly adolescent-like. In fact, next to Mary's conservative, somber presentation, free of adornment or cosmetics, she appeared the more immature of the two. Her manner of dress and make-up was colorful and flamboyant, visually attention-getting and sexually provocative. This seemingly open competition with her daughter was perhaps to some extent unconscious. The childlike impulsivity of her behaviors belied her own sense of helpless victimization and the bond that connected and entrapped both mother and daughter in roles of sacrificed children.

Course of self-destructive behaviors during treatment

Mary's somatic problems continued during the course of her participation in the day treatment center, at least during the first nine months in which I worked with her. Soon after she entered the program, she was hospitalized for a severe asthma attack. And less than one month later she fell victim to an attack by a neighborhood dog. Injuries from the dog bite to her arm were severe, involving nerve damage that required surgery. Mary was frequently absent from school for other minor health complaints. She kept to the sidelines socially, having few friends and rarely speaking. When she did speak, it was usually in a faint, childlike voice. She complied with the requirements of the program, performing well academically, but maintaining a consistently dulled affect and sullen expression. She continued to complain of depressed feelings. No incidents of direct self-mutilation were reported or apparent during the nine months in which I observed her. However, since Mary was usually careful to keep her scars from previous self-mutilations concealed, it is possible that further attacks may have occurred in private.

During the course of her treatment in art therapy, self-destructive and suicidal impulses did surface during the creative process and, more subtly, in the symbolism of finished artworks. The aggression that Mary turned inward upon herself in direct attacks of chronic and at times severe depression, seemed to find a more externally directed outlet in the art process. The following is a description of her process and progress in art therapy over the nine months in which she attended weekly individual sessions. It details the manner in which Mary began to externalize some of her aggressive impulses, and to gain psychological distance from inner feelings of chaos. As she began to acquire some perspective through appraisal of her own artworks, Mary silently began to arrange pictorial elements in consistent patterns. These repeated scenarios were of apparently deep significance to her. As her work progressed, critical comments directed toward her artwork diminished and a quiet sense of ownership and accomplishment took their place.

Art therapy narrative

Initial assessment – drawing

On the first day of art therapy sessions, Mary was given an art therapy evaluation to assess her approximate level of cognitive and expressive abilities within a variety of art media. Behavioral patterns were observed and spontaneous projection of psychological issues were also noted for use in determining a starting place for therapy and formulating treatment goals specific to art therapy. The assessment procedure used was the Kramer Art Evaluation (Kramer and Schehr 1983), involving non-directive art production in three specific media: graphite pencil, tempera paint, and ceramic clay.

Mary presented herself in the art therapy studio slightly earlier than the scheduled time. Shyly hiding herself behind a curtain of thick shoulder-length hair that partially obscured her face, Mary timidly returned my greeting in a barely audible voice and then lapsed into silence. She wordlessly put on the smock that I gave her, and listened to a brief orientation to art therapy. She made no comment, but immediately applied herself to the directive to make a drawing of her choice. Sketching swiftly, she drew an animal, starting with the ears and travelling down the body. Its paws were omitted, the severed legs centered on an invisible baseline at the lower horizontal border of the paper. Her ease and apparent mastery of the drawing medium seemed to preclude the possibility that she could not conceive of a manner in which to draw the paws. The rest of the animal was completed in relatively accurate detail. She began to add light, short strokes to the body, at first tentatively, as though adding just a suggestion of hair. However, once started, this activity accelerated to the point where Mary could not restrain herself from covering the entire creature with a delicate curtain of diagonal slash marks (Figure 3.1).

The creature in Mary's drawing, which she later referred to as a cat, appears somewhat lost in its isolation upon the page. It confronts the viewer directly, with an alert and friendly expression, although the eyes appear to be anxiously unfocused. This, together with its isolation, gives it a homeless quality, as if it might be an abandoned animal seeking adoption. The slash lines that cover its body are suggestive of marks left by claws, and this is significant since the animal seems to have had its paws amputated. The slash marks give it a scarred appearance and its isolation on the page lead to the impression that it may have turned against itself.

Figure 3.1 Mary's first drawing

The raised tail may be interpreted as a friendly wave; however, its arching curve directed back toward the body adds to the effect of self-directed aggression. The missing paws suggest a further punitive aspect to the image; it may be wondered whether these have been removed or cut off in another self-injurious attempt either to control or to deny the possibility of aggressive and possibly erotic impulses. The shaky, broken line quality of the drawing, particularly apparent in the outer contours of the body, add a heightened sense of anxiety. While frenetic line quality in a drawing is sometimes associated with masturbatory or sexual anxieties, it is possible in Mary's case that there was an association to an uncertain or fragmented body contour as well.

Mary's image of a cat, actually resembling a kitten, is similar to subject matter that I have observed in initial drawings by other clients. Such early drawings often feature a small animal, centrally placed on the page, isolated and somewhat helpless or non-threatening in appearance. Schaverien refers to an 'image of the child' (Schaverien 1995, pp.157–160) occurring

frequently among the first drawings of clients. She interprets this image of a young child or fetus as a reflection of an early transference to the therapist, in which the client regresses to a state of infancy, particularly with respect to a sense of emptiness or incompleteness of self. Within the transference is present hopeful desire toward the therapist; while an aspect of this may be unconscious 'incestuous strivings', in a more general sense it represents a wish for protection. The fact that the picture is offered spontaneously, according to Schaverien, suggests to a degree a voluntary letting go of defenses. Seeing this object as a 'talisman' that represents the client's reaching out to the therapist, Schaverien emphasizes the importance of the therapist's 'good enough' response to it (p.160). The investment of special qualities or powers in the object that is implied by the term 'talisman' is similar to the process of the creation of the transitional object. As the transitional object serves a soothing connective function in preparation for separation, the defenseless child image may represent a parallel unconscious wish to establish an initial connection. The initially abandoned child cannot begin to consider separation before a connection has been made.

The abandoned animal image that I have observed may operate in a similar fashion to the 'abandoned child' image that Schaverien describes. As a self-image, the orphaned animal seems particularly helpless and needy. It pulls strongly upon affects of pity, affection, and protectiveness. It may also represent an even more regressed or impaired sense of self as an animal in a pejorative sense – not human. The animal self-image may relate unconsciously to instinctive and impulsive aspects of the self, both aggressive and erotic. Yet the orphaned animal, often small and cuddly looking, resembles a transitional object, even more closely than the child does. Doctors (1981), in a generalized profile of self-cutting adolescent girls, observes that they often continue to cling to transitional objects such as stuffed animals or other soft and furry objects. As the transitional object in Winnicott's formulation is designed to withstand both affectionate cuddling and aggressive attacks (Winnicott 1953), Mary's animal seen in this light seems to have survived the latter treatment. Its signs of aggressive self-attack, along with the removal of its claws, seem to indicate an ambivalent relationship toward itself and its own power. It suggests a desperate to the point of self-injurious need to present itself as passive and non-threatening, perhaps in order to be seen as acceptable for adoption.

Initial assessment – beginning the clay sculpture

After Mary finished her drawing, she chose to work with clay. She approached the clay with a mixture of tenderness and playful aggression, gently patting out and smoothing a pancake and then delicately attacking and destroying its surface with her fingers. She smashed the clay back into a ball and repeated the entire process. Next she rolled out a coil, twisted it into a pretzel shape, and then quickly crushed it with her hand. Like Mary, many art therapy clients begin clay sessions with playful, exploratory work in which regressive, erotic, aggressive, and destructive urges may arise. Objects may appear and disappear in rapid succession. I do not usually intervene at this point to try to 'save' creations, since this playful doing and undoing can help anxious clients to relax and begin to enjoy the creative process. The type of relaxation brought about by such exploratory play can be described as a 'regression in the service of the ego' (Kris 1952). It allows images from the unconscious to assume form; it is, in other words, a process of unleashing the imagination.

Mary's first contact with the clay already began to repeat themes in her drawing. Issues that were theoretically present in the drawing were tangibly acted out upon the clay. The manner in which she scratched and gouged the smooth surface of the clay was kitten-like in its delicate aggression, as though the missing claws in the drawing materialized unconsciously in her own fingertips. The scratched surface of clay subtly repeated the overall pattern of slash marks that overlay the drawing of the kitten. As she scratched at the clay, Mary lifted up pieces of it and began to stir its surface, as though she were opening up and disrupting the skin of the clay, suggesting skin mutilation. In an unconscious identification with the kitten, the same clawing impulse seemed redirected from the self to the clay surface. A 'pretzel' got swiftly and impulsively crushed in Mary's hand in one fierce motion, her hand embodying the strength and power of a bear claw. A bear in the wilderness snatching live fish from a stream might use its paw in a similar fashion. Such an aggressive act, directed at a food symbol, suggested ravenous hunger and oral aggression. Ambivalent feelings around hunger, eating, and nurturing may have unconsciously motivated the destruction of the pretzel, the crushing of it in her hand suggesting a violent wish to swallow it whole. A peaceful acceptance of food and nurturing may not have been possible. The image of the

homeless kitten returned to mind, desperately needy to the point of violence, to the point of hurting itself.

As a plastic medium, the clay responded to Mary's aggression. She appeared to enjoy the feeling of the clay being mashed in her grip. Perhaps there was an erotic component to the tactile experience of manipulating the soft, pliant, and slightly wet flesh-like substance. Eventually Mary stopped her spontaneous play and casually began to form rolled coils. She made two pairs of these, of equal lengths. Then she formed four balls of varying sizes. As she lay all of these pieces out symmetrically, it became apparent that she was planning the formation of a human figure from separate parts: head, torso, arms, legs, and feet.

Leaving the body parts still disconnected, Mary turned her attention to the meticulous labor of forming the hands. To small, flattened rounds she attempted to attach tiny separate fingers. These rounded hands with splayed-out fingers resembled bear claws. Although the second of these bear claw hands was just like the first, with no apparent flaw, Mary turned on it without warning and crushed it mercilessly in her hand. Working patiently and methodically, she made another hand much like the one she had destroyed. When she eventually formed the figure by connecting the separate body parts, Mary placed the arms so that the hands rested somewhat defiantly on the hips, the jutting elbows giving it an imposing girth. However, this pose did not last long. Mary tore off and destroyed the hands in a sudden motion, undoing the painstaking effort she had put into making them. Her expression was placid and flat as she did so. She then fused the wrists with their severed ends into the sides of the figure. With the hands removed and the arms tightly locked into place, the aggressive quality of its previous stance was dramatically altered. It was in fact reversed, from an active to a passive posture, one that appeared non-threatening rather than defiant or decisive. With hands removed and arms immobilized, its instruments for positive and active assertion, or for penetration of the environment, were dismantled. In this sense, it appeared to have been symbolically castrated.

Mary flattened out the shoulders of the figure, making them wide and masculine-looking. She added bulk to the torso with layer upon layer of thin slabs. There was a slow, deliberate quality to this act, as though the apparently soothing process of layering was at least as important as the outcome. Aggression alternating with tenderness continued to be a

pattern in the ongoing process. Mary focused at length upon the lower torso, to which she added a diaper-shaped slab. Along the top of this slab she lay a thick belt across the abdomen. This area became the focus of repeated doing and undoing, as she cut along the lower edge of the belt, creating a long, deep gash. She tenderly smoothed the gash over with her finger, and then cut back into it, repeating this activity several times. She then switched to the neck of the figure and re-enacted the same process, adding a thick collar around the neck and slashing back into it in the same manner.

Having previously set aside two similar-sized balls of clay, Mary added these to the top of the torso for breasts. 'It's a girl', she explained in a barely audible voice. She glanced at me nervously as she tenderly stroked and smoothed the surface of the torso, giving special attention to the breasts and pubic area. My response was to acknowledge her statement quietly, while casually continuing to witness her process, as though I found it interesting but not unusual or remarkable. Mary seemed to relax and carried on. There was almost no dialog during this entire process. I did intervene briefly to provide minimal technical support when Mary had difficulty standing the figure up on its feet. I consciously supported her intent to make a free-standing sculpture, recognizing this as evidence of strength of ego. I was careful to avoid offering too much assistance, as she had demonstrated the ability to struggle on her own, and to tolerate frustration. In fact, in her stoical silence and methodical patience, I sensed resistance to offers of help.

Finally, she added long ringlet-type curls to the head, each curl rolled and attached separately. Mary calmly struggled through this delicate and difficult task, starting, stopping and redoing it several times. Although her facial expression remained emotionally flat, the repetitious manner in which she worked conveyed a sense that she found the painstaking labor to be pleasurable. The figure at this point contained mostly female elements, despite the masculine-looking shoulders. Mary did not specifically say that it represented her; however, it bore similarities to her body type and hairstyle. Mary had been working in uninterrupted concentration for two hours, and she made it clear that there was more to be done. In a standard Kramer Art Evaluation, she would have been directed toward creating a painting as the final task. However, it was apparent from Mary's deep absorption in the work that she had spontaneously entered into

therapy, so the remainder of the evaluation was suspended to allow her to continue with her sculpture during the next scheduled art therapy session.

The interplay between erotic and aggressive urges that appeared in the process was striking. Certainly the hands, or paws, were invested with meaning of an apparently intensely threatening nature, as these were sacrificed in both the drawing and the sculpture. In fact, the sculptural process seemed to clarify the mystery of the missing paws in the drawing, in a literal enactment of the sacrifice. As instruments of both erotic stimulation and penetrating or aggressive action, the hands might be seen as phallic substitutes. At the least, Mary may have unconsciously held the hands responsible for the re-emergence of repressed drive wishes. Even when the hands were removed, the figure apparently still had not been sufficiently punished, as indicated by the constricting collar and the superficial wounds to the abdomen and neck. The special attention to the neck area itself was an indication of concerns regarding the control of impulses. By deeply marking the separation between the head and body, Mary may have been unconsciously attempting to emphasize the domination of the mental realm over the physical. Of course, the neck constriction and slicing was also a direct allusion to suicidal impulses; given Mary's history of suicidal gestures, this was cause for concern. Mary was able to save the figure and to regain a sense of erotic connection to it, leaving the neck and abdomen bound and wounded but still intact, while turning her attention to the caressing of breasts and genitals. Anxieties around sexual identity issues and masturbation fantasies cannot be viewed as extraordinary in a girl of Mary's age, yet the images of bondage and self-inflicted wounding (if the sculpture were viewed as a self-image) that she brought into the scenario raised questions. Her concept of female sexuality as projected upon the sculpture, seemed to be juxtaposed with a heightened degree of passive victimization. Destructive impulses, turned back against the figure and herself, as evidenced by the repeated violent undoing of her own constructive efforts, were clearly apparent. Her erotic and constructive energies struggled to stay alive while battling against destructive forces of nearly equal strength.

I point out this struggle that seemed apparent in the process, because it illustrates a view of masochism involving the interplay and struggle between primary self-destructive and erotic urges (see chapter 2). The concept of a 'death instinct', or primary self-destructive urge unconnected

from guilt feelings, as suggested by Freud (1924), has been met with by doubt from other theorists. Nacht (1965) emphasizes the 'purely speculative' nature of Freud's comments regarding the death instinct theory, and points out that there is no clinical evidence to support it. However, I have watched on more than one occasion a client in art therapy hover on the brink of destruction of a lovingly created artwork, not because the work was found to be flawed, but simply because the creator was overcome by the urge to destroy it. Intervention at this point usually involves a negotiation between conflicting urges, with the hope of delaying the act, to increase distance and awareness. A child that I observed in this dilemma commented, before succumbing to his destructive urge: 'It's such a shame, I did such a good job on it.' In many cases, the destruction appears to be a pleasurable experience. While it may be argued whether the artwork in fact represents the self, the investment in the process is a part of the self that gets obliterated in the act of destruction. Therefore, the presence of a self-destructive element in the pleasurable discharge of aggression, with no apparent guilt feelings involved, seems plausible.

Early sessions – completing the figure

Mary continued to work on her clay figure during the next two sessions. She cut away clay under the armpits, and added clay to the legs and arms. She smoothed out the abdomen area, leaving only what might have been described as a scar of the deep wound that had been inflicted in the previous session. As if continuing this mending process, Mary used a knife-shaped clay tool to scrape away the constricting collar from the neck. Suddenly, without warning, she decapitated the figure with a single smooth stroke of the knife. She set the head aside, then calmly picked it up and crushed it in the palm of one hand. She began the process of forming a new head. When I asked what happened to the first one, Mary replied in a fairly pleasant tone that she hadn't liked it, and wanted to 'fix' it.

I would like to interject here that witnessing this process was not particularly pleasurable from the therapist's point of view. Violence done to the artwork can be difficult to watch, especially when an act of suicide or killing appears to have taken place. The doing and undoing of the work can be agonizing at times to tolerate as a viewer. The therapist may feel the

urge to intervene, to be a savior, or at least a helpful assistant. Yet at such an early stage in treatment, and with boundary-sensitive clients, it may be necessary to maintain restraint. As a viewer I felt disempowered, or immobilized in the same sense as was Mary's figure. I felt an identification with the victim in her drama. But for Mary to feel comfortable enough to expose her passive and aggressive urges, possibly sadistic and masochistic in nature, it was necessary that I be a tolerant container for the potentially threatening emotions that might emerge. This meant, in part, a willingness to experience pain.

When Mary attached its new head, she made significant changes to the figure. The neck became much thicker, without a collar, and the hair, formed by a strip of thin slab draped over the head with lines scratched in it, was cropped to a jaw-length boyish style. Holding the figure in her hands as though it were a doll, Mary brushed its hair with a toothbrush in deliberate, tender motions that conveyed an affectionate attachment to it. She then turned her affection toward a spherically shaped slab with a crease down the center. She lingered over the making of this object, going over the center crease with a clay tool time and time again. Consistent with her pattern of thickening and adding layers of padding to build up the figure, Mary attached this slab to its back to form protruding buttocks. Innumerable times, she tenderly traced over and over the indentation in the buttocks.

It would have been more economically expedient in terms of time and energy for Mary to add a few thick slabs to build up the body, but her unhurried process of adding multiple thinner layers seemed to be intrinsically soothing and meaningful. The thin slabs resembled layers of skin, rather than muscle, and it is possible that the layering process represented an unconscious need to add extra layers of skin for protection. Her emphasis on cutting back into these layers further added to the impression of skin, in terms of cutting, wounding, and scarification. This process seemed to reflect the metaphorical interpretation of scar tissue, left by the healed wounds of self-mutilation, as a 'second skin' functioning psychologically as protective layers of toughened skin (Bick 1986).

During part of the time that Mary worked on the back of the figure, she allowed me to assist her by holding the figure in my hands while she worked on it. Although we continued to have almost no dialog, her willingness to allow the figure to be held metaphorically communicated a

developing trust in the therapeutic 'holding environment'. Soon after, I moved the figure on to an armature that held it securely upright in a free-standing pose. This intervention subtly communicated my willingness to respond to her need for support as well as her need for independence. Incidentally, the armature was not of an external type, rather it consisted of a narrow wooden stake inserted up the center of one leg and secured to a base. While the introduction of this support into the body may have suggested violence done to it, the armature was invisible once in place and at a visceral level demonstrated that a supportive structure could become internalized. Thus, the groundwork for psychological growth, in terms of internalization of the therapist's ego structures for the goal of separation and independent functioning, was laid early on in the metaphorical interaction of therapy.

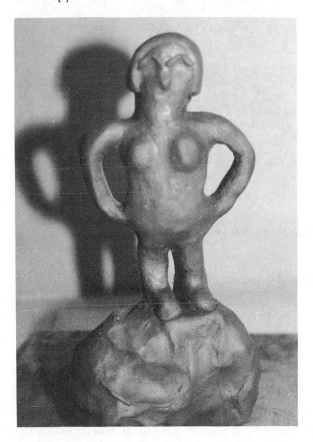

Figure 3.2 Mary's clay figure

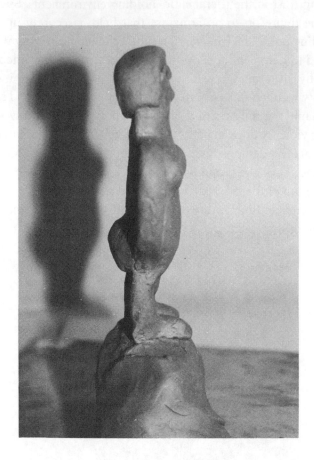

Figure 3.3 Mary's clay figure

Mary had left the face for last. When she eventually did begin to work on this area, it proved to be particularly difficult for her to complete. She tried to etch features on the face, but was not satisfied with the effect, wiping them over several times. Finally, she solved the problem by pasting on separately formed features, however she completed only the nose and eyebrows. The figure remained in unseeing, speechless limbo for many weeks. The sculpture in completion is shown in Figures 3.2 and 3.3.

Symbolically, the clay girl had so far been mutilated, decapitated, and transformed into a more androgynous form. As a conscious or unconscious self-portrait, the figure's ambiguous gender alluded to the possibility that

Mary's own sexual identity may have been unclear, or at least acknowledged with ambivalence. Her mutilation of the figure's body parts, like the attacks upon her own body, may have been related to ambivalence about her sexually mature body, as well as the arousal of erotic feelings within it. The mutilation from this point of view may have served a defensive function, a type of substitute self-castration unconsciously designed to give up, and at the same time to restore, her sexuality. Given her mother's suicidal reaction to Mary's sexual activity, Mary may have feared that her sexual maturation might destroy her mother. At the least, it threatened to damage her relationship with her mother. To avoid further competition with her mother and to preserve the bond of attachment between them, Mary may have sought safety in a fantasy of regressing to a pre-adolescent boyish identity – a theory supported by her childlike demeanor. An unconscious avoidance of identification with her mother's feminine sexuality may have also been a factor contributing to gender ambivalence – an expression of the need to establish a separate identity from her mother.

The lack of mouth and eyes on the figure were significant omissions that clearly established its inability to speak or to see. The clay girl's muteness conveyed a need to maintain defensive silence and secrecy, and also reflected the pattern of nonverbal interaction between Mary and her mother that consisted of impulsive reactions and self-destructive acts. The lack of eyes may have been a protection against realities and feelings that could not yet be allowed into consciousness. Thus, the anger and rage toward her mother which Mary could not articulate, nor probably completely identify, may have been blindly redirected upon herself in mutilating acts that indirectly communicated her pain in the form of physical suffering and scars. The mute and blind quality of the relationship between Mary and her mother underscored their enmeshment. It was as though in such an 'undifferentiated state' (Schaverien 1995, p.146) there was no self and other to see or hear one another. There was little space for the symbolism of verbal communication to form. As in a preverbal relationship between infant and mother the separation between one and the other was amorphous, and physical and emotional needs were expressed through active and passive bodily actions and postures. This fusion of identity may have been subtly expressed in the sculpture as a mixture of male and female aspects. For example, the masculine resurrect-

ion of the figure may have represented an image of Mary's mother that included aspects of dominance and control, while simultaneously expressing a rejection of identification with her mother's feminine sexuality. The ambivalent doing and undoing process may also have reflected Mary's ambivalent wish for a separate identity, and her struggle to separate from but remain connected to her mother.

Painting

Mary missed three consecutive weeks from school and therapy sessions owing to an 'incident' involving a neighborhood dog. The dog was reported to have attacked her and severely bitten her right wrist, the wound requiring surgery. Upon her return to the day treatment program, Mary did not present herself for the session, so I had to search for her on the premises. I found her lounging in the recreation room with a large plaster cast encasing her right forearm, the very picture of a wounded victim. She raised doubts about whether she would be able to make art in this condition. This scene, as though staged, began a pattern in subsequent weeks of her 'forgetting' the session time. I would have to go looking for her and would invariably find her in a lounging pose, half-asleep and feigning resistance; yet she always followed me obediently back to the art studio. Her passive behavior exerted a degree of control in subtly forcing me to take a more aggressive role with her, in making me responsible for her attendance.

The cast on Mary's forearm partially covered her fingers, dramatically limiting the mobility of her hand. Working with clay would be nearly impossible. In the first session following her absence, she rejected suggestions to work in an easily manipulated medium such as collage and chose to make a painting using her non-dominant left hand. She mixed colors with her left hand, awkwardly sandwiching the paint containers between her cast and her body. Occasionally, she winced from the pain induced by pressure on her weak right wrist. Resolutely turning down offers of assistance, Mary seemed to derive some satisfaction from demonstrating her ability to master this painful, unwieldy process that was uncomfortable and frustrating to watch. Equally tedious was the manner in which she painted, using very little water on the brush. This resulted in the paint sticking to the paper in dry patches rather than flowing

smoothly. She anticipated my suggestion to add water to the brush, precluding an intervention before it occurred. 'I don't want it to be watery,' she stated grimly, arduously applying layer after layer of dry gray paint. There was a particular heaviness about her mood on this day, although she soon entered into a trance-like absorption in the process. This level of almost hypnotic concentration lasted for the entire session and the one that followed. The painting turned out to be the most abstract and chaotic-looking of her creations. It seems plausible that the use of the left hand (despite her efforts to control and limit the natural, unpredictable qualities of the paint) tapped into intuitive, less rationally controlled image centers of the right brain.

Mary's final act before declaring the painting finished was to cover the upper half of the horizontal composition with numerous black marks (Figure 3.4). These marks, added from left to right, may have represented birds flying in a sky defined by a yellow sun in the upper right-hand corner. However, the marks were clearly drawn in the form of sharp

Figure 3.4 Mary's 'ugly blob' painting

check-marks, of the type that a teacher might aggressively and punitively mark across an unsatisfactory exam paper. Even as the paint ran dry on the brush, Mary continued to 'mark' the paper with invisible checks. She warned: 'Don't even ask me what it is, I don't know.' Although Mary doubtfully allowed the painting to be matted and displayed in the studio, she continued to disparage it throughout her treatment, referring to it as 'an ugly blob'. She refused to elaborate further on what this description, or the picture, meant to her. She did mention that her eleven-year-old nephew could have done a better job, and that her mother displayed his drawings at home.

Mary's painting is a dynamic composition of uncanny shapes and swirling motion. A dark, ghostly figure hovers ominously on the left. Lavender blobs occupy the space on either side of an opening at the center of the page. The opening leads to a womb-like space, where swirling strands of paint leave a faint suggestion of a fetus-like figure. The lower right-hand corner of the picture appears to break up into fragments, although a brown oblong object hugs the right edge of the paper. A partially cut-off sun spreads cool greenish-yellow light across the picture, adding only an unsatisfying lukewarm temperature. Black checks crowd the top of the paper, further obscuring the light the sun.

The image of the fetus in the womb, albeit tentatively suggested, returns to the theme of the 'image of the child' discussed earlier in reference to Mary's drawing of a kitten. If that part of Mary's picture is taken as a fetus image, it indicates movement toward self-acceptance in that the small animal has been replaced by a human being, a more realistic self-image. I do not include the sculptural figure in this discussion, because it does not seem to fit the theme of the 'image of the child' since there is no apparent regression in terms of chronological age difference between Mary and the clay girl.

Surrounded by images suggestive of various threats – a hovering ghost-like form, a phallic shape, areas of disintegration, and a host of menacing black points – the possible fetus in the womb appears particularly vulnerable and victimized. Mary's behavioral dramatization of victimization in the session might be translated as an extension of her identification with the child in the picture. Her disparagement of the picture as an 'ugly blob' echoed the tone of the punitive black check-marks that proliferate across the top of the picture. These sharp points

reminded me of the self-inflicted wounds that have left scars on Mary's arms. According to one theory (Orgel 1974), it is 'identification with the victim' that leads to suicidal and self-injurious behavior. This is slightly different from, but related to, the theory of self-mutilation as a passive identification with the aggressor.

Mary's intense reaction to the painting may have been related to feelings that it evoked in her. It is possible that it reflected an unpleasant state, and her repeated rejections of it constituted an effort to defend herself from the resurgence of repressed unconscious thoughts or emotions. The chaotic quality of the picture may have been disturbing to her, particularly since most of her artwork displayed more definition and control. Compositionally, the pattern of black check-marks across the top of the painting seems to add a unifying and stabilizing element to the swirling motion, fragmentation, and enigmatic shapes underneath them. In metaphorical terms, the black marks seem to be pressing down on the scene, perhaps 'holding in check' the upwelling of unconscious material below. Mary's emphasis on not knowing what the picture represented, and her request that I not ask that question, lend support to the conjecture that she may have been actively engaged in the process of repressing unconscious material that threatened to become conscious. In the chaotic, not quite formed or differentiated appearance of the image, I am reminded of the descriptions of depersonalized states experienced by self-cutting persons prior to the act of self-mutilation. As cutting episodes can function to bring a person out of such a state, the sharp points in Mary's painting may have somehow helped her in a similar fashion to separate herself from the chaos of the image and to recover from the trance-like state that accompanied its creation. Nevertheless, the intensity of her reaction attested to the power of the image to express and evoke feelings.

Clay sculpture – creating an environment for the figure

Mary returned to her sculpture following the completion of the painting. Working silently, she made a long coil that she vainly attempted to stand upright. I intervened to secure this object on an armature, whereupon she added layer upon layer to it, echoing the manner in which she had added bulk to the human figure. The structure was phallic-like, and Mary accentuated this suggestion by repeatedly stroking and smoothing its

sides as she added more clay. Adding more girth to the base, and attaching a massive ball on top, Mary stated her intention to create a tree. Using a large mallet and a fresh lump of clay, she pounded out a slab for the base of the sculpture. Although she knew a more efficient way to create a slab using the clay roller, Mary preferred this time to use the mallet. This was a more aggressive approach, and she managed this release of aggression a bit timidly at first, as though needing to inhibit or check the urge. However, the activity appeared to be enjoyable and soothing, as she continued it for some time. She cut the clay slab into a square shape and settled the tree in one corner of it, adding yet more layers to the base of the trunk. At this point she aggressively remodeled the tree, pressing and squeezing it between the palms of her hands. It began to look less like a tree, and more like a phallus, a fist, or a bomb. With a clay tool, she scratched delicate marks on the surface of the treetop, not in a decorative all-over pattern, but in a small trail. She took the spray bottle and tentatively sprayed a few drops of water on this area. Surprisingly, Mary seemed shy and somewhat embarrassed about this activity, checking with me initially for reassurance that it was okay with me for her to do it.

The sexual overtones in this process were readily apparent, from the pressing and stroking of the phallic-object to the wetness on its surface. Mary's obvious discomfort indicated that she was either consciously, or nearly consciously, aware of the sexual connotation in the action. It may be significant that her manipulation of the object caused its form to stray beyond clear limits of recognition as a tree. Its massive trunk and compacted ball of foliage formed the image at once reminiscent of phallus, fist, bomb. This trail of associations connected the sexual connotation to possible underlying symbols of aggression. The linking of eroticism and violence continued as a theme in the process and imagery of her work.

It was important to Mary for the figure to be fused to the base of the sculpture and not to be detachable. As in the manner in which she had assembled the figure from separate parts, she was again at the stage of combining the separate parts of the sculpture into an integrated whole. She placed the figure beside the tree, semi-independently standing on its own with an elbow fused to the trunk of the tree. Twice she trimmed the edges of the slab, until the space for the tree and figure began to appear quite cramped. On the tree trunk she carved a heart containing her initials and next to it a variation of a peace symbol. The acts of cutting back the

perimeter of the space, and cutting into the surfaces of objects seemed significant in relation to her opposing tendency to expand boundaries by adding layer upon layer to object surfaces. There seemed to be an emphasis on the boundary itself as an area of special significance and attention – more precisely, of ambivalent back-and-forth alterations. This was most visible in the many alterations made to the figure, however the technique used in the painting (Figure 3.4) also involved layering the paint and cutting back into the layers (symbolically) with sharp black check-marks. The checks may be interpreted as cuts as well as possible images of cutting tools. These forward and backward motions across a theoretical boundary seemed related to the establishment of boundaries and limits in themselves. A struggle between forces was implied, perhaps between inner and outer pressures or between intrapsychic forces such as id and superego demands. The former could be seen as a struggle for basic survival and integrity, while the latter might involve the appeasement of guilt feelings associated with erotic and aggressive drive energies. Both were suggested in Mary's work. First, her manner of creating a figure by starting with small fragments and piecing them together indicated a core feeling of disintegration and possible merging with the environment. In this case, the union of parts into a whole may not have felt quite solid and cohesive, such that special attention to the boundary, for example by padding and marking, might have been necessary to protect and maintain bodily integrity, especially from exterior threats. Second, self-imposed boundary limitations and punishing-type markings might have been meant to appease the threat of retaliation for excessive indulgence in pleasurable urges. Masturbatory or other sexual fantasies, perhaps of an incestuous nature, were alluded to in Mary's clay process, in the embarrassed caressing and rubbing of the figure's erotic zones. Guilt feelings for incestuous fantasies may have been triggered by the incident in which Mary's mother interfered with her sexual relationship, and 'took' the man back from Mary. In Mary's unconscious thought, the young man may have merged with an inner representation of her missing father; therefore her sexual relationship would have been doubly illicit, not only with a man 'too old' for her, but also with an incestuous object.

In the appeasement of guilt feelings, the symbolic castration of Mary's figure becomes significant. It accomplishes a sacrifice to the superego for dual purposes, to undo the threat of actual castration and at the same time

to permit safe indulgence in the illicit fantasy. As discussed in chapter 2, undoing the threat of castration may be reinterpreted as undoing the damage of actual castration, through a fantasied replacement of the lost phallus, or a reactive association of castration with pleasure – genital masochism (Rado 1933). The reinstatement of phallic power may be seen in the reformation of the figure into a masculine form. Also, the large, phallic-shaped tree fused on to the figure and inscribed with Mary's initials may at an unconscious level have referred to a similar theme of restoring the lost body part, almost as a fetish object. Her behavior toward this object, rubbing and smoothing it and making it increase in size was as if it were a thinly disguised phallic fetish.

During the same session in which she assembled the various parts of the sculpture, Mary also added details to the body. First, she stared at the face for a long time, then she said she didn't know how to make the eyes and mouth. I gave suggestions for either adding on or carving out the features. I also demonstrated how she might use a small wedge of clay to form the chin. Mary criticized this addition to the face, peeling it off and saying it was 'uneven'. She carefully molded a larger chin, leaving it so that it jutted out with a defiant, angry-looking expression. With a nervous smile and glance at me, she added nipples to the breasts, using tiny flattened balls. After this was complete, perhaps it was then safe for the figure to see, for she added eyeballs with pupils poked into them by a sharpened pencil tip. She carved a mouth into the space below the nose several times, each time wiping it away. Finally, she left the space wiped clean without a mouth. Either she could not decide upon an expression, or she was not yet ready to give an active form, or voice, to the defiant or angry emotion that the figure seemed to portray. Her response to my intervention indicated both acceptance and rejection of my support, or more precisely, acceptance on her own terms. Initially at a loss for how to proceed with the face, she indicated her need for help. When this was given, she boldly took apart the suggestion and reshaped it to conform to her own vision, namely, the defiantly jutting chin that seemed to portray her need for assertive self-expression and independence in general. In this sense, the interaction between us of asking, giving, rejecting, and reframing became a transition toward separation and individuation for Mary. The art process and art object constituted the medium and space in which this transaction was able to occur.

The final session on the sculpture was devoted to the addition of a few finishing details. Of particular concern was the mouth. Several times Mary tried to add on a mouth, using a tiny coil of clay. When I reflected out loud on the difficulty of this task, Mary remarked: 'I wanted it to be smiling, but it just looks stupid.' Then she flattened a tiny piece of clay and cut out a bow-shaped mouth, which she pasted on. She etched with a pencil the line between the lips and, in a satisfied tone of voice, asked how it looked. The pasted-on smile seemed to solve the problem for her of representing an emotion that may have been very difficult to maintain without self-criticism or feelings of fraudulence.

Mary stated that the sculpture was completed (Figure 3.5), adding specifically that the figure was wearing no clothes. This revealed a

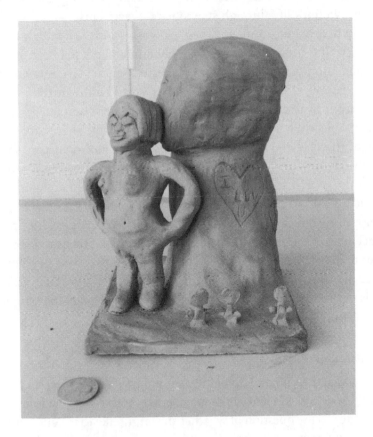

Figure 3.5 Mary's clay figure given an environment

conscious or nearly conscious intention that the sculpture was at least in part an attempt to deal with sexual issues. If the tree represented a phallic extension of Mary, whether of erotic or aggressive power, or both, the naked figure exposed the vulnerability, passivity and silence of a wounded, yet also erotic, state. While this interpretation relies on a foundation of psychoanalytic theory regarding feminine genital masochism, later theory developed from research on childhood trauma throws another light upon Mary's artwork. The view of herself as vulnerable, exposed and scarred, juxtaposed with images and acts where eroticism and violence seemed to be fused, may have reflected actual traumatic events in her history. In the next session, the configuration in the sculpture reappeared in another medium; this repetition of a particular scene was reminiscent of the tendency for trauma to be repeated over and over in a victim's life through symbolic re-enactments.

Mary had begun to interact verbally in sessions with slightly more frequency. She continued to require only minimal assistance; I remained quiet and unintrusive in an attempt to create a neutral space in which she could explore feelings related to her sexuality and individuation through the metaphorical use of imagery. Considering her completed sculpture from an object-relations perspective, it seemed to me that Mary's place-ment of the clay figure within an environment indicated that she was actively attempting to create an appropriate space, however constricted, for the figure. Her extended use of the clay mallet and her addition of a protruding chin to the figure seemed to indicate that Mary had begun to develop more direct means of expressing aggressive feelings. The dramatic impact of the scene in Mary's sculpture suggested that she was discovering a way to 'talk' through visual metaphors and perhaps was beginning to isolate and clarify aspects of the chaos present in her 'ugly blob' painting. In this regard, her ability to communicate effectively was showing in the artwork a preliminary movement toward growth.

Pastel drawings

As she was accustomed to do before beginning a new project, in the next session Mary looked blank. In a small flat voice, she said she didn't know what to do. To my question of whether she might like to try out a different medium she responded depressively and somewhat provocatively: 'Not

Figure 3.6 Mary's 'rainbow' pastel drawing

Figure 3.7 Mary's pastel drawing with ghost figures

really.' I waited patiently in silence; after a short moment, Mary said the word 'pastels' in a soft, childlike voice. She made two pastel drawings in the session. The first was a picture of a rainbow with bands of blue, orange, green, and pink. She smeared together and muddied the colors with her hand. The center bands of the rainbow were fused together, while the outer bands were separated from the inner rainbow by a white space, as though they formed protective outer coverings. She added a blue cloud in the upper left, which she smeared all over the top of the paper, darkening the yellow sun in the upper right. After deepening the blue sky to purple on the lower portion of the paper, Mary superimposed black check-marks over the sky, sun, and a portion of the rainbow (Figure 3.6). She immediately asked to begin a second drawing. In a flurry of activity, as opposed to her usually slow working pace, she completed the picture shown in Figure 3.7.

She began by drawing the crescent moon and the tree in pencil. She filled in the moon shape with white pastel, rubbing the pastel until it grayed from contamination by the pencil graphite. She added brown and green to the trunk and foliage of the tree, expanding the color well beyond the pencil outlines. Next she drew the two ghost figures floating in the center of the page, and the small girl figure to the left of the tree. The girl had clenched fists extended freely out to the sides and an open mouth. Her hairstyle was similar to that of Mary's clay figure, suggesting that this girl in the picture, also standing beside a tree, might have been related to the figure in the sculpture. The girl's expression and body language looked openly defiant and vocally angry.

Originally, Mary depicted the girl floating above the grass. In a fantastic scene of airborne figures and an anthropomorphic moon, only the tree managed to be rooted to the ground. Yet even the tree appeared to be somewhat ethereal, as the transparent color overlaying and extending beyond the borders of the drawing made it appear as though dressed in see-through clothing. The grass area and the figure of the little girl were the most realistic and healthy-looking aspects of the picture; I attempted to appeal to this part of Mary's ego functioning when I asked her where the girl might be standing. Mary considered this, and instead of adding more grass beneath the figure as I expected she would, she connected the girl to the ground with a mass of brown that resembled a hill of dirt. In retrospect, this area of soil seems reminiscent of fecal discharge and, as

such, suggests another manner in which her rage was beginning to show. The anal sadistic rage suggested by this image may in effect, as the picture laid out in graphic form, have stood between her and the healthy, growing grass. In this metaphor, her discharge of rage also gave her a greater sense of solidity and grounding; in this sense, it may have been a necessary step toward making a realistic connection to the world. In the therapeutic relationship, her response to my intervention seemed to express both acceptance and defiance of the pressure being put on her to mature. The ambivalent struggle related to conflicts over separation and individuation is sometimes associated with anal phase tasks and emotions. So, in this sense, her angry shouting child standing on a pile of fecal discharge may have been related to conflicting feelings about separation.

The original object of her struggle toward separation and individuation was quickly apparent in Mary's drawing, the rage having been only momentarily deflected on to myself. In the picture, it is the phallic, seductively transparent-looking tree that separates the angry child from the two ghost-like images on the right. Like the tree in her sculpture, this tree seemed to grow in tumescence beyond its boundaries, in this case through the rubbing of the pastels with her finger. Whether related at a deeper level to masturbatory fantasies, or more directly to her sexual encounters with a man, bonding to this entity may have been seen by her as a way to separate from her seductive and overpowering mother. The two ghost figures, one large and provocatively grinning and the other small and smilingly passive, seemed symbolic of their relationship. The leering crescent moon, watching over the scene with its sharp point menacingly aimed at the tree, suggested the psychological position of a critical superego toward id desires rising from below ground, in the form of a sexualized tree. This moon, shaped like a knife or some other cutting tool, with its obvious directional thrust toward the tree may have represented an unconscious symbol of the threat of castration, related to incestuous wishes. The incestuous triangle between Mary, her mother, and the man shared by both has been previously discussed.

The ghost images seemed to repeat, in a more explicit form, the abstract ghoulish shape on the left side of Mary's painting. A ghost, having no corporeality, has no clear boundary between inside and outside. Its existence is in question. This metaphor brings to mind the feelings of depersonalization and numbness experienced by many self-cutters, for

whom cutting and blood-letting may be a means for proving their existence. Woods (1988) presents a case history of a self-cutting depressed adolescent girl who was 'shunned by many and was described as a ghost or as a "black hole"' (p.57). The girl presented herself with such passive negativity that the therapeutic relationship became very dull and lifeless, infused with the deadness of non-existence that she felt. On the other hand, she clung to a rich fantasy life filled with imaginary characters. Mary was in some ways similar to the girl in Woods's case. Others tended to quietly avoid Mary, and although she stood out as physically large her presence had a ghost-like quality that made it easy to treat her as though she did not exist. There was a dull flatness, or deadness, within her expression, and at times lifeless behavior. On occasions when I went to find her for sessions, I would find her in a semi-sleeping, half-aware state of repose. If I had tried to engage her verbally, the therapeutic relationship probably would have stalled, or continued in a lifeless vein. As it was, Mary's nonverbal engagement in the art process allowed access for both of us into her inner fantasy life. This was in her case, like that described by Woods, richly populated with imaginary and symbolic characters. The art process also had the effect of working subtly to ground and to materialize some of her fantasized projections within the protected transitional space of the art therapy studio. This helped to inject life and interest into what might otherwise have been a dull interaction.

Together, the two pastel drawings from the session depict change from day to night. The buoyant, expansive image of the rainbow seems to be qualified, perhaps 'held in check', by the black check-marks which seem to add a malign element to the picture. The configuration of smaller delicate checks is directly superimposed on the bands of the rainbow, which in turn resemble the many layers of skin on Mary's figure. The finishing touch on the first drawing, these checks introduce the transition to the second picture which, as was previously stated, spilled out of Mary with an unusual force of urgency. Just as self-inflicted wounds may provide relief by restoring order and cleansing the body of 'bad blood', Mary's second drawing seems to release a flood of dark images and negative feelings in a well-controlled manner. In another sense, the checks in the first drawing, like sharp knives, seem to cut through the superficial layer of the stereotypical rainbow image to reveal a deeper layer of emotion which is

revealed in the second drawing. Here are features already familiar in Mary's artwork: a girl next to a tree, ghouls, and a sharp object in the sky.

While there were parallels between the repetitive reworking of Mary's images (the layering, cutting and relayering of her clay figure) and the ritualistic damaging, healing and scarring of her own skin, I believe that the changes in Mary's artwork constituted a significant difference. For example, images such as a ghoulish figure, tree-like phallic forms, and a faint human form that were only vaguely and chaotically suggested in the left-handed painting became more specifically separated and defined in the second pastel drawing. It was as if the left-handed technique, as well as the non-directed interactive contact with the raw materials of the studio, helped to guide Mary into a murky zone of not quite formed symbols that she was then able to pull out into more conscious focus. This regression into less formed layers of consciousness was paralleled in the artwork as regression backward in time to the womb, and then forward again. In the artwork, Mary's child self-image began to free its arms, its mouth, and its bowels in order to discharge some of the anger and aggression that had been spilling over into self-directed attacks. Access to this anger was necessary for her to begin the difficult and painful process of separation from her mother and from her childhood. In the artwork she may have begun to find a way to reframe, or reorganize her past into a more coherent and acceptable story that would allow her to move on. In this sense, the reworking of symbolism that Mary had been doing in the artwork and the art process was more than an unconscious 'repetition compulsion' of trauma re-enactment that could only lead to further traumatization. The artwork began to help her to externalize her internal and bodily experiences, and to put these into a more coherent form. She was gaining more skill and flexibility in the use of symbolism to provide a connected but safely separated distance between herself and others. The presence of another human being, not intrusive, but consistently witnessing, holding, reflecting, and sometimes helping to clarify her fantasies within a non-judgmental arena helped to maintain conditions in which the danger of retraumatization was minimized. In this new way of experiencing trauma, she might have begun to realize that it did not have to destroy her, or to end in utter disintegration.

Termination

By this point in treatment, the end of the school year was approaching, and Mary knew that my internship was ending and I would be leaving. For the first time in many weeks, Mary came to the session on her own without my having to search for her. She folded a piece of paper in half and announced that she was going to make a birthday card for her mother. In the upper-right hand corner of the card she drew a heart. She painted the heart red and with black paint added to it a long bushy tail resembling the tail of an animal. It also appeared that a trail of excrement spewed from the bottom of the heart, giving it an unappealing aspect as a gift to her mother. The original feeling of affection associated with the heart changed, or was mixed with an opposing emotion, resulting in an ambivalent image.

In the remaining space on the card, Mary drew three cats and dog. The cats were drawn according to the scheme of her first cat drawing, with no paws and the tail curved back against the body. She drew the dog below these. She painted these animals in different mixtures of white, black, gray, and brown, using a paper towel on which to mix these colors. When I provided her with a tray for this purpose she politely ignored it, continuing to stain the paper towel with dabs of dark paint, a subtle reference to fecal discharge. The anal allusions may have come about in reaction to the imminent termination – a regressive and oppositional (in Mary's subtle style) response to an event that was largely out of Mary's control. The imagery of this last session returned to where Mary began – with the drawing of cats. The revival of the animal image, a possible representation for a transitional object, may have come in response to fear and anxieties about separation and abandonment. These were the same concerns that were raised in the beginning of the treatment, and may have indicated a renewed sense of helplessness in the face of change. Yet, as she collected all of her pets together in one image, she seemed to be summoning up inner representations of comfort and self-soothing in order to prepare for the change.

At this stage in treatment, Mary was able to be more explicit about the cats. She labeled each one with a name, and added a heart beside each. She placed one more cat off to the side, next to the heart. This was the only one of the animals that was no longer alive. It had been 'put to sleep' when the large cat in the center was just a kitten. The other two cats came later, in consecutive years, on Mary's birthdays. '[The center cat] is the only one

Figure 3.8 Mary's 'birthday card' painting

that's a girl, and she doesn't like to be touched,' Mary stated, and with this remark implied a special identification with the animal. Perhaps this was Mary's way of expressing her feelings about the violation of her boundaries, and her dawning awareness of the possibility of setting limits about her body. The center cat carried a large tail that might be useful in defending its boundaries, as well as for hurting itself (Figure 3.8). Spontaneously, the card had undergone a change in focus from her mother's birthday to Mary's own birthdays, a transformation that added another piece to the groundwork that she was laying in order to begin an actual separation from her mother.

Mary's last art therapy session occurred the following week, and on that day she reverted to her previous behavior of needing to be brought to the session. She completed the card she had begun in the previous session by adding spots and other details to the animals. Inside the card, she wrote a memorial to the deceased cat. She finished by explaining that it had grown up with her, and had let her 'do anything' to it. With these words, Mary acknowledged the other side of her passive victimization, that of

active and possibly sadistic aggression. This implication of the deceased cat as a likely tortured victim, and its subsequent idolization constituted a sacrificial process. Yet she was speaking of the past, during the act of temporarily reviving the deceased cat, commemorating it, and then putting it finally to rest. This was a powerful metaphor not only for the immediate termination process, but also for the entire therapeutic process, in which the past was revived, re-enacted, transformed, and (to a degree) let go of. The appearance of the young cat at the beginning and the deceased cat at the end of the therapy underscored this process. Metaphorically, she was able to 'grow up with' the cat again, in changed circumstances. In the present, she seemed to identify more clearly with the cat that 'doesn't like to be touched'. This knowledge and awareness of boundaries was a crucial step in the growing-up process.

Mary was able to discuss termination, and to express her regrets about not continuing to work with me. She accepted my explanation that I was finishing internship and hoping to find a job. She added: 'My aunt is a therapist but I don't really understand what it means.' This last remark was significant in its revelation of Mary's apparent need to remain somewhat unconscious of what had been accomplished in our time together. It typified her negative approach toward the world, a gentle pushing away of others; however, it also contained the seeds of a growing awareness and openness toward learning more about herself and others.

Conclusion

In this chapter, I have attempted to show how the motivations for self-mutilation, like the multiple layers in Mary's artwork, can be multi-faceted, and layered. Among the motivations in Mary's case were Oedipal issues and associated difficulties with separation and individuation. Her relationship with her mother involved competition for male attention, as well as a merging of identification, making individuation difficult. Experimentation and identification with her sexuality, while necessary for individuation, was a threatening proposition for Mary, due to both inner restrictions and extreme outer reactions from her mother. Self-inflicted punishment may have been a way that Mary was able to relieve sexual tension along the interconnecting pathways of pleasure and pain, to resolve guilt for sexual urges, and to make possible the enjoyment of

sexual urges free from guilt. This assumption rests on the theory that self-mutilation involves a masochistic component of sexual gratification. The art process alluded at different times to conflicts regarding mastur-batory urges, in conjunction with acts of mutilation and violence. At another level, conflicts over aggressive urges were also indicated; this may have been related to a deep need to preserve the relationship with her mother. Mary's habitual childlike and passive attitudes and behaviors seemed aimed toward convincing others of her harmlessness, as the castration of threatening body parts removed the possibility of aggression. The need for inhibiting her aggression indicated an underlying ambiv-alence in the relationship with her mother that had not been sufficiently integrated, or ameliorated with affection. The possibility of trauma as a contributing factor was likely, in the conditioning of identification with victimization. Aside from the repetition in her artwork of themes of violence, victimization, and vulnerability, Mary's numbed and deadened affect and nonverbal impulsive acts were symptoms indicative of trau-matic experiences from an early age. Her inhibition of aggression and difficulty with verbal self-expression were also likely results of social gender conditioning, to a degree held in common with other girls of her age.

In psychiatric populations, repetitive self-cutting or other superficial damage to the skin is generally associated with personality disorders; more severe forms of mutilation, such as the severing of body parts, with psychosis; and head banging or other forms of bruising with mental retardation or brain damage (Favazza 1987). In the next chapter, in the case of another adolescent girl called Kate, self-mutilation took more 'primitive' forms than the superficial skin wounding and pill taking of Mary. These included head banging and self-biting. Both Mary and Kate were chronically depressed teenagers, and both were suspected of having experienced childhood traumas. Yet, despite the potential seriousness of her suicide attempts, Mary had ego strengths, such as intact cognitive functioning and reality testing, which may have helped to determine the 'superficiality' of her wounding. Kate, on the other hand, had more severe deficits in cognition and reality-orientation. While anal and phallic stage issues were prominent in the case of Mary, oral and anal phase aggression was pronounced in the case of Kate. Chapter 4 follows Kate through the

art therapy process, as it revealed separation and individuation issues at a very early stage of development.

Merging and Differentiation
in the Case of Kate

Introduction

The case of Mary described in chapter 3 involved dynamics of adolescent separation and individuation compounded by possible childhood trauma. Kate, also a self-harming adolescent girl, presented a clinical picture similar to Mary's, in terms of enmeshed family dynamics and probable trauma. Kate, however, showed a greater degree of regression and disorganization, combined with a less highly developed ego structure. Some of the self-abusive behaviors exhibited by Kate were congruent with an earlier phase of development, that of orality and early symbiosis. Anal phase ambivalence and sadistic aggression were also present; however, the emphasis on neglect in the earlier phase seemed to color Kate's overall ability to master later phase tasks, as well as to weather further traumatic experiences. In discussing her creation of a fetish-type object, I have been primarily informed by theoretical approaches in which fetish use refers to pre-Oedipal rather than Oedipal dynamics. Particularly significant in this regard is the self-psychology approach of Kohut (1977) that views the fetish defensively as an attempt to patch together a fragmented, deformed, or incomplete self. In keeping with this angle on Kate's dynamic presentation, the therapeutic approach that evolved spontaneously in response to her confusing behavior and distorted projective material involved an empathic immersion in her confounding world. The role of the art in this process was crucial in making sense out of the haziness and incomprehension that invaded the atmosphere of the therapeutic space. It was precisely through the concretizing, organizing, and distancing functions of the process and products of Kate's creative activity that grounding in

reality and formation of clear boundaries between objects began to occur. This was a necessary step for Kate to begin the process of separating and identifying herself as a separate and whole individual. As in the previous chapter, the art therapy process will be described in great detail, since it was in the primarily nonverbal interventions that change was effected.

Clinical history

At 17, Kate lived at home with her parents and her 23-year-old brother. Kate's father was a retired maintenance worker, who, toward the end of the nine months covered in this case study, was diagnosed with an inoperable form of cancer. Her mother had been previously diagnosed with schizophrenia and agoraphobia, and had not left the house for years at a stretch. Because of this, Kate did most of the shopping and laundry for the family. City authorities had on two occasions entered and cleaned the family's apartment because of grossly insanitary conditions.

In part because of the invalidism of her parents, Kate lived in a family environment where parent and child roles were blurred and personal boundaries were ill-defined. The apartment was cramped; and while Kate's brother had a separate bedroom, she was accustomed to sleeping in the same room with her parents. Kate vehemently resisted any change to this arrangement; however, at the insistence of her social worker she was separated from her father. It was reported that Kate continued to share a room with her mother, while her father slept on the living-room couch. In public, Kate carried on a relationship with her father that involved provocative teasing, fighting, and clinging behaviors. Family therapy had been recommended, but the family resisted treatment.

During her adolescent years, Kate reported two occurrences of sexual assault. The first was an incident of anal abuse, in which a man allegedly assaulted her with a broom handle. She gave conflicting stories of this event, describing the man as either a school janitor or a man at the laundromat. The second incident involved a bus driver, a man that was reported by Kate to have touched her breasts. Because Kate often blurred fact and fiction in her everyday conversation, and no physical evidence was present, these incidents remained unsubstantiated. However, public school authorities were sufficiently alarmed that after two such reports

they referred Kate to a day treatment program. She was 15 at the time she entered the program.

Physical, emotional, and behavioral profile

Kate had an obese figure with a humpbacked posture. She wore thick glasses, and had difficulty with physical coordination. Her facial expression was habitually morose, periodically breaking into a wide infantile grin. She was chronically depressed and withdrawn, and had no close friends. Her classmates made fun of her appearance, treating her as a scapegoat, a situation to which she contributed by acting silly or inappropriately and making self-ridiculing remarks. She was frequently out of control, and physically self-abusive. On one occasion, she threatened to tear out her fingernails to gain a teacher's attention, and subsequently succeeded in banging a hole in the wall with her head.

Kate spoke in a monotonous, rambling voice. Her conversation consisted of long monologs that drifted from one thought to another in a confusing progression of facts and fiction. These fantastic tales frequently dealt with morbid topics such as sick and dying friends and relatives. Eating was of extreme importance to her. She preferred soft gooey foods, like the doughy centers of muffins, which she crumbled and mashed between her fingers before eating. At the dining table, she would eat and talk at the same time, grinning widely as she discussed in unappealing detail her favorite meals. She probed and questioned others about their taste preferences and eating habits as well.

Behavioral presentation in art therapy

When I began working with Kate, she had already completed two years in art therapy. I was her third art therapist, and from the outset she wanted to know whether I would be able to come to her graduation ceremony, two years away. She understood from experience that art therapy interns stayed only for one year appointments, so her question betrayed an expectation of disappointment. However, it also underscored her need for information to combat the feelings of loss and abandonment that were an inevitable recurrence in her life. Likewise, in the art therapy studio Kate needed predictability and stability. She developed rituals for entering and leaving sessions to ease her difficulty with adjusting to change. For example, Kate

inspected the room each time she entered it, checking carefully for any changes that might have occurred between sessions and noting these out loud. She made a point of always using the same smock, going through the pockets for any clue that might have been left behind by another user. She was suspicious and protective of the therapist, preoccupied with how much time was spent with other clients. She repeatedly asked for extra time or longer sessions, and devised various tactics to delay the separation at the end of each session. This behavior persisted despite frequent reminders of the limits that had been agreed upon regarding session length and frequency.

Early art therapy sessions

Kate took charge of the session immediately. On her first day, she selected and put on a smock before I was able to offer her one; she explained that as she was 'large' only one smock would fit her. She then requested that we change places, pointing out a couple of other chairs where I could sit. Instead of choosing a medium to work in, Kate launched upon a long discourse on the wedging of clay, and I had to guide her back to the focus of the session. Eventually, she chose to work with pastels on brown paper.

Already, in the beginning of this first session, Kate's behavior made several subtle references to anal-phase issues such as control, withholding, and then regression. Her impulse to take charge and possession of the art room and its objects was probably a way of coping with a new and potentially threatening situation. As though familiar items and routines represented her feces, she was anxious to maintain control of them at first, slowly easing into production as she tested my ability to receive her gifts graciously. For example, the discussion on the wedging of clay may have been an unconscious metaphor for fecal play, and it was necessary for me to allow this lengthy topic to be aired with acceptance before leading her back to the focus of the session. Her choice of pastels on brown paper – another 'messy' medium – continued the theme of anal play.

Kate chose shades of blue and green to make a sky, marking long diagonal arcs from the lower left to the upper right. She attempted to blend colors by rubbing them with a paper towel; she also applied pastel pigments directly on the paper towel and transferred the color back to her paper. Her strokes were heavy and aggressive, causing the paper to slide

with her motion, so I steadied the paper and suggested that she move her hand more slowly. By doing this, she was able to exercise enough control to achieve the softer effect she desired. Nevertheless, the forceful curving strokes of the sky resembled claw marks, bearing similarity to the slash marks in Mary's first drawing. Her application of color to the paper towel, similar to Mary's use of a paper towel on which to blend her paints, suggested fecal staining of toilet paper and she appeared to take pleasure in the regressive quality of the action. She continued to smear the colors together until the colors became muddied, as Mary had also done with her drawings. In the upper right-hand corner she left a white space for a moon, explaining that the picture was going to be a night scene.

For the moon, Kate traced around a jar lid and colored the full circle with bright white pastel that she brushed beyond the outline of the circle to make a spreading aura of light. This rather successful effect of moonlight did not last, however, as she covered the white with several layers of gray so that the moon disappeared into its surroundings. Again, the layering and blurring and spreading of boundaries was a similar feature of Mary's work. The 'disappeared' quality of the dark gray moon paralleled the ghost images in Mary's pastel, and evoked the theme of vanishing bodies in contemporary feminist art as well as references to ghost selves in trauma literature (discussed in chapter 3). Kate wanted to make a face on the moon but encountered great difficulty doing so. She drew the moon's face with a smiling hopeful expression, wiped it out and drew a second face much like the first. Dissatisfied, she smeared over the second one to make it disappear also. 'I guess it will have to be blank,' she remarked. Finally, Kate got the idea to cut out the features from paper to glue on the moon face. She doubted at first that it would be possible to do so because the features were so small, but she allowed me to convince her to try. There was a striking similarity in her process to the manner in which Mary completed the eyes and mouth of her sculpture, by pasting them on after repeatedly wiping out the first drawn attempts. Kate chose gray paper for the features, and the resulting face had a blank expression, ironically mirroring her earlier statement that it would have to be blank. The eyes seemed either closed shut or nonexistent beneath thick eyebrows. The nose was a dark circle, and the small mouth appeared to be passively open (Figure 4.1).

The colors that Kate chose were cool and withholding. It is possible that Kate's struggle with the moon face in part represented her attempt to come to terms with the loss of her previous two art therapists, and her ambivalent feelings about starting again with a new therapist. She gave the final moon face a bland appearance that may have reflected a decision to reserve judgment about whether she might decide to trust me. If the moon was a self-representation it was a reticent one, receding into the background and barely stepping away from the edges of the page in the corner where it was protected. She instructed me to save the drawing for her until the following week, when she intended to complete it.

The moon's face was not unlike Kate's rounded face with its bland, morose expression. Its stereotypical smiles that she had wiped away one after another were reminiscent of the infantile grins that broke across her face from time to time. Both expressions had a fixed and rigid quality; she switched between one and the other like changing masks, leaving no room for variation or even degrees of expression between these two extremes. The sudden switching from one rigid expression to another may have been connected to her general impulsivity, which also resulted in collapsed distance between urge and action. Kate's stereotypical mask-like expressions, both in reality and as projected on her artwork, were suggestive of the bodily feelings of numbness or freezing that are common after-effects of exposure to trauma. Impulsivity, stereotypical behavior, and numbness may all be associated with impairment in the ability to modulate affect, as was discussed in chapter 2 with reference to the symptoms and effects of trauma.

Kate's process of redoing the moon, adding layers and thereby creating a veil over the face, may also have been related to self-esteem problems shared by survivors of trauma. The shading and covering of faces – as though in shame – and repetitive doing and undoing processes are phenomena that I have observed frequently among sexually abused girls in art therapy. If verbal disclosure of sexual or physical abuse is made, it is often followed up with a denial of the same, and a striking parallel to this behavior often appears in the artwork through doing and undoing actions. The lack of eyes, or hollow eyes – either possibility seems apparent in Kate's moon – may be an indicator of sexual abuse, according to a study by Lev-Wiesel (1999). As was mentioned in the previous chapter with respect to the exclusion of eyes on Mary's sculpture, this avoidance of sight may

be related to a defensive denial of a reality that is either too painful to acknowledge, or that must be kept secret for other reasons. As Kate's art process continued and became more intense, other factors indicative of physical or sexual trauma surfaced.

In the next session, Kate announced that she had been 'talking about' her picture, stating 'my boyfriend – he died – said that the moon sort of watches over you'. Her expression was devoid of affect, other than a grim cheerfulness. She smeared layers of gray and white over the moon's face, further effacing its features. Then she complained that some of the color had smeared off the drawing during her absence. Intending to draw birds, she picked up a black pastel, then changed her mind saying 'birds don't fly at night, bugs fly at night.' She did not add either, but the words echoed in the room, casting upon the night scene a disturbing tone. Kate wanted to put 'a boy with a baseball cap' in the picture, but complained that she didn't know how. She drew a figure starting at the base of the pants and moving upward. When she reached the crotch area of the figure, she stalled in confusion and could not continue. With careful coaching and step-by-step instructions, she was able to complete the figure, although she experienced unusual difficulty when drawing the shoulders and attaching the arms to them. She looked at my shoulders, saw them as 'little hills', and tried to draw them that way. Her anxiety about this area of the body may have been associated with possible feelings of confusion with respect to the shape of her own body. She erased the arms several times and, with apparent confusion, drew a line cutting off the arm entirely. She also left the figure without feet. Again, similarities to aspects of Mary's artwork – cut off paws and hands and fusion of the wrists to the body of the sculpture – was striking. Such phenomena as 'clinging', 'detached', 'cut-off', or 'omitted' hands and arms in drawings may indicate sexual abuse, according to Lev-Wiesel (1999). The act of castration implied by the amputation, in conjunction with Kate's confusion and anxiety concerning the boy's genital area, suggested that the arms may have held a symbolic significance as displaced phallic forms. Her attack upon the arms might thus have represented a defensive gesture against anxieties associated with sexuality.

Kate drew a small amount of hair on the boy's head, 'because he has cancer', she explained. She drew a baseball cap on top of the hair, leaving the hair showing through, but with the line of the cap cutting through the

hair. The hair formed a pointed shaft sticking upward out of the hat. The phallic aspect of this unusual hairstyle was enhanced by the manner in which it thrust through the cap. The line cutting through the shaft of hair suggested yet another reference to castration. Considering Kate's difficulty in drawing the crotch area, it seems plausible that the hair might have been the site of an unconsciously displaced phallus. The connection of the hairstyle to a disease further implicated this area of the figure, and was suggestive of a conversion symptom, in which a repressed thought or affect appears as a somatic complaint upon the body. For Kate, fascination with disease and morbidity might have been a generalized unconscious shield, used to convert repressed and irrational-seeming traumatic impressions into a form that was coherent to her. Her morbid stories may also have functioned as a way to draw attention to her pain and need, in the manner that the pants, eventually colored flaming orange, brought attention to that troubled area of the picture. The pointed shaft of hair was aimed in the direction of the passive unseeing moon face with its circular nose and open mouth, at least remotely suggesting an unconscious association to anal or oral intercourse. This possible scenario was present in Kate's conscious mind to the extent of her verbal accusations of such abuse.

At this point in treatment, it had not yet been revealed or confirmed that Kate's father was ill with cancer. In fact, confirmation of this fact did not occur until several months later. It was possible that she knew of or suspected his illness, but just as likely she was aware of it on an unconscious or preconscious level. Her blurring of associations between illness, death, and sexuality had an unreal and ungrounded quality; her apparently loose connections with reality may have helped her to defend against a reality that she did not want to see. There probably was also a dreamy aspect to her home life, with a mother existing in a detached state and relationships among family members that were unusually devoid of realistic boundaries. Life within the confines of the home was probably a kind of ritualized chaos, unrelated to, and irrationally disconnected from, the rules of living that Kate encountered outside at school and other places. Her reaction to the material that surfaced, both in the picture and in her associations to it, was one of confusion and panic. While she tried creating 'stories' to explain, to contain, and to organize the chaos, these stories also turned bizarre. Her distortions of body image and difficulty

with connecting and integrating various parts of the body seemed connected to her own tentative sense of reality. Perhaps the castrating urge, suggested in her impulsive, virtually unconscious severing of the figure's arms, represented a desperate attempt to cut through the confusion, to do away with offending 'bad' and intrusive realities, and to save a mutilated but intact remaining self. The castrating urge was to appear over and over in her process, matched by a parallel struggle to regain control of her sense of reality.

Kate added three colored stars, blue and green, to the sky. In the next session, she stated that she wanted to color in the boy, but began instead by adding more colored stars. She asked if stars could be red, and I wondered whether she might be seeking confirmation of reality. Her picture had taken on a fantastic appearance, with the boy floating in the night sky with colored stars. I asked Kate where the boy was standing, and she replied: 'Under the stars, he needs feet.' I pursued this further, asking where his feet were standing. Kate eventually came to the conclusion that he was standing on the ground. After a brief discussion of the difference between standing on air and standing on the ground, Kate decided that the ground felt hard. She added feet, grass, and two lines of stones to the right of the figure. The stones embedded in the grass, lined up in neat rows, were reminiscent of carefully placed feces in the grass. Curiously, her addition of this item was similar to Mary's placing of the figure on a mound of feces-like dirt in response to the intervention to ground the figure. In Mary's case, the anal reference seemed a diarrheic discharge, perhaps in accord with her growing ability to portray expressions of anger. In Kate's case, the anal discharge was very small and measured, portraying a sense of withholding, in keeping with her careful, watchful behavior. Kate signed her name to the drawing, pleased to be finished (Figure 4.1).

I reminded her that she had intended to color in the boy. I did not anticipate the difficulty that she would encounter with this task. She immediately began to color the pants, starting again from the feet upward, using a bright orange pastel. However, the drawing had no waistline and when Kate reached the crotch area she panicked, not knowing how to complete the pants. She recovered herself enough to draw a waistline and complete the coloring. However, the feelings and associations that the crotch area brought up for her left her flooded with anxiety and confusion. She wanted to use a darker shade of the same color for the shirt, but called

Figure 4.1 Kate's pastel drawing

it brown instead of orange. She said rather dramatically: 'He was *such* a good dresser until he got sick, and then I had to dress him…but we won't go into that.' Her words began to take on the quality of a fantasy blended with fragments of reality. The rust color of the shirt spilled over into the neck area, finally stopping at the chin. Kate noticed that the figure had no hands. She set out to remedy this omission by practicing drawing hands on a separate sheet of paper. She had difficulty drawing the thumbs, placing them both facing in the same direction. She corrected this, but added an extra small finger to the right hand. As her attention to the details of intact reality was restored, it was also slightly taken back, as though she needed to make some small sacrifice to the conflict that caused her confusion and anxiety. Thus, the displaced phallic object again reappeared, in a smaller, less noticeable form.

The glowing red-orange color of the pants was heightened by Kate's choice of orange backing paper for the drawing. This color choice may have been influenced by a spreading of the stimulus associated with the

color, as well as by an unconscious need to draw attention to that area. The stories that accompanied Kate's drawing process were similarly provocative, indicating a need to convey something of her experience, yet falling short of effective communication. In her case, it was not paucity or faintness of speech that inhibited her ability to communicate but a tendency toward flight away from reality. It was also possible that such flights of fantasy also served as 'cover stories' for deeper repressed or cut-off memories. If such memories were connected with the boy's genitals, it made sense that her efforts to cut off those threatening thoughts might have been reflected in the cutting off of phallic displacements, such as the hair, arms, and hands.

A few months later, Kate inexplicably appeared at school wearing jeans, a tee shirt, and a baseball cap. This costume was a dramatic departure from the conservative sweater and skirt combinations that she typically wore. The resemblance to the figure in her drawing was striking. It appeared as though the boy in the baseball cap had materialized, magically transforming Kate into an opposite self-image: masculine and physically active. Kate's symbolic gender switching was more pronounced than the subtler gender ambivalence alluded to in the changes made upon Mary's figure. Both may have been motivated by a similar impulse to reject or deny feminine identities. In Mary's case, violence done to the feminine version of the figure resulted in a more masculine image, suggesting that a form of sexual self-sacrifice made possible the transcendence of gender-based victimization. In Kate's drawn version of the boy, violence marked the masculine image in the form of a debilitating illness, while she assumed the role of caretaker toward it. The costume thus represented a switch in roles for her, to identification with the victim. Kate's confusing behavior of gender switching, role changing, and mixing up of concrete reality with pictorial imagery was consistent with her habit of spinning illogical stories; this made more evident the state of real confusion in her thinking.

This was not the first time that Kate had appeared at school dressed in a costume. On Halloween, she dressed in a sheer nightgown, with her hair done up in rollers beneath a hairnet. She described this outfit as the costume of a 'stressed-out housewife'. Kate reacted with an extreme fit of temper when advised that the seductive outfit was inappropriate for the Halloween party and would likely incite ridicule from peers. Kate insisted on wearing the costume, even over her regular school clothes. At the party

she was ridiculed by her classmates, causing her to leave the party in tears. Kate's insistence on carrying through the ill-advised charade was not inconsistent with her frequent behaviors within the social milieu of attracting negative attention and ridicule. In this case, however, she was more explicit in terms of her sexual identification with a victim. The erotic component of the masochistic act and her unmovable resistance to abstaining from it echoed the fierceness of a child clinging to masturbatory behavior in the face of parental disapproval. Her identification with victimization was possibly associated with concealed past or current traumatic events in her life that erupted into public symbolic re-enactments from time to time. The pressure to keep these events concealed or repressed, coupled with Kate's need to develop socially may have formed compromised attempts to reach out for help through negative symbolic acts. An element of sadistic aggression also appeared in the drama, as the character that was subjected to victimization resembled Kate's agoraphobic, often bed-ridden, mother, to whom she must have borne deep resentment. If Kate had been a victim of incest, as events in her life had indicated as a possibility, then her rage toward her mother as a 'non-protecting bystander' (Miller 1994) would have been predictable. Kate's mother was a 'victim' of her own fears and phobias, a fact that robbed Kate of her need to be taken care of, forcing her into the role of caretaker. This unfair responsibility in itself might have been enough to fuel Kate's deep resentment and anger. However, the seductive aspect of her sadistic fantasy, along with the family dynamics suggestive of incest, indicated that her masochistic behavior was a product of complex factors.

I often found it difficult to tolerate the sessions with Kate. I sensed an undercurrent of hostility directed toward me, which was uncomfortable. This usually began at the start of sessions, when Kate invariably made comments that subtly accused me of failing to provide for her needs or to protect her welfare. This allowed her to set up a situation in which I felt impelled to respond to her needs. For example, one day she complained that 'her' smock was missing from the rack where the smocks hung. It was there, hanging beneath another smock, but Kate 'needed' me to find it for her. She explained again patiently, as if I were slow-witted, why she needed that particular smock. At first, I was overly concerned about trying to make up for these perceived deficits in my ability to maintain an adequate therapeutic environment. I felt slightly guilty, not so much as a

perpetrator of her victimization, but as an uninvolved, nonprotective mother figure. Eventually, I realized that she was letting me know how generally uncared-for she felt in her life. Despite my coming to a more empathic understanding, her barbed remarks continued to embed themselves just beneath my skin, causing discomfort. Part of my job was to feel the pain that she felt, and to contain it without reflecting hostility back toward her. I had to be on guard to avoid slipping into the role of perpetrator. I also had to be willing to accept the role that she assigned to me, as nonprotective 'mother', in order to make the subtle interventions that would later provide a different experience for her. It was in the concrete and technical details of creating artworks that I was eventually able to reach out to Kate, circumventing her defensive patterns of interaction.

Another aspect of the difficulty in working with Kate was my tendency to feel depressed, bored, lost, and unfocused. This was in part a reaction to the flatness of her affect combined with occasional silly outbursts, that conveyed either lack of interest in or disdain for my efforts. My suggestions were generally met with doubt, indifference, or rejection, although she often tried them later. This seemed to be a way that she provided for, and simultaneously denied, her dependency needs. By erasing me from the process, she was able to assert a sense of her own independence and individuation. I found Kate's lapses into not-quite-real stories to be disconcerting. Not being able to make sense of her meaning, I was stymied with how to respond and was thrown at times into a state of suspension or disengagement, almost as if I were the boy in her picture, floating stiffly beneath irrationally colored stars. Slowly, I came to appreciate the helplessness and entrapment that she must have felt. I also felt trapped in the sessions, frustrated with her helpless passivity and catching myself in daydreams and inertia, that must have been similar to the dissociative floating that went along with her attempts to cut off, or escape from feelings. Again, it was the focus on the tangible and concrete dimensions of the art process that helped to bring back my concentration. In this regard, the earthbound, tactile, and three-dimensional qualities of clay work were particularly helpful.

Clay sculpture

Bowl

When the pastel drawing was completed and hung in the studio, Kate looked around the room and fixed her attention upon a clay sculpture of a bowl of fruit done by a former student. She wanted to make one, too. I made a sketch to her specifications of what the sculpture would look like, in order to encourage planning and to provide a reference to reality, in case she became confused or overwhelmed during the process. I had not yet observed her working with clay, but I was prepared to expect some degree of disorganization while working in a medium that promoted regression in most clients. She planned to include an orange, an apple, a banana, a lemon, and two cherries. Although bananas were present every morning at the school breakfast, Kate began to worry about how she would make the banana. She complained that she did not have a clear idea of its shape. As the crotch area of the boy's pants in the drawing had confused and dismayed her, the phallic shape of the banana seemed to paralyze her thoughts. In the first session of work on the sculpture, she began to construct the clay bowl by forming the base and a part of one side using slabs. She had had enough previous experience with clay sculpture that she was able to begin the project with a minimum of assistance. She spent a large portion of the time smoothing the clay surface with her fingers, apparently soothed and gratified by the sensation of the clay next to her skin. Symbolically, the making of the bowl – a unifying and protective container – was an appropriate place to begin the process of creating a complex sculpture with many separate pieces.

Kate arrived early at the next session, asking if she could copy something into her notebook. When she finished writing, she said in a defensive tone: 'You can read it if you want to.' I asked gently whether she wanted me to look at it; she responded with a wide grin, nodding her head. Not wanting to intrude on her notebook, I suggested she read it to me. The story described a 'wonderful angel' named Susan. Kate explained that Susan was one of her 'patients' in a nursing home that she visited regularly. Susan was paralyzed, according to Kate, but 'getting better', miraculously. This story may have reflected her role at home as the caretaker of her immobilized mother, and the magical wish that she might be able to make her mother get better. The paralyzed patient may also have referred to herself, as she fantasized finding a miraculous cure to help her

to gain more feeling and mobility. If I represented a 'wonderful angel', her self-identification as this character in the story indicated her need to merge with my goodness. I suggested to Kate that she could make a book of her stories. I felt that the process of collecting her stories into a bound book with covers might support her need for boundaries and reality testing, by honoring her fantasies in a special space separate from reality. Because her stories seemed metaphorically connected to her traumatic memories, the storing of these narratives in an enclosed binding might also provide her with a greater sense of control over her ability to enter and leave them at will. Kate expressed enthusiasm for this idea; however, she did not pursue it further.

Kate was eager to continue with her clay bowl, begun in the previous session. As the base was quite thin, I suggested that she add another layer of clay to thicken it so that it would support the sides. She pressed clay into the bottom of the bowl, but had difficulty controlling the pressure of her hand, so that the base again became thin. When she built up the sides of the bowl her impulsive, aggressive gestures caused the walls to become weak and shredded. She announced defeat, saying that we would have to let the bowl collapse. I demonstrated how she could use slower and gentler movements, supporting the walls with the palm of my hand as she added more clay to the inside walls. 'I am *not* a gentle person,' she declared as she did this. The reshaped bowl emerged somewhat wider and larger, with a rough, crumpled interior surface. Kate declared it finished, without further refinement. I was surprised by her satisfaction with the rough interior, remembering how compulsively she had smoothed the surface of the bowl in the previous session. The completion of a structurally sound bowl, large enough to metaphorically contain some of her nurturing needs, had been a difficult and exhausting task. Her impulse to destroy, or let collapse, the bowl had been strong, and its lumpy interior surface bore the marks of her struggle. I recognized that it took courage for her to allow this self-created object to emerge structurally intact, and that the damaged-looking interior may have been a necessary tribute to her victimized self. 'I think we better clean up now,' she stated, departing from her customary ritual of delaying the endings of sessions. This change suggested that some of the bowl's structure and containment might have been absorbed by her ego in the process.

The 'cupcake'

Earlier in same session Kate had playfully rolled up a scrap of slab into a cinnamon roll shape with a tip protruding from the center. She set this piece to the side of the bowl, calling it a cupcake. Since it did not 'belong' to the fruit bowl, I did not initially attach significant meaning to this piece. In the following session, Kate was annoyed that I had let the 'cupcake' dry. 'I didn't think I was finished,' she said, somewhat severely. Using a sharp tool, she spent a considerable portion of the session scraping 'decorations' on the dry surface of the cupcake. These were repetitive straight scratches. She seemed to derive pleasure from this aggressive activity, adding more and more scratches until the top and sides were covered entirely (Figure 4.2). She then began scraping the pointed tip of the cupcake, so aggressively that it broke off. Kate looked surprised and guilty when this happened, saying that she hadn't intended to break it. I showed her how to reposition the tip, gluing it back on with clay slip.

The round cupcake with its delicate point in the center was suggestive of a breast form, or combined breast and phallic form, and her aggressive carving and scratching on it resembled an unconscious attack on a hated breast. The tip, not broken with conscious intent, resembled another unconscious act of castration. A theme was developing in Kate's process in

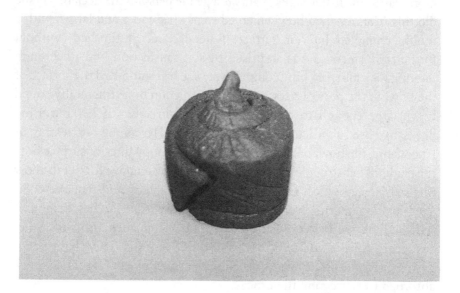

Figure 4.2 Kate's 'cupcake' sculpture

which unconscious sexual references tended to be mixed with aggression toward symbols of mothering. Her attack upon a food image, doubling as a breast form, suggested that her aggression in this case might be rooted in an early oral phase of development. This corresponded to the type of self-mutilation that she had engaged in – biting herself. At this point, Kate was ready to begin working on creating fruit for her sculpture.

Apple and orange

Kate started work on the apple and orange in this session, wrapping clay around spherical newspaper forms, as I demonstrated to her. She was curious about what would happen to the newspaper inside the fruit. I explained that a small hole would be left in the clay so that the paper would burn away in the kiln, and she became fascinated by the idea of the hole. She intended to distinguish the orange from the apple by pricking its surface with a tool to create the skin texture of the peel. She did not create an all-over pattern, but added only a few lines of dots like animal tracks. This was similar to the pattern of indentations that Mary had pricked on the surface of the ball of her tree. Kate commented that the tracks made the orange resemble a baseball. This remark expanded into a story about a baseball that her father took away from her because a boy on the street got hit on the head with a baseball bat and 'passed away'. Kate followed up this story with the activity of poking a hole in the top of the apple with her finger to insert the stem. Her excitement with this activity suggestive of a metaphorical sexual act was visible, and she ended the session with great reluctance.

The aggression in Kate's story suggested a fantasy of murder, in which the props of violence – baseball bat and ball – were thinly veiled symbols of masculine genitalia. The 'taking away' of the ball by her father resembled a form of castration. The killing of the boy seemed to carry this act to the extreme of human sacrifice, and may have represented Kate's simultaneous identifications with both victim and aggressor, using the restored phallic weapon. The sacrifice of the boy suggested as well that Kate was experimenting with the idea of killing off this self-repre-sentation to preserve the integrity of the rest of her. As she gave up the phallic object to her father in the story, she may have simultaneously been unconsciously giving up the irrational fantasy of being a boy, thereby

submitting to a form of symbolic castration. Considering the passive state of her mother, Kate's periodic masculine identification may have been a resistance to the feminine identification with her mother, thereby prolonging an early adolescent phase of tomboyish identification into late adolescence. However, the linking of sexual symbolism and erotic excitement with illness and mortality in this story suggested a masochistic element of deeper significance, underlying adolescent phase identification and separation issues.

At the beginning of the following session, Kate told stories about her animal 'friends'. These had to do with animals desperately seeking food: a bird that pecked on her window every morning for food, and a squirrel with a nut that it couldn't crack open. While 'nuts' and 'pecking' could be construed as references to masculine genitalia, the overriding concern in the story seemed to be the fact that food and nurturing remained inaccessible. In these stories tinted with deprivation, Kate's gnawing losses in nurturing were symbolically juxtaposed with subtle references to sexual urgency or attempted invasion. Her violation and abandonment were intertwined, as both of her caregiving figures must have failed her.

Because Kate continued to have difficulty separating from the room at the end of sessions, I set up a clearly defined clean-up time. Kate agreed to comply with this rule, and said she would wash the surface of the table as part of the clean-up routine. She spent the session creating a stem and leaf for the apple, after initially lapsing into confusion over the difference between the orange and the apple. She digressed into a discussion about oranges with deformities, such as those with unusually placed navels, or a third navel 'with a baby orange underneath the third navel'. This subtle reference to a baby in the womb reiterated a theme that was suggested in the artwork of Mary. In Chapter 3, I discussed the 'image of the child' (Schaverien 1995) with reference to a regressed, wishful transference reaction to the therapist. The curious addition of a 'third navel' echoed the three moon faces, the number that also corresponded to Kate's three therapists. The baby orange 'underneath' the third navel may have been an unconscious reference to the relationship between us, as I was the third art therapist. The image of the baby orange inside the big orange not only evoked the concept of an infant in the womb, but also a sense of merging or absorption. Because of the solidity of an orange, it seemed that a baby inside it would have been merged and engulfed, rather than held in a

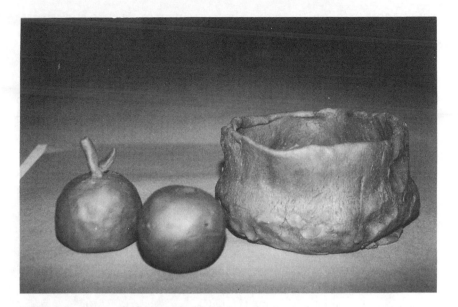

Figure 4.3 Kate's 'bowl, orange and apple' sculpture

protective space. In this case, Kate's transference seemed to embody a wish for merging, while her ambivalence about such a connection, perhaps related to negative feelings about herself, was suggested by her references to deformed and defective oranges.

Kate was able to complete the orange with a navel in the appropriate location. The sculpture to this point, with the bowl, orange, and apple is shown in Figure 4.3.

She stated that she intended to start on the banana in the next session. Kate was able to clean up after the session as agreed, but before doing so she impulsively picked up the 'cupcake' and aggressively scratched at it. This time she drew a circular line all around its base, simulating a castration of the cylindrical object. Her focus in the session upon unmet nurturing and merging needs, colored by diffuse sexual overtones, may have generated feelings of rage, confusion or anxiety. It was as though these ill-defined feelings and images surfacing from the unconscious through fruit metaphors spilled over into a defensive attack upon the substitute phallic object, in another symbolic castration. The release of erotically tinged aggression seemed to restore her sense of order, so that

she was able to follow through on her agreement to clean up and separate from the therapy session in a more organized manner.

Banana and 'baby' lemon

In the following session, Kate smoothed the interior of the bowl, which she had not touched for several weeks. This self-soothing activity signaled an interest in caring for herself and may have helped to calm her anxieties related to the task that faced her, that of creating the banana. I demonstrated to her the step-by-step process of creating a banana, referring to the pencil drawing of the fruit. Kate wanted to make a banana herself, and rolled a coil of clay vigorously between her hands, pressing too tightly. The clay squeezed out of her fist at one end, leaving an explicitly phallic rounded tip. 'I think I'm getting it,' she said, 'but it's not as good as yours.' I showed her how to shape the banana into its natural curve with pointed ends, and to flatten the sides slightly, diminishing its phallic appearance. Kate tried this, but continued to deform the banana with impulsive, anxious movements. When she flattened the sides, a ridge formed at one corner that she wanted to cut off. I suggested she could fold it over and reincorporate it into the banana. She did so, and commented that the banana was 'stronger' and 'more firm' that way, indicating an awareness of the concept of integration. With this, Kate stated contentedly that the banana was made by both of us. She did assert her healthy need for individuation by insisting on creating her own banana separate from mine, but it also seemed important to her that we be connected in the process of creating her banana. This reflected her increasing trust in drawing from my support and ego strengths in an alliance focused on a common exterior goal, that of creating an object between us but removed from both of us. The process of creating objects paralleled the interior process of reforming and re-creating her identity, partially in accordance with examples provided by modeling.

Kate also completed a 'baby' lemon in this session. She wrapped a slab around a small newspaper form, and I showed her how to squeeze the clay toward each end to make bluntly pointed tips. There was a lot of excess clay to trim off the ends, which Kate added to a pile of clay scraps. She squeezed the lemon with so much force that it started to become deformed, so I asked her to press more delicately. It took so much

concentration for her to control her aggressive motions to that extent, that when she cut off the excess clay she slammed it hard down on the stack of scrap clay. Deflecting her aggression to the stack of clay allowed her to continue to work on the lemon without further deforming it.

At the end of the session, she inspected the tip of the 'cupcake' and decided that it was broken and needed fixing. There was a ritualistic, perhaps fetishistic, quality in the way that she gave a token portion of her attention to this piece each week. It was perpetually unfinished and, when not attacked, in need of repair or further refinements. She had created a special side relationship with this object that was split off from the main project, the bowl of fruit.

The cherries

It took an entire session for Kate to form two small cherries out of clay. Her manipulation was too aggressive at first to form a small ball of clay. I demonstrated with another piece of clay how to form a ball delicately and to make a light indentation in the top for the attachment of a stem. Kate followed my example, but instead of lightly indenting the clay she stabbed it aggressively in the center. She formed a second cherry, slightly smaller than the first, but smoothly shaped. As part of a discussion of how to attach and create stems, I drew a picture of two cherries joined at the top of the stem. Kate lit upon this idea at once, seized the two cherries and started to press them together. Similar to the fantasy of the baby orange inside the big orange, this act again suggested a symbolic enactment of a very early symbiotic relationship in which self and other, or infant and mother, are perceived by the child as merged, rather than existing side by side. That Kate tended to view the fruit as imbued with human or animate qualities was evidenced by her reference in the same session to the banana as 'he' and the cupcake object as 'it…or whatever it is, I don't know'. Because she was so easily subject to states of fragmentation, I focused upon providing reality orientation. I did not support her inclination to merge the cherries, and let her know that the cherries could eventually be joined together at the stems. This intervention was aimed not only at preserving reality, but also at laying the groundwork for what I hoped would be internalization of a concept of a relationship in which objects may be connected and

related, but separate and intact. Kate added the third cherry, the sample that I had made, to her collection of fruit.

At the next session, Kate entered the room and charged that the cupcake was 'missing'. It was in fact beside the fruit bowl, out of her immediate range of vision. Although Kate was extremely attuned to finding things, on this occasion she impulsively jumped to the conclusion that the 'cupcake' was missing without stopping to imagine where it might be. Her behavior was again reminiscent of an early development phase, when the 'constancy' or permanence of objects, both cognitively and emotionally, is not secure. It appeared that Kate at times viewed the 'cupcake' as a symbolic mother figure or substitute, and her behavior toward it is aptly described in the following quote from Mahler: 'She was not able to imagine where mother was when mother was not in her visual field.' (Mahler, Pine and Bergman 1975, p.162.) Mahler theorizes that aggression and ambivalence interferes with the child's ability to develop object constancy. The progression of Kate's interaction with the 'cupcake', which was both ambivalent and aggressive, leading up to this instance of failure to maintain a sense of the object's constancy, seemed to illustrate Mahler's theory in action.

The same pattern of ambivalence spread to the two cherries she had made, which happened to be Kate's next focus of attention in the same session. 'How come one is soft and the other is hard?' she questioned. I checked, and both were equally hard, having dried over the week since the previous session. Although I said they felt the same to me, Kate insisted that the larger one was soft and the smaller one was hard. The two cherries, suggestive of nipples, appeared to be another mother symbol. This time, mother may have been viewed ambivalently as opposing 'good' and 'bad', or nurturing and withholding nipples. During early phases of separation and individuation, if the parent has been experienced as intrusive or unpredictable, according to Mahler *et al.* (1975), the child may attempt to eject the 'bad' piece of the internalized parent, and may redirect its aggression toward these mother or father substitutes. It appeared that the cherries in Kate's case were substitutes for such unassimilated good and bad pieces of the parent.

The pear

Kate formed the last fruit, a pear, by wrapping clay slabs around a newspaper form, as she had done to form other fruits. She remembered how the lemon had been formed and used the same technique with the pear, molding the clay tightly around the form and removing excess from the top. Her execution of this process was aggressive, as she contentedly chopped the phallic-shaped coil that extruded beyond the pressure of her squeeze. She became engrossed with the activity, repeating it over and over enthusiastically, commenting with excitement about the profusion of excess clay she had cut off. Eventually she was able to stop, leaving a small stem, which she cut to give it square sides. After this, she beat the pear aggressively in her hands, so hard that she pounded the bottom of it flat. She allowed me to restore the pear gently to a realistic shape. It had taken considerable abuse, but managed to emerge intact.

In the creation of the pear, Kate appeared to bring unconscious castration fantasies that had been alluded to in the earlier process to a more clear and focused climax. She clearly enjoyed the stimulation and soothing release of aggression derived from squeezing and chopping the clay coil. She also demonstrated that she had begun to internalize from her earlier experiences some self-regulatory strength. For example, she used the technique of squaring the sides of the stem, learned from the experience of flattening the sides of the banana, as a means to restore order and realism to the pear stem. Thus she was able to restore her reality orientation following a compellingly regressive process. Perhaps the flattening of the pear was an extension of this squaring process, carried to the extreme. The aggressive banging of this and other fruits to the point of deformation was similar to her occasional self-harming technique of banging her head or other body parts against objects. Perhaps the physical enactment of self-bruising, reflected symbolically in similar actions upon the fruit bodies, helped to communicate a defective and deformed self-image to others. It may also have been a means by which she sought to gain control of her shape and appearance, by becoming the dispatcher of deformation and reformation. However, by gaining control in this manner, she simultaneously lost control, by losing the ability to protect and maintain the integrity and realism of the fruit. Her need for my intervention to prevent the ultimate destruction of the fruit may have been a metaphorical means of expressing her ambivalence about her efforts at individuation

and her fear of independence. She demonstrated concretely that without my support, she might continue to be self-destructive. Her willingness to accept interventions to restore order indicated that she may have been testing my ability to withstand her healthy attempts at separation, and my commitment to continue to be available even when she no longer needed it. The incompleteness of her separation was apparent in the following scene that ended the pear-making session.

Kate placed all of the finished fruit in the bowl and hesitated, unsure whether to add the 'cupcake' to the assembled sculpture. I suggested that she make a separate small plate for this object. This idea delighted her and she readily agreed, however adding, 'then I can attach it [the plate] to the side of the bowl'. Her ambivalence about adding the cupcake to the fruit bowl reflected her ambivalence toward the object itself. As the fruit bowl managed to reach a final stage of intact completion reflective of her individuating self, the cupcake remained as a testament, perhaps, to a split parental representation. While the similarly ambivalently split cherries were finally incorporated into the sculpture realistically, indicating a growing ability to integrate internalized objects, the cupcake continued to represent split-off fragments. Kate was not yet ready to separate her intact sculpture from this object, opting again for superficial merging at the level of surface contact. Using the nurturing food metaphor, I reframed the situation by suggesting that the bowl of fruit and the cupcake could be different dishes on the table, separate but included in the same meal. The metaphor of a meal held these objects together, providing integration without bizarre merging. The same metaphor created an imaginary perimeter: the borders of the table on which the meal was collected. Such an imagined border expanded the potential space around the fruit bowl to include connected but separate objects within a comfortably sized area. The image of the meal table within the larger room was a metaphor for the art therapy studio itself, with a table as the center of sacrifice and nurturing within a larger space. The boundaries of the room delineated the protected space of the therapeutic relationship itself – an intimate subdivision of real space and time in which self-nurturing, as well as separation and accept-ance of external reality and objectivity became possible.

If Kate had been allowed to fuse the plate to the fruit bowl it would have resulted in a bizarre configuration that might have served to reflect only a regressed, distorted perspective of reality. She would have been left

vulnerable to the ridicule of others, thus lending support to her maso-chistic tendencies. She did not resist the intervention to prevent this outcome, but busied herself in making a separate plate for the cupcake. In the future, Kate's finished fruit bowl would endure as an example of the level of integration and intact functioning that she had been able to achieve. Aggressive and erotic drive energies had been unleashed and sublimated in the process of its creation, and transformed into a socially acceptable product that could potentially enhance Kate's self-esteem.

Termination

Kate was not only terminating from art therapy at the end of the school year, but she was also graduating and leaving the day treatment program. She missed four consecutive weeks of sessions, because of absences from school. It appeared that she had begun her termination process pre-maturely. In essence, her process of separation took the form of cutting off the relationship before its natural conclusion, which gave her an illusion of greater control over an inevitable loss. This was consistent with masochistic styles of behaving and with the theme of self-mutilation. By denying herself and others the possibility of a mutual separation process, she defended against the pain of perceived rejection and loss by assuming control over its administration.

However, when Kate returned to school I showed her the sculpture after it had been fired, and she agreed to come to a session to paint the fruit. She became engrossed in this process, and was subsequently able to return for the last two sessions before termination. She spent this time sanding rough patches on the surface of the fruit, and painting all of the clay pieces. While sanding the apple, she broke off its stem as she had broken the tip off of the 'cupcake' previously. Later, when painting the apple, she had great difficulty separating the colors in this area. Although I gave her a tiny brush for the detail of the stem, she still seemed to have difficulty determining the boundary between the brown stem and the red apple. As she struggled with this task, she repeated to herself aloud: 'I'm going to have to paint it very, very gently.' Although the delicate area where the stem attached to the fruit probably generated anxiety and accompanying hostile defenses, Kate's repetition to herself of advice I had

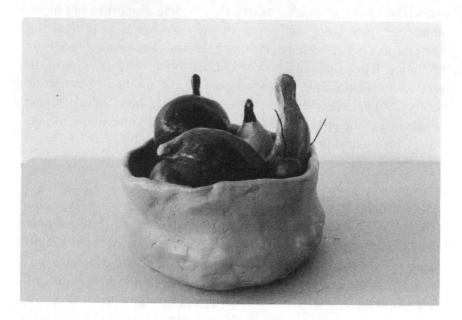

Figure 4.4 Kate's completed 'fruit bowl' sculpture

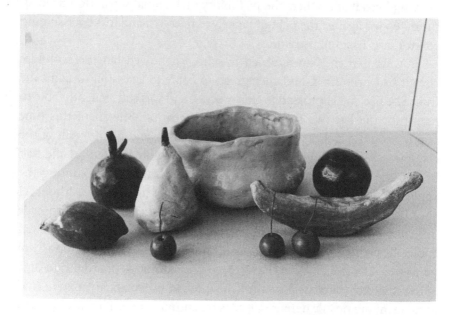

Figure 4.5 Kate's completed 'fruit bowl' sculpture

earlier suggested indicated that she had begun to internalize some of the controls that had previously been provided externally.

Kate glanced from time to time at the bowl of fruit made by a previous client, checking the colors of the fruit to make sure that her color choices were accurate. She was independently seeking confirmation of reality, and was able to complete all of the fruits in realistic colors. She hesitated over painting the bowl purple, like the other fruit bowl, but eventually used a deep blue of her own choosing. The deep blue provided a more stable, controlled, and aesthetically pleasing contrast to the brightly colored fruit than the more sensuously stimulating purple would have done. Her ability to make a healthy choice, different from the model that she was depending upon, was another indication of increasing independence and self-confidence. The completed sculpture appears in Figures 4.4 and 4.5.

In these final sessions, Kate did not give any ritualistic-type attention to the 'cupcake'. She painted it and its dish a cinnamon-brown color when the fruit bowl was completed. As she organized herself to make the transition toward leaving, she seemed to be ready to let go of the ritualistic attachment to this object. She chose to allow the fruit bowl to become part of a permanent collection on display in the day treatment center, which brought her respect and admiration from the rest of the staff and clients. Upon entering the room on her next to last day of sessions, she had noticed her apron folded over a chair, and had commented: 'Someone cares about me.' This willingness to accept and internalize a positive feeling was a crucial step that gave her the inner support to follow through with a separation and termination that reflected growing self-confidence and maturity.

Conclusion

In overall functioning, Kate was more impaired than Mary; consequently, the prognosis for improvement was less optimistic. Both Mary and Kate had ambivalent relationships with their mothers. However, I believe that Mary and her mother's enmeshment had at least provided Mary with a degree of attachment that formed a base from which to begin separation. Mary's mother displayed an intrusive and self-absorbed style of mothering, yet was able to assist in the process of Mary's treatment by engaging in therapy. Kate's mother displayed a different style of mothering. She stayed

passively uninvolved and unreachable it seemed; probably, therefore, she could be characterized as more neglectful than abusive. Kate's response to this lack, especially as she struggled through the adolescent separation and individuation phase, was to regress into nearly psychotic states of undifferentiation. She had probably not experienced enough narcissistic gratification of needs, such as validation of inner feelings of magical omnipotence, to face the challenge of coming to terms with external reality. Her fantasies around fusion and the merging of objects reflected the gnawing need to be held, fed, contained, and mirrored, in order to develop a positive sense of herself as a cohesive unit. Consequently, she had loose, permeable boundaries that seemed conditioned to cave in under the painful pressures and blows of external forces.

She appeared to be subject to the type of fracturing and splintering described by Kohut (1977) as leading to the ritualistic use of fetish objects as patches to fill in the holes of a deformed or incomplete body image. Her use of a fetish-type object was apparent in the erotically and aggressively charged relationship that she devised with respect to the 'cupcake'. Her impulse to attach it to the side of the fruit bowl was reminiscent of the psychoanalytic view of a fetish as an illusory penis intended as a replacement for the mother's lost phallus. The phallic-like shape of the object, along with the many castrating urges toward it, combined with the mothering image of the fruit bowl, support this hypothesis. The impulsive and ritualistic castration gestures that she made toward the 'cupcake' were reminiscent of the theoretical approach to castration discussed in Chapter 2, in which the symbolic sacrifice of the genital substitute serves as a magical protection against its actual loss. In part because the fetish represents a restored body part rather than an intact being, it does not achieve the level and purpose of a transitional object. For the reason of her fragility and tendency to deteriorate, Kate needed therapeutic support to achieve some degree of separation from the fetish. This could only be achieved by a slow process of building a solidly complete self-object, symbolically realized through the creative process of forming the bowl of fruit with its solid boundaries containing a rich collection of good nurturing and harmonizing objects. The detachment of the 'cupcake' from the bowl of fruit paradoxically helped to create a bridge that separated and connected the two objects; in effect making possible a transformation of the fetish into a true object.

I believe that without the actual creation of concrete objects, separate enough from fantasy to be partially 'of the real world', it would have been difficult for Kate to gain enough distance from her unconscious and its confusing images to begin a process of separation and reality testing. Kate's tendency toward dissociation and loss of grounding was counteracted by the weight, gravity, and tactility of the clay and other art materials. Therapeutic support, as well as the struggle to master the process, helped to strengthen her ego to the degree that it could begin to detach itself, and defend itself to some extent, in the face of overwhelming impulses and irrational images or thoughts. Owing to the severity of Kate's impairment, she would have needed continuing external structures and support of this nature to further her development.

The likelihood of some form of incestuous trauma compounded Kate's trauma of maternal neglect. Her sexual identity was not only unclear but fraught with invasive negative associations, such as morbid illness and death. Ambivalent switching between possible mother identifications to possible father identifications was alluded to in the opposing characters of her costume identities: 'stressed-out housewife' and 'boy with a baseball cap'. Neither of these characters was positive or healthy, and therefore unlikely to provide the kind of nurturing and self-esteem building internal objects that Kate needed to support and feed her independence. Yet through the slow process of building symbolic objects, and the vicissitudes involved in that process (such as damaging attacks, failure, splitting, re-doing, and eventually achieving a degree of integration), Kate was able to begin to internalize some of the good object identifications that she lacked.

The therapeutic presence supported Kate's need for mirroring, and received her aggressive attacks without judgment or retaliation. The powdery pastels and the sticky and soft feel of the clay surface helped to provide some of the tactile holding that she required. The clay surface also yielded to her physical aggression without retaliation, and then allowed itself to be lovingly repaired and reconstituted, thereby modeling a patient, empathic, and enduring object with which to relate. Of course, informed interventions were necessary to create this illusion of the clay as a loving and forgiving object. The advantage to this scheme was that the clay was able to receive the actual physical blows and attacks that the

human therapist parent substitute could not, simultaneously deflecting the attacks from Kate's own body.

This chapter concludes the case material dealing with adolescent clients in art therapy who had engaged in traditionally defined forms of self-mutilation. The following chapter presents a case of a young boy who was involved in art therapy treatment at the time of the writing of this book. His aggressive behavior was often directed toward others, but also included self-destructive elements such as self-hatred and suicidal ideation. This case, while still in progress, and therefore in some ways only a fragment, is included because it illustrates in a graphic manner a transition between impulsive enactment of aggression and the gradual separation from violent action effected by a dawning realization of the possibility of symbol formation. The process of the boy's activity in art therapy is appropriate to this discussion because it involved graphic enactment of sacrificial acts, which gradually led away from violent gestures toward symbolic images of protection and nurturing that helped to delay the gratification of aggressive urges.

Sacrifice to Symbolization in the Case of Eric

Introduction

Clinical history

Eric was a seven-year-old boy diagnosed with attention deficit and hyperactivity disorder. His developmental history, as reported, was fairly unremarkable, although his home environment appeared to have been disruptive in Eric's early years. His father suffered from alcoholism and left home when Eric was four months old. Between the ages of one and two Eric received periodic visits from his father, but after that his father did not contact the family. When Eric was three years old his mother married his stepfather. During the span of time that this case study refers to, Eric's eighth year, his mother tried without success to conceive another child. Simultaneously, Eric's primary therapist became pregnant, and the juxtaposition of these circumstances impacted significantly upon Eric's emotional state.

Although he had a fairly sophisticated vocabulary, Eric had extreme difficulty verbalizing his emotions and needs. His hyperactivity and poor impulse control became apparent by age five, when he was in kindergarten. At age seven, he was still unable to relate to other children without pushing and hitting them. Consequently, he spent the days mostly in isolation, set apart from the other children for his safety and theirs. When he was six years old, he was taken to the psychiatric emergency room for suicidal ideation. On that occasion, he reiterated that he hated and wanted to kill himself. When given verbal limits, he was for the most part either unresponsive or only in momentary compliance. His sturdy, muscular body seemed to be bursting at the seams with aggressive energy and

constant motion. He was insecure and anxious, often using defensive rituals and repetitive behaviors as one of the few ways in which he was able to exercise a degree of self-control.

Symbolic capacities

Aside from his marked anxiety and rapidly shifting attention, the aspect of Eric that seemed most striking from the outset of my work with him was his delay in expressive and symbolic capacities. He used words and speech sparsely, although with apparent intelligence. His most common form of expression was bodily action, such as running, hiding, touching, and playful hitting. These actions were often accompanied by nervous, taunting laughter. Initially, he made poor eye contact, although his visual attention darted about, alertly scanning the surroundings. When faced with drawing or sculpting materials, Eric became easily overwhelmed and anxious, which led to various aggressive and regressive reactions. He seemed to view the art media as an enemy, which he playfully and then increasingly more viciously attacked. He spoke of monsters and nightmares as he did this, and urged me to join him in defensive rituals to guard against these enemies. For example, he asked me to remind him every week not to mention the word 'nightmare', because that word spoken out loud would cause both of us to have nightmares. The art materials, especially the clay, catalyzed Eric's tendency to regress to more chaotic forms of behavior. He treated the clay as a plaything on which to discharge his aggression through physical contact. At first, he seemed unable to regard the clay as anything other than inanimate material, but eventually he began to invest it with the abstract concept of emotion. He explained that he was hitting it because 'the clay hates Eric'. He began to label it a monster while he attacked it, but was still unable to create an image of a monster. There seemed to be no distance between his emotion and the physical response to it, a distance that would have been necessary in order to form a mental picture of a monster that could then have been shaped into a material representation.

Eric had a somewhat different response to the sensuality of color and paint. Mixing colors and painting with them seemed to bring out an erotic and sensitive side to his nature. His paintings were nonsubjective action paintings, usually consisting of a few wide brush strokes in one or two

colors not well integrated or elaborated. He did get to the point of naming one of these compositions a 'sunset', which led to his request for an expanse of mural paper on which to paint a large version of a sunset. On the day that Eric painted on the mural paper, his behavior was calmer than on other weeks. The paint, and perhaps the erotic feeling that it stirred in him, seemed to soothe and relax him. He began to describe himself at home watching the sunset out of the window, and attempted to add the house and the yard to his painting. Although he indicated that he would finish the mural at a later time, afterward he refused to continue with it and was rarely able to regain the degree of relaxed and imaginative expression with paint that he had achieved on that day.

Interaction with the therapist

Eric was initially apprehensive and anxious. I met with him for an evaluation, and an intern happened to be observing the session on that day. Eric was extremely uncomfortable with this arrangement, and moved as far away as possible from the observer with his back up against a wall so that he could keep an eye on her movements. His discomfort being in the session was matched by his difficulty with ending the session. He grabbed clay to take with him back to the classroom, and when this was not allowed, clung to his chair and refused to leave. His body was rigid, and his face stiff with panic. Eventually, in our sessions alone together, Eric developed a close relationship with me that was an ambivalent com-bination of affectionate clinging and defiant resistance to limits. He never allowed me simply to watch him work. In the beginning, he ordered me to join him in parallel play; later on, he developed routines of interactive play that required my active involvement in specific roles and tasks. Taking directions or responding to limits was always difficult for Eric: he either responded with vehement negatives, or simply appeared not to hear directions. When limits were strictly enforced, he sometimes simply shut down, immobilized with rage.

Other times, Eric related to me affectionately, calling me 'mom', or clinging to my arm and saying 'I love you'. On one occasion, he stated that I was more important to him than the art activity. This remark shed light on the possible reasons for his difficulty with symbolism. Although he was able to form an attachment to me as a maternal figure, his interest in the

exterior world of objects beyond 'mother' was still quite limited. Transferring his affection and sense of connection to an object that might become transitional was either too threatening to consider or simply beyond comprehension. Letting go of the real, tangible love object must have felt to him like stepping off into an abyss. Where another child might have created a soothing or loving presence in fantasy, Eric was only able to imagine monsters and self-despising entities. Although Eric was able to separate from home enough to attend school, his participation in the classroom was minimal because he was unable to socialize with the other children. He was invariably separated from the group, at a desk set apart and turned away, or at a separate table alone in the lunchroom. In art therapy sessions his interaction with me, manifesting as a strong maternal transference, overrode his interest in the art activity. His symbolic capacities were thus stunted by the limited space available in which to develop.

Eric's ambivalence reflected his conflicts regarding the outward expression of aggression. He seemed to need a playful testing ground for the release of such feelings. This began ritualistically at the beginnings of sessions, when he ran ahead to hide in the room so that I would have to 'find' him, at which point he would often playfully slap me with the dangling long sleeves of his smock. His eyes gleamed maliciously as he did this, waiting for my reaction. With slightly antagonistic, taunting behavior, he tested my reactions to his refusal to follow instructions. He was sensitive to strict or severe responses, to which he might react with panic by shutting himself down, as previously described. Like an infant that needed its mother to receive its aggressive impulses without overreacting or retaliating, Eric continued to put me in the position of receiving and absorbing his attacks with equanimity. Eventually, this drama was transferred on to the claywork, in ritualistic play that will be described in detail in the next section.

Selected art therapy sessions
Stencil drawings
Because Eric demonstrated in the early sessions that he was unable to generate his own forms and images I began to provide ready-made shapes such as clay cutters and stencils with the rest of the art supplies. I hoped

that the structure provided by the stencils would make it possible for Eric to begin to express his ideas in images. Eric spied the stencils at once and carried them back to his workspace at the table. He picked out a package of dinosaur stencils and began to trace them on his paper at random. He methodically traced one of each of the different dinosaurs. Somewhat impatiently, he ordered me to choose another package of stencils and join him. I suggested adding trees to the picture, in order to establish a context for the dinosaurs. Eric agreed absent-mindedly, but made no indication of having a conscious awareness of, or interest in, the pictorial space and its contents. The dinosaurs as aggressive icons were of initial interest to him, but he could not distance himself enough from them, and from the motor activity of tracing them, to allow his imagination to place them in a contextual space. Eric quickly tired of this activity, and restlessly searched the room and the closets for other ideas. He asked to 'play with clay', and ended the session by furiously attacking a piece of clay. In the process of this play, he formed and destroyed a 'big mouth' and a 'monster' that he beat and stabbed, saying excitedly 'he likes it, he wants it'.

Weeks later, on the day of the school Christmas party in December, Eric came to the session in a highly agitated state, gripped with the fear that he was not going to get a present at the party. He could not be soothed by reassurances that all of the children, including him, would receive gifts. He

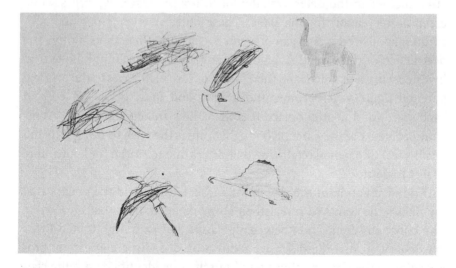

Figure 5.1 Eric's scribbled-over animals

seized the stencils and sorted through them wildly, choosing the package of dinosaur shapes to work with. He ordered me to get stencils also, and work beside him. I ended up holding the dinosaur stencils while he traced them, because in his state of agitation he was unable to draw and steady the stencil and the paper at the same time. Eric traced one after another of the stencils, methodically drawing one of each dinosaur. As in the previous stencil drawing, he added the images to the paper in a random order, floating and disconnected from one another. He 'colored' some of the dinosaurs by violently scribbling over them with colored pencil. He did not pay attention to the outlines as he did so, and the result was that the scribbled over animals looked as though they were crossed out, censored, or destroyed (Figure 5.1).

Eric moved to another paper briefly, tracing two trucks and obliterating them with scribbles, explaining that they had crashed. He pounded the pencil lead on the paper, and then threw the paper and the stencils across the table. He allowed me to lead him back to the classroom by the hand.

Eric's drawing appeared as a map of his destructive path, obliterating the work behind as he traveled from one object to another. This behavior was reflected in his activity in the room, as he searched for different objects upon which to vent his aggression. I was reminded of Klein's (1930) theory of symbol formation, in which the child destroys one object after another in the defensive attempt to gratify aggressive urges while escaping retaliation for the same. These objects serve as parental substitutes, upon which rage can be vented – rage that has as its motive the destruction of the parent. As an object becomes too meaningful – that is, invested with attachment and therefore too close in likeness to the original parental figure – it becomes threatening and must be destroyed and exchanged for a neutral object. It is the child's anxiety about the frightening contents of the parental body that causes the wish to destroy it; and it is his fear of parental retaliation that drives him to search for a substitute object to destroy.

Eric's mutilation of the clay in the earlier session, and the remark that 'he likes it, he wants it' revealed an erotic counterpart to his aggression. The conscious connection between pleasure and pain highlighted Eric's masochism, in that the defensive redirection of sadistic aggression, projected on to the clay and thus on to himself as he identified with the clay, was labeled pleasurable. At other times, when Eric attacked me playfully,

his erotic feelings must have mixed with his fear of retaliation and possible loss of a maternal relationship. Therefore, he reserved the majority of his aggression for substitutes – namely objects that were connected to me through belonging to the art therapy studio. When he was the most furious with me, for example when I set limits about his unsupervised forays into the supply closet, he turned in desperation to face the wall – a self-punishing gesture.

Gradually, Eric began to develop more extended fantasies while 'playing' with clay. He became somewhat less agitated as he focused for entire sessions without searching out other activities to occupy his attention. From the outset, the clay play fantasies were highly destructive. I demonstrated the use of the clay cutters, making a series of houses. Eric imagined the houses were on fire and sent fire trucks to the scene, throwing clay on the houses to put out the fire. The houses were totally destroyed in the process. A few weeks later, Eric simulated a surgical operation with the clay. After repeatedly stabbing and wounding a 'monster' (an unformed flattened mass of clay), he patched it up again with clay bandages. He enjoyed gluing bits of clay back on to the body with the clay slip. This wounded 'body' was the first object that Eric allowed me to save so that he could continue to play with it later. He subsequently ignored it, and the following week busied himself with building clay towers and smashing them down. He identified his feelings as he did so, saying 'he makes me angry and sad'. He switched to making sharks and dogs with the clay cutters, all of which died violently either in accidents or during surgery in the hospital. He 'resurrected' the animals, creating new ones that he allowed me to save, although later showing no interest in these either.

I observed that Eric was beginning to experiment with the creative side of the destructive/creative cycle. This was apparent by the surgical fantasies that went beyond wounding to attempts at healing or patching over, and by the resurrection of new animals from the remains of those that had violently died. He was also beginning to conceive of his created objects as having a degree of permanence beyond their immediate role in the action of the play fantasy. Even so, this progress was tentative, because he was still not enough attached to any of these objects to sustain interest in them through the following session.

Painted wood sculpture

Eric was excited when he discovered wood scraps among the art supplies. 'No-one else can use them,' he exclaimed. He announced that he was not going to work with clay any more, and began to paint upon pieces of wood. He came up with the idea of gluing pieces together to make 'a rocket ship', but could not focus himself enough to sustain a constructive idea. In all of the many sessions that he devoted to working with wood, it was the painting that held his attention. He persistently resisted gluing, although sometimes he allowed the therapist to glue things together according to his instructions. Following his earlier pattern with the stencils, Eric moved restlessly from one piece of wood to another. He was unhappy if he did not have all of the wood at his disposal, continuously searching for more pieces while leaving others incompletely painted, untouched, or abandoned. I provided Eric with a masonite board to use as a base on which to construct a form. When I worked beside him on a similar board, painting and gluing a structure, Eric showed a brief interest in copying the process. He instructed me to glue together the pieces in an abstract arrangement of his choosing, but did not allow it to remain in existence for long. Using a scrap of wood as a mallet, he beat upon the structure until it fell apart.

Above all, Eric was fascinated by the paint, mixing colors together on the wood surface. He usually chose bright and sensuous colors mixed with white to make various shades of pinks, purples, and blues. Unlike many children that manifest regression in the paint mixing to the point that all of the colors eventually become muddy grays and browns, Eric preserved the integrity of his colors. His regression was reserved for such behaviors as throwing the wood and brushes or breaking apart the sculpture. When this happened, Eric seemed relieved to return to his classroom. Sometimes, he stopped the activity, cutting short the session, because he apparently had reached a limit in his tolerance for stimulation.

Eric focused upon the activity of painting wood for about two months, at which time he began to ask for clay again. Eventually, Eric developed a pattern of switching between painting wood and playing with clay. This seemed to be connected to the predominant erotic or aggressive nature of his mood on that particular day. Sometimes, this was predictable by the level of agitation that he displayed during the walk to the art therapy studio. On calm days, he reveled in the sensuous mixing of colors. On

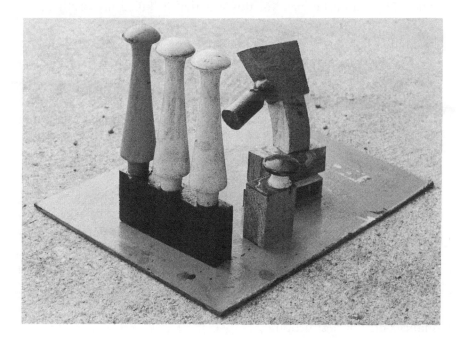

Figure 5.2 Eric's wood sculpture

anxious days, he asked for clay. The latter followed a consistent pattern of ritual enactments of sacrifice and war. With the therapist's assistance in gluing, Eric completed the wood sculpture shown in Figure 5.2, which was displayed in an annual school art therapy exhibition.

Killing of clay babies

During the months that Eric worked on painting wood, he had also been working on developing a bond with me that included overt and sometimes provocative displays of affection. It was during this time that he hugged me and told me that I, like his mother, was more important to him than the art activity. On the day that he reverted to playing with clay after the long interlude of painting wood continuously, he came to the session in an aggressive, oppositional mood, demanding that I work alongside him. Responding intuitively to his mood, I made a baby person out of the clay, a reflection of what might have been his level of need and emotional functioning on that day. Eric seized this baby and stabbed it multiple

times. The reason he gave for this was that it 'killed my brother'. He requested that I make more babies, which he destroyed one after another, in a similar fashion. When I questioned him on why all the babies had to die, Eric thought and then said that there needed to be two babies: a 'real baby' and a 'toy baby'. He would kill the toy baby to save the real baby. The real baby was made to sit and watch the toy baby get killed. I asked Eric how the real baby felt about this, and he responded that it was crying because it felt sad. I drew a sad face with tears on the baby. Eric promptly picked it up, stabbed it, and chopped it up into little pieces as he had done to all of the other babies. He looked at my face intently and asked if I was sad. I replied: 'Yes, I'm sad because there is no safe place for babies.' Eric then said that the box with the clay tools was a safe place, and asked me to make a new baby to put in there. He added that he was going to throw clay at it but it wouldn't die because he would be hurt instead. He stated, somewhat defensively, that none of the babies was actually real because all were just clay. Eric ended the session by aggressively pounding and stabbing the clay, and putting a plastic clay cutter against his throat, to simulate his self-destruction.

The week following the first killing of babies, Eric came to session and immediately asked me to make two clay babies, a 'real' one and a 'toy' substitute. Without the slightest hesitation, he smashed the 'toy' baby and then asked for the 'real' one. He started throwing clay 'bullets' at it, calling it 'dirty' and 'disgusting'. I made another 'toy' baby and created a clay shield for the 'real' baby. Eric demanded that the 'toy' baby also have a protective shield. When he threw bullets at the shield of the 'real' baby, he devised a game in which there were good and bad bullets. I had to peel the 'bad' bullets off the shield because they were 'hot', but the 'good' bullets I had to press into the shield to give it more powers of protection. Eventually both babies got smashed along with their protective shields. He stabbed the misshapen lump of clay in which the dead babies were buried, saying: 'No one come near me!'

As a result of these interactions, Eric later was able to talk to his mother about his fear that he would have to die if another baby was born. Because his mother was having difficulty conceiving, Eric may have felt that he could magically help his mother give birth by doing away with himself. Yet Eric's fantasy play with clay also involved repetitive violent killings of babies, and probably reflected a deeper wish to destroy the baby in favor

of self-preservation. It was likely that Eric felt deep feelings of rejection, resentment, and anger toward his mother for the disruption in his life that the prospect of a new baby held, especially one that was getting so much attention devoted to it in the struggle for conception. He may have felt responsible, at least unconsciously, for the failure of his mother to conceive due to the perceived power of his own destructive aggression.

Eric's interest in my emotional reaction to the violence in the baby-killing drama indicated his own search for limits to what could reasonably be tolerated, especially since I had not intervened to directly censor his aggression. His anxiety about others' retaliation against his aggressive urges was probably matched by anxieties about his ability to control his aggression. When I expressed sadness about the babies' lack of safety he began to come up with defensive strategies, such as devising substitute 'toy babies', or inventing justifications that the violence would ultimately be turned upon himself. Aside from protecting the babies, these tactics seemed to be aimed at reducing feelings of guilt that he may have felt, so that he could continue the pleasure and excitement of destroying them.

Significantly, the final act of violence in which everything and every-one that the clay represented was stabbed, smashed, and annihilated was beginning to be slightly delayed. Originally, Eric had directly stabbed the 'babies' with his bare hands or a clay tool. With the introduction of substitute babies came more elaborate fantasies: for example, the existence of an observing 'real' baby whose destruction was delayed in the process of watching the other baby die. Fantasies led to conversation about the emotions of the baby as it watched the killing, and these considerations further prolonged its demise. When shields were introduced, more dis-tance, delay, and fantasizing occurred. Bullets and bombs replaced hands and tools as weapons of destruction, so that instantaneous murder meta-morphosed into a prolonged war. Moral issues arose, such as giving both sides equal levels of protection, and the idea that aggression (or bullets) might be classified as either good or bad. Eric's willingness to incorporate 'good bullets' into the protective shields indicated a change in the ability of his ego to absorb a degree of anxiety. Ultimately, of course, the good elements were overpowered by the bad and everything was destroyed, both in clay and wood. Eric continued to solve the problem of his uncontrollable aggression through a fantasy of complete self-annihilation

('No one come near me!'), even though his ego strengths were slowly improving.

The latter point became more apparent the following week, when Eric chose to paint wood. The session was remarkable in his efforts to learn self-control, as he asked me how I managed to paint without smearing my hands. When I replied that I painted slowly, Eric asked me to demonstrate how he painted, so that he could observe the difference. His mood was light and pleasant, but he chose to end the session ten minutes early, recognizing the limit to his concentration in the effort to maintain self-control.

At the next session, Eric returned to the clay drama, with a new theme. This time there was only one baby and a protective wall, which he appropriated for his area of the table. Eric altered the script so that I was no longer the one protecting the baby, because he had taken over that function. I was required to throw clay bullets at the baby, but with the rule that I could only hit the wall, not the baby. Eric became feverishly involved in building a higher and stronger wall around the baby, using pieces of wood and other loose objects in the room. Some of the bullets that I hurled he labeled good and some bad. The good ones got absorbed into the wall to provide more protection and the bad ones he collected into bombs to throw back at me. At the end of the session, Eric smashed the baby into the rest of the clay, saying: 'Someone ate him'.

A couple of weeks elapsed before Eric returned to art therapy. Part of this delay was because of a school holiday, and part of it was due to my having been sick one week. Eric was agitated when he returned. He threatened to run out of the room, and began throwing things in my direction. When I set limits, he calmed down and remarked: 'I'm not myself today'. He wanted to play 'the war' again, with each of us having a baby and a wall. Left with no extra clay for bullets, Eric decided that my wall had bombs in it, and had to blow up in order to give him ammunition. I allowed the wall to blow up, leaving my baby exposed to attack. Eric could not tolerate the vulnerability of my baby, snatched it up and placed it behind his wall. I was again assigned the role of aggressor, having to attack his wall. I warned him that I might attack from the sides or from behind, so he had better build more walls. Eric screamed that this was unfair and against the rules. I pursued the question of why he didn't want more

protective walls, and Eric complained that the babies would then be trapped inside without food, and they would die of starvation.

I was getting weary of the war, the dead babies, and the role of aggressor. I had been slowly introducing the possibility of protecting and possibly saving at least one baby, so it seemed to be a breakthrough when Eric reversed the roles and began to assume a caretaking, self-protective role. Along with widening the repertoire of possible symbolic roles, it seemed that he was finally beginning to internalize some of the 'good' parent introjects, while I continued in the role of the aggressor. He seemed to be developing a degree of affection for the babies as self-object symbols. Eric's concern for the babies' starvation revealed underlying survival concerns related to nurturing needs. I quickly began to make food for the babies. Eric accepted the food, but clamored to get back to the war. I stalled him further, forming beds for the babies. Eric relented, agreeing that the babies should take a nap before continuing the war. I engaged him in questioning what else the babies needed, and subsequently ended up creating cups and dishes for the food, a television set, newspapers, and a sink to wash the dirty dishes. At some point, Eric's imagination was engaged, and he forgot the war long enough to ask me what else the babies needed. There was a collection of objects scattered about on the clay board at this point, so to solidify the metaphor of integration, I suggested that they needed a floor. Eric agreed to allow the protective wall left over from the war to be reconstructed into a floor. He placed the objects on the floor, allowing his imagination to envision a room. He made plans to add walls and more rooms to the space that was becoming a house. He asked me to cover it with a piece of paper until the following week so that it would be safe, 'because it's not finished'. His agitation from the beginning of the session had disappeared.

The following week, Eric for the first time walked beside me to the session instead of running ahead through the hallway. He played his ritual game of hiding under the table until I 'found' him, and then announced that he wanted to play with clay, specifically two babies and two walls. Excitedly, he added that he wanted to destroy the house that he had saved from last time. He was adamant that he was no longer interested in creating walls or more rooms. I gave the measured response that he could do one thing at a time, and so he took a piece of clay and made a thick, sturdy wall. He instructed me to do the same, and in the ensuing war, decided that the

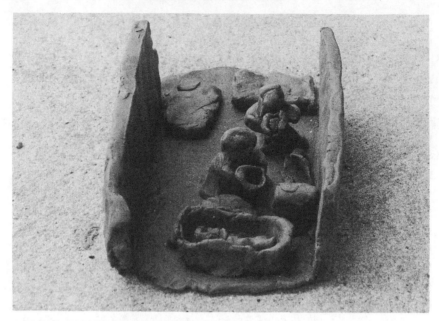

Figure 5.3 Eric's 'floor with walls' sculpture

bullets were all tiny ones and had to be blended into the wall to make it thicker. After some time of engagement in this play, I casually took down my wall, rolled it evenly and cut straight sides. Eric watched with interest, and copied what I was doing with his own wall. I traced straight cutting lines on the edges of his slab for him to follow, which he was able to do. I stood the new wall upright and glued it to the edge of the floor of the house, while Eric watched the process. I assisted him in gluing his wall to the other side of the house (Figure 5.3). This was a technically difficult process, but Eric was sensitive about my involvement. 'I was supposed to do that,' he complained. Once again he became interested in the house, stating his intention to add more walls and a bathroom. As he had done the previous week, Eric ended the session calmly.

This session represented a peak in Eric's growing sense of confidence and independence. He showed that he was able to build his own wall for protection, and to accept all of the 'bullets' sent his way as experiences that could add to his growing strength. The bullets themselves, as representatives of outside dangers and fears, had diminished into tiny pellets of a more realistic and manageable size. His resistance to my help in attaching

the new wall to the house was a healthy sign of a growing awareness of his individuality, possibly encouraged by increasing feelings of inner strength and calmness. He was eager to take over the building construction on his own – a metaphor for the building up of his ego-strengths.

Following this session, Eric's progress toward greater freedom and independence appeared to deteriorate. He was faced with the departure of his primary therapist, to whom he had grown quite attached. The end of the school year was fast approaching, a time when the school environment generally reached a more chaotic level of anxiety. Eric followed patterns around him, reverting to the less controlled behaviors of the beginning of the year. In the art therapy sessions, he required strict setting of limits, as his aggressive and destructive behaviors renewed strength. However, he steadfastly continued to focus upon the project of painting wood, something that he had not been able to do at the beginning of the year.

Eric did not continue building his house. He was intent on destroying it and resented my efforts to protect it. I removed it from his reach, hoping that he would redirect his aggression to other activities as he had done before, in order to rethink the destructive urge from a distance of time and a calmer mind state. He subsequently worked only on painting wood. Although the house was technically mostly constructed by me, Eric had contributed to its making by the engagement of his imagination in directing the process to some degree, and his eventual appropriation of it as his own self-representation. It represented the highest level of symbolization he had achieved and, given his level of technical skills, ego strengths, and maturity, I felt that the destruction of it would have too closely approximated an undoing of our work together. I hoped that he would eventually begin the process of rebuilding the house according to his own level of ability, with less input and assistance from me. However, this still seemed a great leap for such a fragile child.

Conclusion

This case, despite its relative lack of completion, illustrates how ritualistic sacrificial processes at one end of a scale may be distant from, but connected to, symbolization at the other end of the same scale. Eric's ritual behaviors and repetitive games helped to ease his anxieties and fears. For example, the hide and seek game at the beginning of the session probably helped him to adjust to the change from the classroom to the art studio,

where unpredictable things were bound to occur. By taking control and establishing the rules of the game, Eric initially set himself up as the boss, however illusory his actual powers proved to be. In fact, his need for power was reflected in the rigidity and irrationality of his own exaggerated fears and superstitions, such as the fear that mentioning the word 'nightmare' would cause one to occur. Therefore, he was engaged in an unending cycle of reactions: rigid fear and feelings of powerlessness led to rigidity of behavior, which in turn created powerlessness and diminished choices of action. In his imagination, fear turned all things to deadly violence; and aggressive action became the primary means of soothing anxiety, through expelling or killing the 'bad'. It was as though a sensitive antenna constantly searched the environment for danger, and any stimulus such as unexpected change could trip the fear alarm. This automatically touched off a stereotypical image of violence that in turn set off a stereotypical response of aggression. It may also have been possible for this circuit to short, defensively cutting out the violent image completely and moving directly to the aggressive response. This would explain why initially Eric's art process avoided any engagement with the imagination, opting for direct discharge of aggression. Gradually, the fears and monsters in the imagination began to be named and killed one after another. It took interventions, such as questions or reflective comments aimed at naming an action, to begin to expand the space between stimulus and response with the insertion of thinking and image-forming activities. It also took the introduction of art materials and structured aids such as stencils to expand the variety of visual and concrete possibilities within a limited imaginal space.

It was likely that the wood-painting process, though more abstractly expressive than the ritualized clay process, also provided a key element of change. Eric showed genuine excitement at the discovery of the new and different colors that he created. He was able to stop briefly to appreciate the beauty of new colors, and did not destroy them with regressive over-mixing. It was here that Eric found a connection with something that he loved, with something that engaged his erotic sensuality and provided the beginnings of a sublimation of those feelings. This process had the possibility of providing an alternative to violent means of coping with anxiety, even for very brief periods of time. Less abstract than paint on paper, the wood was a found object concretely existing in the external

world, upon which Eric was able to exert the power of his erotic creative markings. The wood also may have represented to him something masculine, connected to the male-dominated construction trade, appealing to his need for phallic power. Although he had visions of constructing a car or a rocket from the wood pieces, both images of phallic strength, he did not achieve that level of creation. Instead, he continued to be convinced that his sculptures were monsters to be toppled. Yet the ability to take in something 'good' may have started partly through his erotic connection and appreciation for color.

The unfolding drama of the clay process did reflect his gradually increasing ability to accept 'good' things. This played out with his appropriation of the caretaking role, in building protective walls that were able to absorb good bullets and thereby increase in strength. This was a potent metaphor for the building of protective boundaries separating him from others, which eventually led to a more realistic appraisal of external dangers. Bullets became tiny, manageable bits of power that could safely be incorporated into his protective structure. The strengthening of boundaries along with increasing internal strength led to greater feelings of autonomy, or at least the desire for such, evidenced by Eric's growing resistance at this time to my 'helpful' interventions. At one point during our negotiations over destroying or saving the house, Eric seized the house out of the space between us and slid it over to his other side, beyond my reach. He stated emphatically that it was his. In a metaphorical sense, he was perhaps claiming and incorporating my ego strengths into his own, and establishing distance between us. While this implied willingness to take in a positive parental-type introject, his apparent ambivalence toward the house indicated that his internal conflicts between good and bad were still not fully integrated, thus indicating a yet shaky ego structure.

Another significant marker of Eric's growing ability to take in good aspects of parental objects was the dramatic appearance of nurturing images in the protected area behind the wall of defense and the subsequent delaying of the war. Eric's tenacious resistance to surrounding the babies with defensive walls may have represented the life instinct that recognized its need to remain open and vulnerable in order to receive the nurturing necessary for survival. The defensive wall, then, and the entire war was a smokescreen. Eric really did not want the babies to die, and the killings were only pretend – a ritual to prevent the horror of a worse fate, that of

psychic death or abandonment by loss of nurturing and affection. The ritual killing of babies in the pretend war probably served dual symbolic functions: that of doing away with the potential new rival for affection in Eric's life should his mother become pregnant, and that of the defensive negation and punishment of this illicit wish through ritual self-annihilations. The power of the symbol to evoke contrasting meanings reflects back upon the core meaning and power of sacrifice. This was explained in chapter 1 as the creation of order through the separation of good and bad forms of violence, and the transformation through violence of bad into good, and human into divine. The image of the two-faced or Janus-faced god forms a metaphorical link between sacrifice and symbolism.

Eric was stuck in repetitive rituals of aggression aimed at keeping good and bad separate. When he began to find ways to incorporate bad and good together, such as bullets in walls that protected against bullets, the need for violent reactions decreased. The formation of such symbols of integration was a more efficient means of binding anxiety, freed energy, and space for the creation of soothing and nurturing images such as food, shelter, and beds. Conversely, the creation of such images helped to put space between the anxiety stimulus and response, represented in this case by the delaying of the war. In masochistic form, Eric was prone to the redirection of aggression upon himself to protect parental ideals from loss of purity, while sadistically enjoying the act of killing. In other words, Eric's theme of sadistic aggression, killing, and sacrifice was shown to have a reverse goal of maintaining survival. But this did not become clear until the development of more efficient and diversified symbols opened the way for a more specific communication of his needs and fears. Thus, Eric's case illustrates the premise that the sacrifice inherent in the act of self-mutilation can represent a rudimentary kind of symbolization that leaves little space for the ego to exercise its freedom of choice and control over the actions of the body. With therapeutic interventions to strengthen the ego so that erotic and aggressive urges could find expression in manageable forms, the space for reflection, understanding, and expression became slightly more expansive. The use of art therapy to increase symbolic capacities helped in this case to move the client further along the imaginary scale, beyond sacrifice to more abstract and efficient uses of symbols to effect separation and connection through communication.

Art Therapy Processes
with Self-mutilating Clients

The need for treatment modalities that complement, or provide an alternative to, traditional verbal psychotherapy methods has been mentioned with regularity in the literature on self-mutilating clients. Simpson (1980) finds verbal psychotherapy to be of limited help with these patients when self-mutilation, so often rooted in preverbal stages of childhood, is generally accompanied by difficulties with verbalizing feelings. Van der Kolk advocates the use of expressive arts modalities for clients that have lost verbal and symbolic capacities due to traumatization: 'Prone to action, and deficient in words, these patients can often express their internal states more articulately in physical movements or in pictures than in words. Utilizing drawings and psychodrama may help them develop a language that is essential for effective communication and for the symbolic transformation than can occur in psychotherapy.' (van der Kolk, 1996, p.195.) Because self-mutilation involves 'body alienation', or cognitive and emotional distortions related to the body, Cash and Pruzinsky (1990) suggest the use of treatments that work with the body.

The last three chapters presented cases in which specific art therapy processes and interventions with self-mutilating or self-destructive clients were described in some detail. In this chapter, I would like to review some of the general aspects of the art process that I believe make art therapy a potentially useful treatment for clients that are prone to attacking and hurting their own bodies. The discussion will focus upon seven different themes of significance for self-mutilating clients: self-stimulation; containment and protection; self-object and transitional object; destructive and

creative process; symbolic expression; power, self-control and self-esteem; and transference and countertransference problems.

Self-stimulation

Many clients are intrigued by the tactile sensations of art media against their skin. There is often a regressive urge to put one or both hands into the paint or to paint on the skin. While this can lead to excessive loss of control in highly impulsive clients, many art materials seem inherently appropriate for tactile soothing and stimulation. Chalk pastels and clay are both typically worked with the hands and, as in the cases of Mary and Kate, are often chosen by clients with boundary disturbance issues. Another such client commented as she smeared pastel colors with her hand: 'I just love pastels, because there are no boundaries!' The blurring and blending of colors, accomplished with soft caresses of the hand, can perhaps provide a pleasant experience of merging and touching, where the lack of adequate holding in infancy may have led to boundary disturbances. When the client learns how to control and manage the material, she also becomes in charge of her own degree of tactile stimulation. For example, clay can be worked to various consistencies of hardness and wetness, according to the purpose for which it is used. Water applied to the surface of the clay with the fingers can often be a stimulating and pleasurable experience. Kate expressed particular interest in the wedging of the clay. The wedging, or kneading, of clay in preparation for work can be an important step in the process, providing soothing and holding. In its likeness to the kneading of bread dough it evokes a maternal activity; in fact, in the lore of mothers, bread dough is said to be ready when its surface is smooth like the skin of a baby. Similarly, when the clay is sufficiently wedged the surface is no longer sticky, but silky and smooth. The weight and lumpy shape of the clay mass, similar to bread dough, may resemble the relative weight and size of a small infant. By unconsciously stepping into the mothering role of caressing and holding through the symbolic activity of wedging the clay, the client may be from the beginning of the clay process creating a model for self-care.

The erotic and stimulating aspects of the feel of the materials may be useful to clients, as in Mary's case when the stroking of her clay figure seemed to gratify masturbatory urges. According to one of the theories on self-mutilation, repression of sexual urges may lead to their displacement

in the laceration of the skin in other areas of the body. The enactment of such wishes upon the surface of the artwork, performed symbolically and veiled from conscious view, may help to preclude the need for morbid forms of erotic stimulation upon the body. For example, the cutting open and manipulation of wounds on the skin surface, when symbolic of female genital stimulation (Siomopoulos 1974), may be unconsciously simulated on the surface of clay as was suggested by Mary's alternately incising and smoothing over of the abdomen of her clay figure. Clay, aside from the fact that it does not bleed when cut, is imminently suitable for a vast array of manipulations, similar to those that may be performed upon skin. That the association of flesh may be not far from consciousness is suggested by the frequency in my observation with which emotionally disturbed children are prone to smearing wet clay slip or red paint, simulating blood, over their clay pieces. This brings to mind the common practice of smearing ritual objects with red ocher paint to symbolize blood or life force, in connection with burial rites and sacrificial celebrations in various cultures.

Clay and pastels are readily accessible and easily controlled, but other media such as wet plaster, sand, finger paint, and textured collage materials may also promote tactile stimulation and soothing. It must be kept in mind that these are only generalizations, for what is soothing to one person may feel harsh, disgusting, or threatening to another. Sometimes it takes time and small increments of exposure for a client to develop an affinity with a particular art material. The art therapist remains alert to the reactions of patients and intervenes when necessary to provide support, limits, or alternative choices concerning the use of art materials. Naturally, the therapist working in this modality must be comfortable with the art processes and materials herself in order to intervene effectively. As well, she must be prepared to provide appropriate responses to the psychic material that may arise in reference to erotic stimulation or other experiences of tactile sensitivity.

Containment and protection

Whether flat or three-dimensional, art is made up of surfaces that can be touched, seen, or perceived. These surfaces describe an object in terms of its characteristic shape, volume, and structure. The surface of a drawing or

painting, although tangible and impenetrable, may double as a window into illusory three-dimensional space where demarcations and boundaries define figure and ground relationships. Without the boundaries of line, surface, or subtler types of delineation, there would be no picture, no symbol, no art, and no meaning. The most abstract forms of art imply the construction of some type of framework for conceiving ideas or visions of art in relation to everything else, even if that framework concerns the deconstruction of its former meaning. So the surfaces and outlines of art objects, whether concrete or imaginary represent boundaries between objects and the surrounding environment. The boundary marks the point at which an object is both separate and connected. Its contour provides containment and a unifying structure, while also defining its way of touching and relating to the objects around it. The structuring of all perceptual stimuli into organized patterns of shapes and forms is what helps us to make sense out of our experience, whether it relates to inner stimuli or stimuli crossing the sense barrier from outside to inside our bodies. In this sense, the art object in space is parallel to our own bodies in space, our skin surface forming a defining border between ourselves and the outside world. A clear and undistorted sense of this border, where 'I' interfaces with what is 'not I', can be one aspect of a sense of being that is both unique and of the world. In other words, a clear sense of self is in part defined by an undistorted awareness of one's boundaries.

The skin boundary of the body provides containment, protection, and definition of the self. Likewise, artworks can provide containment, protection, and definition. Kate's fruit bowl, a concrete vessel, provided containment for the potentially disorganizing effect that the erotic associations to its contents aroused in her. The careful attention given to the duplication of realistic boundaries and forms of each of the fruits also helped to protect Kate from the distortions caused by intrusions of unconscious associations. The protective wall that Eric built helped to separate his babies, representative of a vulnerable fledgling self, from the overwhelming stimuli that were a part of Eric's actual experience of the external world. The transformation of the protective barrier into a floor and walls of a house carried the metaphor of containment to a deeper level of holding, in a maternal nurturing sense. A similar feeding and holding metaphor was more overtly expressed in Kate's fruit bowl. Mary's process of reworking the same themes in her artwork gradually led from chaotic

and merged expressions to more clearly delineated and organized depict-
ions of her inner state. Vague, incompletely formed feelings found
definition within the outlines of ghost representations. From there, Mary's
child self was able to separate itself from a ghost image and begin to find
its own voice and identity with more clear definition. Mary's frequent
reworking of the surfaces and boundaries of forms reflected her relation-
ship toward the surface of her own body, whether this was a tendency to
spill beyond the edges or to cut back into the interior. The process of
creating a cohesive unit of self was an ongoing one of adjustments,
realized symbolically on the malleable surface of the artwork.

Mary's process of layering deserves special mention as an example of
the metaphorical use of art technique in establishing protective bound-
aries. Layering is used extensively in various art media, to add thickness,
structure, strength, and opacity, and, in watercolor, to create an illusion of
depth through transparency. Layering adds texture, subtlety and com-
plexity to color, as in the case of certain pastel techniques. In Mary's case,
the layering techniques gave extra padding and bulk to her clay forms, a
palpable reference to her vulnerability and corresponding need for
protection. As has been frequently mentioned, the formation of layers of
tough scar tissue on the body over self-inflicted wounds may be associated
with feelings of vulnerability due to impermeable or diffuse boundaries.
Therefore, the layering techniques that Mary spontaneously used on her
artworks probably unconsciously provided some of the soothing and
protection that she needed.

Self-object and transitional object

An art process or object may promote a healing reaction by containing and
reflecting conscious or unconscious projections of the artist. Both as a
container, and as a self-contained object separate from the creator, the
artwork can help the artist to externalize thoughts and feelings in a
controlled manner, thus increasing feelings of power and self-awareness.
As a container for projections of the self, the art object is a separate
self-object with which the artist may form a relationship. The healing
power of the artwork comes through the transformational power of the
creative process in this relationship. Because the artist is creating his own
self-object, he may alter and form it at will, and eventually create a

transformed image representative of himself. This process roughly follows the concept of image magic, in which operations performed upon an image will simultaneously affect the original. However, in the art process, the power of transformation remains in the hands of the creator. Mary's clay figure, a fairly literal self-representation, underwent numerous transformations similar to, but different from, those acted out upon her own body. It eventually emerged as a more aggressive self-image. The malleability and impressionability of the clay, enough like but enough different from her skin, made it possible for the transference of self-relating to an object outside her body. Rather than sacrificing parts of her body, Mary began to use the clay self-object at first ritualistically and sacrificially, and later on symbolically as part of a sculptural tableau that helped to organize inner and outer experiences.

Whether it is slammed down hard on a board, punched, gouged, or sliced up into little pieces, clay yields cooperatively to aggressive handling. It does not scold, punish, or strike back, even though it may be perceived to have feelings toward the handler, as on the occasion that Eric stated: 'The clay hates Eric'. It continues to be soft and, for most people, pleasurable to the touch when stored properly in sealed containers, and therefore maintains a consistent relationship to the artist. At the same time, the clay and other art materials may not always perform as the artist wishes, so an element of frustration can enter into the relationship as well. Struggles for mastery of the material can parallel the struggles in any other type of relationship where there is difficulty at times in making oneself understood. Unlike transitory forms of expression using the voice or the body such as singing or dancing, the art process can result in permanent objects. Because of these properties, the process of making artworks is ideally suited to the formation of transitional objects, to aid in the ongoing movement toward separation and not only individuation but also connection that is an important aspect of the dynamics of self-mutilation. For example, this may occur through the process of the therapist assisting the client to create her visions, as in the case of Kate and the banana. She said that her banana was 'not as good as' mine, but the one that we created together and that ultimately became hers brought contentment because it helped to support her autonomy without letting her fall into the abyss of complete isolation. Incorporating something of both of us in an external object helped to bridge the gap that widened between us as Kate became

more aware of herself as an individual. It helped her to begin to form positive relationships with other objects in the external world.

The creative process of combining imagination with art materials is a crucible for the meeting of inner and external worlds. This is similar to the election of a transitional object that is experienced as both *of* the world and *created by* the child. But it is different in that it usually requires more effort and imagination on the part of the artist to transform raw material into meaningful form. The transformation is a more dramatic one. That is why the studio and the art process can be likened to a crucible, or a place of transformation of matter into other more refined substances. In this sense, it is like a sacrifice that transforms bad into good or impure into pure. It is also similar to the boundary zone where the negotiations and trans-formations of self-mutilation take place. Yet the creative process moves beyond a ritual to open the way into more possibilities and flexibility of expression. The limitless varieties of forms that may be created, taken apart, and recreated suggest to the artist, and to the ego of the client, that the self is not as fixed and limited as one might have thought. Creative development strengthens the ego and brings hope into the struggle of coping with the self, and with the self in relation to the external world.

Destructive and creative process

We tend to speak of the creative process as a constructive activity that exists happily on its own, much as we might envision the universe as expanding and developing in ever more increasing complexity. Yet creation does not exist in a vacuum and, like nature, derives its building blocks from the decomposition of previous creation. In nature, a vast invisible network of bacteria, nematodes, and other parasitic life forms, in nonstop gnawing activity, busily takes apart that which has passed the apex of its creative growth. The pieces fall away and disappear into a chaotic mixture from which new living forms will be organized. Thus, destruction precedes and follows creation, and the complementary cycles of destruction and creation can in a general way be related to the death and life instincts making up the dual drive theory. In this scheme, sadistic aggression has its place in the destructive cycle. The creative process in the art studio demonstrates that the 'dark' emotions connected to aggression and sadism

can come out of hiding and shame into dignity in the service of whatever creative outcomes may follow.

The destructive process of self-mutilation may also be seen as a part of the hidden or negative side of the creative process. In this sense, it has been viewed not simply as morbid and destructive, but as an attempt at healing, aimed at the goal of transforming the self. However, self-mutilation may become fixed in morbidity, inhibiting the creative cycle from taking over. When aggression is redirected upon the self, it often represents an inhibition of the aggressive drive from its actual target, as we have seen. This backward looping of energy tends to get stuck in repetitive cycles of ritualistic negative or destructive behaviors designed to prevent the greater destruction that might occur were the urge allowed to act upon its true aim. Therefore, it may be seen that the inhibition of aggression can paradoxically result in controlled ritualistic aggression and the inhibition of expression. The redirection of aggression back upon the self merely substitutes the self as the intended victim in a type of sacrificial ritual. This corresponds to the 'lateral displacement' of destructive energy, as opposed to 'upward deflections' referred to by Menninger (1938) (see chapter 2) that may occur when such energy is redirected into constructive activities. In other words, creativity comes about, at least in part, through the sublimation of aggression; and sublimation is a transformational process.

In the art therapy studio, I have observed what might be called 'lateral displacements' of aggression. For example, when a child furiously bangs on a piece of clay while calling it a monster, the activity probably represents such a displacement of aggression. If no constructive or symbolic activity follows, there is no transformation of the energy. Eric's repetitive war games invariably ended with total destruction and annihilation of any symbolic objects that appeared in the process. Intensive intervention was necessary in his case to introduce constructive processes into the game. Eric reached the point where he was able to sustain a constructive activity for a period of time, until he reverted to the destructive cycle, demolishing what he had created. Other children are able to save a created object by redirecting some of the overflow of aggression to other objects. One angry child was able to create meticulous sculptures, pieced together from separate parts like an intricate puzzle. If these were not perfect, he patiently took them apart and reformed them. Some of his rage was probably channeled into the fervor of his perfect-

ionism, and contained by the obsessive ritual of this activity. However, anger occasionally spilled over at the end of the session. On one occasion, it impelled the boy to slice up his creation into tiny pieces. He regretted having done this, and afterward reserved the end of future sessions for pounding on clay on a separate board to the side of his creative work. He began to label this activity, and the clay, as 'anger', pounding the clay as hard as was safely possible. Then he put his 'anger' back into the clay bin until the next session, when he could 'take it out' again. A perceptive child, he soon hit upon the profound idea that he could turn the product of his rage into a sculpture called 'anger' and display it as a work of art. He asked me to save the pounded piece of clay to dry, rather than putting it back into the clay bin. This recognition signaled the beginning of a conscious transition on his part of 'lateral displacements' into constructive symbolic expression. Although most children do this spontaneously to a degree, this particular boy had begun to do so with an unusually sophisticated level of conscious awareness of his expanding powers of expression and self-control.

Of course, the art therapist does not sponsor the free expression of rage and destruction when safety may be compromised. Art therapy does, however, recognize the place of destructive activity within the creative process. Interventions related to the channeling and eventual trans-formation of destructive energies are determined by the need of the client, and by the level of coping strengths that are brought to the session.

Symbolic expression

It is often a therapeutic goal with nonverbal clients to get them to talk. Self-mutilating clients especially may resist talking because of difficulties with verbalization, as has been mentioned frequently in this book. Fear of self-disclosure may be a factor in the resistance to talking, particularly in clients with traumatic histories, as is so often the case with self-harming patients. The introduction of art into the therapy with such clients offers a metaphorical alternative to spoken language, one that requires active involvement with the body. For this reason alone, it may appeal to clients that tend to use the body to act out what cannot be put into words. The making of art, while an active process, also distances expression from the body, so that the act that formerly was attached to the body gets

transferred to an object. Expression then becomes embodied in a separate object that stands alone as a permanent reflection of what has been 'said'. Sometimes this reflective distance is enough to spur the client to begin talking about what she has made, or what she sees in her creation. For others, the 'crossover' from nonverbal to verbal expression may be long delayed, or may never occur. It may not need to occur because of the fact that art *is* a viable form of expression distinct from verbal language. For this reason, I do not believe that the art therapist's goal should necessarily be to get the client to talk.

In the case of traumatized clients, revisiting traumatic memories in verbal psychotherapy may be counterproductive, at least in the initial stages of treatment. Van der Kolk (1997) advocates the use of nonverbal treatments aimed at enhancing feelings of bodily safety and establishing more effective controls over boundaries. As has been shown in the stories of Mary, Kate, and Eric, art processes can address these issues. Artwork may be used to help with the retrieval of 'lost' memories, and the reordering of memories into coherent order. Mary's work resembled this process as she re-enacted a similar scene in various artworks, making subtle changes and clarifications from one to the next. The client may be able to engage in this process through visual metaphor without verbal disclosure to the therapist. The power of the artwork to express what cannot be stated in words rests upon the nature of symbolism to convey conflicting feelings and illogical juxtapositions with simplicity, grace, and sometimes humor. The evocative strength of an artwork lies in its ability to move both the creator and the viewer at levels of experience and comprehension that may defy words. The potential for the artwork at this level to promote transformation in terms of restructuring and restoration of internal order is at least equal to that of verbal processing.

As a language that converts action into symbol, art can address the self-mutilating client's need to create an impact on the outside world. By expanding the possibilities for self-expression, while incorporating the self-mutilating and masochistic person's affinity for drama and symbolic action, making art can lead to increased feelings of power. The artist can become a director, as well as a participant or a victim in the drama. The difference is that with the empowerment of symbolic capabilities there is more freedom of choice about how one interacts with others.

Power, self-control, and self-esteem

An aspect of the process of making art is the gradual mastery of the art materials and the development of various technical skills. Considerable time and effort may go into the realization of a mental projection in plastic form. Self-mutilating clients tend to be impulsive and may be impatient or hard on themselves, giving up easily. Sometimes, sabotaging the process or giving up on the artwork are ways of expressing feelings of victimization and helplessness. However, with adequate support, clients can often develop greater self-control, coordination, concentration, and patience as a result of learning and practicing a creative discipline.

Feelings of powerlessness often play into the urge to hurt oneself, as it becomes a demonstration of taking control over the territory of one's own body. In the art therapy studio, the patient is presented with a new terrain of possibilities in the aspect of raw surfaces to be marked, shaped, altered, manipulated, or otherwise taken possession of. In the process of mastering a variety of techniques, the raw materials become both servant and companion to the artist. Mastery of the raw materials of art, like control over the body surface, represents a degree and sphere of influence and power within the concrete external world. At the same time, the art process has the potential to bring into existence solid forms and symbols only previously existing in the imagination or the unconscious. This is a powerful and empowering activity in which to engage oneself.

The union of concrete and symbolic processes in the creation of artwork can support self-esteem and the development of self-control. This is illustrated in the following story.

Aaron was a ten-year-old boy with a history of severe trauma, having been abandoned by his mother and then having experienced the violent death of another caregiver. Aaron bounced from one foster home to another, distrusting attachments and testing his caregivers with self-destructive and suicidal gestures such as running away, climbing on roofs or in high windows and threatening to jump, or hoarding sharp objects and barricading himself in inaccessible spaces. During the first several months of art therapy, Aaron created many symbols of aggressive power, particularly clay dinosaurs with threatening or bloody mouths. This type of artwork is especially common among traumatized children, and is often interpreted as a manifestation of an 'identification with the aggressor' mechanism of defense. Aaron's identification with aggressive dinosaurs

helped to protect him in fantasy from feelings and experiences of victimization. In this sense, it was empowering and might, with therapeutic support, get him to a position where he could feel confident enough to begin to develop other areas of control and ego strength.

Toward the end of his first school year in art therapy, Aaron built a house for himself from a large cardboard box just big enough for him to sit inside. He covered the entire outside surface with red paint, watching drops of it slither and drip through cracks, comparing it to blood. While the exterior surface of this structure, or its 'skin', advertised Aaron's preoccupation with morbidity and trauma, for him the inside was a place of safety. He developed a ritual of ending sessions by getting inside the house, to be by himself for a few minutes. The house, then, symbolically functioned as the home that he needed, but also as a protective outer layer of skin. The fact that it was covered in blood is reminiscent of certain self-cutting adolescent girls that found soothing and comfort in the blood flowing from their skin wounds. For Aaron, the creation of his own house and protective covering gave him a source of symbolic comfort and control over his environment that both contained him and accepted his murderous, bloody feelings left over from violent life experiences. He was extremely proud of his accomplishment, which dwarfed in size the creations of other children; this added to his sense of power.

The following school year, Aaron's focus on self-empowerment in art therapy attained a higher level of sophistication and consciousness, both technically and symbolically. He worked for many months on an elaborate clay sculpture that he referred to as 'Water World'. It consisted of a system of pipes, sluices, pools, and dams to direct and control the flow of water. A small volcano could be made to erupt with water in the center of one of the pools, or the water could be sent in a different direction if he wished. Aaron acknowledged aloud that he enjoyed being the engineer of this project, in charge and in control in this limited arena in his life, which in so many ways was tragically beyond his control. In discovering that he could create a miniature world according to his own rules and specifications, he was beginning also to accept the fact that much of what had happened to him was out of his control and therefore not his fault. The flow of water through the system was an unconscious but apt metaphor for the rushing of emotions through his body. The mental and creative effort that it took to master the flow of water through the 'Water World' system was similar

to the struggle that it took to gain control of the emotional flow and impulsive reactions occurring within his body. The ego strengths that were developed through external mastery of a technical and symbolic process – focus, planning, patience, and imagination – could conceivably be applied internally as well toward the expansion of personal choice and power.

Transference and countertransference problems

For people that are victims, or that identify with victimization, as do many traumatized and self-mutilating patients, issues of power and control pose special difficulties within the therapeutic relationship. As I described in the cases of Mary and Kate, part of my experience in the role of therapist was to be cast at different times as either victim or persecutor. While this helped me to develop empathy for the feelings of helplessness felt by both, it was the introduction of the art materials and processes into the relationship that brought about more flexibility in our roles. The drama of victim and aggressor gradually shifted to the art media and images, at times freeing up both therapist and client to watch the process from a slight distance. It was as though we were able to move from the highly involved and enmeshed roles of actors to the more objective roles of director and audience member. Without taking power and control away from the client in her role as creator, I was able to become her helper and ally, rather than her adversary, by providing technical assistance and support in a subtle and nonintrusive way. I was also able to join her as a quiet witness of her process, not as a critical force or an impediment to her self-expression. If communication was stalled or inactive between us, the artwork became the center of our interaction, and our outward reason for being in relationship with one another. Ultimately, the artwork put the client into a relationship of increased distance and objectivity with herself, which was one of the important goals of therapy. Kate, for example, was only able to come to the realization that someone cared about her after she had developed a lasting and caring affect for her fruit bowl sculpture. Just as it was initially my failure, in her perception, to provide the necessary supplies for her work, it was later my assistance and good-enough providing that convinced her of my caring for her. The satisfying

connection to her completed artwork, the product of our interaction, brought about this transformation of perception.

An aspect of the self-mutilating or masochistic client's difficulty in therapy is the inherent resistance to getting better. For such clients, failure may bring a sense of relief and satisfaction derived from the cleansing and purifying power of self-sacrifice. The idea of conscious selfishness, or positive narcissistic self-love, is an abhorrent thought to the sacrificial victim, as well as to the values of the society at large. However, a consciously, rather than unconsciously, driven selfishness may be exactly what the self-sacrificing person needs. One of the few roles in society in which self-adulation is openly tolerated is in the persona of the artist. The artist's activity revolves around the self-absorbed creation of self-reflect-ions, in an open and even celebratory attitude. At the same time, the artist's devotion to art has an ascetic flavor to it, a quality of self-sacrifice in terms of dedication and commitment to a discipline and a calling. The creating of art is a process of transforming matter through the interplay of destructive and creative forces, thereby resembling a form of sacrifice. In fact, Schaverien (1995) expands on this theme in her application of the term 'scapegoat transference' to the patient's relationship with the art-work. Like a scapegoat or sacrificial victim that helps to distance a community from its own violence, and ostensibly raise its consciousness to a higher level of spiritual awareness, the artwork performs a similar function for the creator on an individual level. It serves as a vehicle for the transference of inner, unconscious, and potentially disturbing aspects of the self into objectified form, safely removed from the creator. Schaverien explains that this process of transference from inner to outer form parallels the crossing of unconscious material into consciousness, or of undiffer-entiated chaos into symbolism. In the art therapy studio, the client's relationship with the art objects may assume overtly sacrificial tones, as was apparent in all of the cases described in the previous chapters. Mary's decapitation and mutilation of her clay figure, Kate's castrating attacks on the 'cupcake', and Eric's successive destruction of babies all exemplify the extraordinary power of the artist to change, obliterate, or destroy the artwork, or parts of it, representing the self or parts of the self. When aspects of self are thus projected into the artwork rather than upon the therapist, there is less threat of damage occurring to the therapeutic relationship. There is less need for the client to turn sadistic rage back upon

himself, either through self-mutilating episodes or transformation of the therapist into a sadistic persecutor.

The art therapist, of course, must be able to tolerate the destructive cycle of the creative process and must sense when to support destruction and when to intervene to promote constructive development. The ability to work with, rather than against, violence is a necessary attribute for the therapist working with self-mutilating clients. This is certainly never easy; but in a modality such as art therapy, it can be approached with care, in a way that becomes more manageable for both therapist and patient.

Conclusion

The following quote is from an article in *Art in America* entitled 'The dynamics of destruction', describing the way that sculptor Peter Voulkos uses aggression as a formal element of expression.

> Harnessing destruction as a creative force, he focuses on the character of clay in the course of its breaking up – its cracks, edges, flaws and fragments. He tests it to see what it will do, how far he can pile it up before it collapses, making of the drama of crumble and fall its vista and vocabulary. The heaving surfaces evoke earthquakes or volcano spills. Voulkos sheds new light on the role of the clay itself, highlighting its compelling possibilities as a material of transformative power. (Slivka 1999, p.85)

Voulkos leaves cracks, crumbles, collapses, and markings intact upon the finished sculptures, reflecting a battle undergone by the artist in the process. The description of the artist's relationship with the material is evocative of a similar war waged by the self-mutilating person upon his body – it being used as a plastic sculptural material capable of evoking transformation. The affinity shown by these patients for the clay medium, in the examples discussed in this book, is perhaps not coincidental. The potential of the clay *as a material of transformative power* is not lost upon these self-mutilating clients. Their experiences in art therapy helped them to focus and further develop what may be described as an especially powerful impetus toward *harnessing destruction as a creative force*.

Transformation has throughout this discussion been the goal for the achievement of which intentional, willful violence is perpetrated. In chapter 1, the concepts of good and bad violence were related to the belief in violence as a cure for violence. In this case, violence channeled by the community as a group toward a scapegoat had the effect of purging the

185

community of uncontrolled violence among its members. This splitting of violence into good and bad partners paralleled the splitting of the sacrificial victim into good and bad aspects, the thoroughly guilty and the purely divine. Sacrifice effected the transformation of the victim into a venerated deity, or of bad into good.

Self-mutilation used in individual and unconscious forms of sacrifice may also aim to transform bad into good, or guilt into purity. In the latter case, guilt about sexual desires and fantasies, particularly of an incestuous nature, is cleansed through self-inflicted suffering. Self-mutilation may be used as a symbolic form of self-castration to prevent, at least in unconscious fantasy, feared retaliation for incestuous fantasies. Self-inflicted wounding serves the purpose of protecting against the greater threat of castration, while allowing an indirect indulgence in the illicit desire. The connection between sacrifice, self-mutilation and castration anxiety was alluded to in the two examples of communal sacrifice described at length in chapter 1. Both of these, the Mapuche sacrifice and the Lakota sundance, were enacted in the presence of an upright center pole of great sacred importance. It may be farfetched to conclude that the upright tree represented a phallic symbol; yet this would seem likely if the ritual were seen as a ritual castration. The traditional Lakota sundance, for which extensive historical details are available, included many aspects suggestive of parallels to ritual castration and genital mutilation. For example, feigned attacks on the tree, including the severing of its 'limbs' and smearing of red paint on the 'wounds' simulated castration. A sexual connotation to the rite is suggested by the fact that only women were allowed the honor of cutting down the tree. As a sacred object, it had to be carried to the ritual site and erected in position without being touched to prevent contamination by human hands. The sundancers endured days of self-torture and mutilation, some connected to the pole by ropes in the most extreme form of sacrifice and veneration. This entire drama seems to describe a vilified, castrated phallus that was somehow purified or magically replaced by the multitude of acts of self-mutilation occurring around its base.

While Russel Means explains that the sacrifices and self-mutilations endured by contemporary sundancers are intended to venerate women by symbolizing the pain of childbirth (Wideman 1995), it is possible that the ritual also has an unconscious motive to protect men against becoming

women. The symbolic castration is given in payment for protection against actual castration. Early psychoanalytic views on castration anxiety in women were discussed in Chapter 2, including possible reactions to a girl's realization of having been 'castrated' and defensive postures toward this knowledge such as the unconscious creation of an 'illusory penis'. In Mary's sculpture, described in Chapter 3, a sacrificed and resurrected figure was placed next to a phallus-like tree, in a surprising and subtle similarity to the sundance ritual in which a sacrificial figure 'dances' next to a tree. Castrating urges were frequently alluded to in Kate's process, discussed at length in Chapter 4. Her relationship with the 'cupcake' included mutilation of the entire object, as well as destruction and restoration of the tiny phallic tip of the object.

Self-mutilation from a noncultural standpoint may be used to reverse guilt feelings, but may also be used to transform bad into good in another sense. When a person's self-injury deflects aggression that is meant for another back to the self, the sacrifice that takes place magically transforms the other from bad to good. This is because the self-injurer chooses to set himself up as the bad one, in other words as a substitute sacrificial victim. This 'selfless' act magically purifies him, reversing him once again to a position of good. A side gratification may be gained if the other is made to feel guilty in the process; thus the original aggression finds its target in a less direct fashion. However, at a fundamental level of relating, there may be a strong need to maintain an illusion of the other as good and the self as bad. For a young child, the reality that a parent does bad things to her may be too shattering to endure. Her natural narcissism protects her by assuming that she must be the cause of these bad things. This preserves her parent as benevolent and intact as a caregiver. In this way, the transformation of the parent from bad to good through a sacrifice of the self is parallel to the manner in which the greater culture forms idealized gods and icons through the sacrifice of substitute victims.

Sometimes the god image is double, a combination of opposing elements such as mortal and immortal, human and divine, or bad and good. It may come to mean a union of opposites into an integrated whole, and may be represented by symbols such as the Janus-faced god or the yin/yang icon. The capacity of a symbol for containing and representing opposites simultaneously is key in the resolution of conflicts of splitting and ambivalence. A symbolic form occurs originally through a splitting up

of undifferentiated matter into a figure and ground relationship, and the symbol comes to represent the different parts, and the unified whole. The symbol is a concept, a mental double, that can be applied over and over to make sense out of chaos or undifferentiation. It is a visual key that breaks chaos down into manageable parts and then puts the pieces back together to make sense out of the whole. In a sense, sacrifice follows a similar process by breaking down violence into good and bad, and then reuniting these opposites within the transcendent deity. The sacrificial victim, although a direct substitute for something else, has symbolic qualities in that it embodies both similarity to and difference from the original target of aggression. Yet the victim is only a stage in the process of becoming whole, transcendent, and invested with meaning.

Meaning is power. How the sacrificial victim moves into a position of power is through the acquisition of meaning. It is not enough to reverse roles temporarily with an abuser, for both are ultimately victims of an unending struggle for power. Authentic power can be achieved through the creation of a transcendent experience, or vision, that can contain the opposites, bit players, split-off fragments, and irrational juxtapositions in a cohesive whole. It is in this process that art therapy can help a self-mutilating patient by providing the tools and the milieu to promote the development of creative and symbolic capacities. It may not always be pretty, or neat, because destruction, separation, violence, dismemberment, and victimization can enter into the process at appropriate stages. The sculptor Peter Voulkos, despite international recognition, has had difficulty being accepted by museums and collections in the USA because of the violent aspects of his work. Yet the historical example of the Lakota sundance illustrates the pitfalls of trying to 'confine and...civilize' the natives (Holler 1995, p.111). Ritual sacrifice has reappeared with renewed violence in contemporary times, along with a similar resurgence of ritual violence in the mass culture and fashion of piercing and tattooing. Eric, in his resistance to the construction of confining walls and civilized behavior within them, illustrated the delicacy with which a therapist must proceed in honoring a client's need for violent solutions along the path to creativity and wholeness. With patients that engage in self-abusive behaviors, a philosophy to 'confine and civilize' may serve only to increase the sense of powerlessness and victimization. The introduction of options for expressive development that do honor the patient's entire spectrum of

capabilities and drive energies will ultimately lead to an increase in authentic power, as the patient begins to break down threatening urges and sensations into manageable parts, and to reconstruct these into meaningful symbols.

Constructive activity is fed by the erotic drive, which is in turn nurtured and strengthened as creativity grows. Whether a death instinct exists and drives self-destructive behavior, or whether self-abuse stems from aggression reversed as a defensive measure against guilt, fear of retaliation, or loss of affection, it can only help that the erotic drive be strengthened accordingly. The erotic drive will intervene to ameliorate destructive tendencies by delaying gratification of sadistic urges and even transforming them into symbolic forms through the process of sublimation. If this can be accomplished through a combined process of nurturing artistic expression and appreciation, alongside the development of ego strengths, much can be done to move a patient from a position of victimization to one of increased power.

Art is healing, or not. Art doesn't care whether a person is healed or not; and certainly an artist may not want to be healed. Artists can, and do, self-destruct. Self-destruction may be used in the context of artistic expression; whether this is healing or not depends upon the artist's intent. Self-mutilation may in some cases transcend its destructive intent in the achievement of an aesthetic goal. It takes a certain awareness and strength of desire to reach this level of expression in the exercise of violent urges. Most self-mutilating patients are far from possessing the emotional and cognitive tools to transform aggression with love. They self-mutilate because it is the best way they have learned to care for themselves. They may be attracted to art materials and processes simply as instruments and vehicles of aggression. In the beginning, it is with the therapist's caring that art can become a healing force. The therapist cares by providing the interventions and structure that will help direct the indifferent flow of art into channels that are at least slightly more constructive than destructive. In this process, the self-mutilating patient begins to want to care for herself differently. She allows herself to be cared for, so that she can learn by example how to direct the flow of constructive and destructive energies. This process amounts to the gradual strengthening of her individual and separate ego, and the transformation from victimization to power. If it means separation from a symbiotic union, it also means the acquisition of

the ability to reconnect on her own terms. Art can enter into the building of bridges to cross the unthinkable abyss. It is not easy; but in the presence of a caring therapist that knows the language of art and art therapy, relatively safe crossings between isolated worlds may occur. With time, the abysses and bridges may come to form a network of friendly spaces that connect and separate within a greater scheme of meaning.

Afterword

Mary completed high school and moved by herself to a distant area of the country, where she was at least considering attending college, according to informal reports from the clinic. She is also reported to have begun decorating her body with multiple piercings.

Kate moved to a group home for mentally ill young adults when she passed the age limit for the day treatment program.

At the time of writing, Eric continues to be seen in individual art therapy sessions. He has shown steady improvement, both in behavior and in development of symbolic capacities. His mother reported that over the summer following the sessions described in Chapter 6, Eric began to create recognizable forms with his erector set. During the next fall, he spontaneously began to create delicately detailed clay figures and airplanes in art therapy sessions. He has begun to talk more profusely, expressing feelings of anger, aggression, anxiety and fear directly in words. Although the theme of warfare continues to dominate the sessions, Eric now spends most of the session time in calm and focused creative activity. This activity usually builds up to an ultimately destructive climax, in which the figures are destroyed in the last few moments in a very brief war. He no longer assigns to the therapist the role of aggressor; instead, he invites her to join with him on the side of the 'good guys' against pretend aggressors. He is beginning to allow certain pieces to be saved intact for drying, firing and painting at a later date. Eric's performance in the classroom has also changed dramatically. He is making friends, is trying to keep up with schoolwork, and is concentrating on acting in a mature manner. For his efforts, he is receiving and accepting positive attention both at home and at school.

References

American Psychiatric Association (1994) *Diagnostic and Statistical Manual Disorders* (4th edition). Washington, DC: American Psychiatric Association.

Asch, S. (1971) 'Wrist scratching as a symptom of anhedonia.' *Psychoanalytic Quarterly 40*, 603–617.

Asch, S. (1988) 'The analytic concepts of masochism: A reevaluation.' In R.A. Glick and D.I. Meyers (eds) *Masochism: Current Psychoanalytic Perspectives.* Hillsdale, NJ, and London: The Analytic Press.

Berger, J. (1972) *Ways of Seeing.* London: British Broadcasting Corporation and Penguin Books.

Berliner, B. (1958) 'The role of object relations in moral masochism.' *Psychoanalytic Quarterly 27*, 38–56.

Bernstein, I. (1983) 'Masochistic pathology and feminine development.' *Journal of the American Psychoanalytic Association 31*, 467–486.

Bick, E. (1986) 'Further considerations on the function of the skin in early object relations.' *British Journal of Psychotherapy 2*, 4, 292–299.

Blos, P. (1962) *On Adolescence: A Psychoanalytic Interpretation.* New York: The Free Press.

Bradford, D.T. (1990) 'Early christian martyrdom and the psychology of depression, suicide, and body mutilation.' *Psychotherapy 27*, 1, 30–41.

Briere, J. and Gil, E. (1998) 'Self-mutilation in clinical and general population samples: Prevalence, correlates and functions.' *American Journal of Orthopsychiatry 68*, 4, 609–620.

Carr, C. (1997) 'The pain artist.' *The Village Voice*, November 18, p.27.

Carr, C. (1998) 'Monsters from the id.' *The Village Voice*, May 26, p.67.

Cash, T. and Pruzinsky, T. (eds) (1990) *Body Images: Development, Deviance and Change.* New York and London: Guilford Press.

Cooper, A.M. (1988) 'The narcissistic-masochistic character.' In R.A. Glick and D.I. Meyers (eds) *Masochism: Current Psychoanalytic Perspectives.* Hillsdale, NJ, and London: The Analytic Press.

Deri, S. (1984) *Symbolization and Creativity.* Madison, CT: International Universities Press.

Deutsch, H. (1930) 'The significance of masochism in the mental life of women.' *International Journal of Psycho-Analysis 11*, 48–60.

Doctors, S. (1981) 'The symptom of delicate self-cutting in adolescent females: A developmental view. In S.C. Feinstein, J.G. Looney, A.Z. Schwartzberg and A.D. Sorosky (eds) *Adolescent Psychiatry*. Chicago: University of Chicago Press.

Favazza, A.R. (1987) *Bodies Under Siege*. Baltimore: Johns Hopkins University Press.

Favazza, A.R. (1989) 'Normal and deviant self-mutilation.' *Transcultural-Psychiatric Research Review 26*, 2, 113–127.

Favazza, A.R. (1998) 'The coming age of self-mutilation.' *The Journal of Nervous and Mental Disease 186*, 5, 259–268.

Frazer, J.G. (1922) *The Golden Bough*. New York: Macmillan.

Freud, A. (1946) *The Ego and the Mechanisms of Defence*. New York: International Universities Press.

Freud, A. (1972) 'Comments on aggression.' *Journal of Psycho-Analysis 53*, 163–171.

Freud, S. (1905) 'Three essays on the theory of sexuality.' In J. Strachey (ed) (1961) *Standard Edition of the Complete Psychological Works of Sigmund Freud*. London: Hogarth Press and the Institute of Psycho-Analysis.

Freud, S. (1924) 'The economic problem of masochism.' In J. Strachey (ed) (1961) *Standard Edition of the Complete Psychological Works of Sigmund Freud*. London: Hogarth Press and the Institute of Psycho-Analysis.

Freud, S. (1927) 'Fetishism.' In J. Strachey (ed) (1961) *Standard Edition of the Complete Psychological Works of Sigmund Freud*. London: Hogarth Press and the Institute of Psycho-Analysis.

Galenson, E. (1988) 'Precursors of masochism.' In H.P. Blum (ed) *Fantasy, Myth and Reality: Essays in Honor of Jacob A. Arlow*. Madison, CT: International Universities Press.

Gedo, J.E. (1988) 'Masochism and the repetition compulsion.' In R.A. Glick and D.I. Meyers (eds) *Masochism: Current Psychoanalytic Perspectives*. Hillsdale, NJ, and London: The Analytic Press.

Gilligan, C. (1982) *In a Different Voice*. Cambridge, MA, and London: Harvard University Press.

Girard, R. (1977) *Violence and the Sacred*. Baltimore and London: Johns Hopkins University Press.

Glenn, J. (1984) 'Psychic trauma and masochism.' *Journal of the American Psychoanalytic Association 32*, 357–386.

Greenacre, P. (1953) 'Certain relationships between fetishism and the faulty development of the body image.' In P. Greenacre (1971) *Emotional Growth*. New York: International Universities Press.

Greenacre, P. (1969) 'The fetish and the transitional object.' In P. Greenacre (1971) *Emotional Growth*. New York: International Universities Press.

Greenacre, P. (1970) 'The transitional object and the fetish: With special reference to the role of illusion.' In P. Greenacre (1971) *Emotional Growth*. New York: International Universities Press.

Haeseler, M.P. (1991) 'Finding a voice: Art therapy with eating disordered clients.' Paper presented at the University of Bridgeport Art Therapy Lecture Series.

Haj, F. (1970) *Disability in Antiquity.* New York: Philosophical Library.

Hawton, K. (1990) 'Self-cutting: Can it be prevented?' In K. Hawton and P. Cohen (eds) *Dilemmas and Difficulties in the Management of Psychiatric Patients.* New York: Oxford University Press.

Herman, J.L. (1992) *Trauma and Recovery.* New York: Basic Books.

Hermann, I. (1976) 'Clinging – going in search: A contrasting pair of instincts and their relation to sadism and masochism.' *Psychoanalytic Quarterly 45*, 1, 5–36.

Hewitt, K. (1997) *Mutilating the Body: Identity in Blood and Ink.* Bowling Green, OH: Bowling Green State University Popular Press.

Holler, C. (1995) *Black Elk's Religion.* Syracuse, NY: Syracuse University Press.

Kafka, J.S. (1969) 'The body as transitional object.' *British Journal of Medical Psychology 42*, 207–212.

Klein, M. (1930) 'The importance of symbol formation in the development of the ego.' In J. Mitchell (ed) (1986) *The Selected Melanie Klein.* New York: The Free Press.

Kohut, H. (1977) *The Restoration of the Self.* New York: International Universities Press.

Kramer, E. and Schehr, J. (1983) 'An art therapy evaluation session for children.' *American Journal of Art Therapy 23*, 3–12.

Kris, E. (1952) *Psychoanalytic Explorations in Art.* Madison, CT: International Universities Press.

Kwawer, J.S. (1980) 'Some interpersonal aspects of self-mutilation in a borderline patient.' *Journal of the American Academy of Psychoanalysis 8*, 2, 203–216.

Lev-Wiesel, R. (1999) 'The use of the machover draw-a-person test in detecting adult survivors of sexual abuse: A pilot study.' *American Journal of Art Therapy 37*, 4, 106–112.

Levy, G.R. (1948) *The Gate of Horn.* London: Faber and Faber.

Lorenz, K. (1966) *On Aggression.* San Diego, New York, and London: Harcourt, Brace, Jovanovich.

Mahler, M., Pine, F. and Bergman, A. (1975) *The Psychological Birth of the Human Infant.* New York: Basic Books.

Mendieta, A. (1993) *A Book of Works.* Miami: Grassfield Press.

Menninger, K.A. (1938) *Man Against Himself.* New York: Harcourt, Brace.

Meyers, H. (1988) 'A consideration of treatment techniques in relation to the functions of masochism.' In R.A. Glick and D.I. Meyers (eds) *Masochism: Current Psychoanalytic Perspectives.* Hillsdale, NJ, and London: The Analytic Press.

Miller, D. (1994) *Women Who Hurt Themselves.* New York: Basic Books.

Modell, A.H. (1970) 'The transitional object and the creative act.' *Psychoanalytic Quarterly 39*, 2, 240–250.

Molderings, H. (1984) 'Life is no performance: Performance by Jochen Gerz.' In G. Battcock and R. Nickas (eds) *The Art of Performance.* New York: E.P. Dutton.

Nacht, S. (1965) 'Le masochisme, introduction.' In M. Hanly (ed) (1995) *Essential Papers on Masochism.* New York: New York University Press.

Niederland, W.G. (1967) 'Clinical aspects of creativity.' *American Imago 24*, 6–34.

Orgel, S. (1974) 'Fusion with the victim and suicide.' *International Journal of Psycho-Analysis 55*, 531–538.

Paffrath, J. (ed) (1984) *Obsolete Body/Suspensions/Stelarc.* Davis, CA: JP Publications.

Pao, P. (1969) 'The syndrome of delicate self-cutting.' *British Journal of Medical Psychology 42*, 195–206.

Radin, P. (1957) *Primitive Religion.* New York: Dover.

Rado, S. (1933) 'Fear of castration in women.' *Psychoanalytic Quarterly 2*, 425–475.

Rank, O. (1958) 'The double as immortal self.' In O. Rank *Beyond Psychology.* New York: Dover.

Richards, A.D. (1988) 'Self-mutilation and father–daughter incest: A psychoanalytic case report.' In H. Blum, Y. Kramer, A.K. Richards and A.D. Richards (eds) *Fantasy, Myth, and Reality.* Madison, CT: International Universities Press.

Sanders, C.R. (1989) *Customizing the Body.* Philadelphia: Temple University Press.

Sarnoff, C.A. (1988) 'Adolescent masochism.' In R.A. Glick and D.I. Meyers (eds) *Masochism: Current Psychoanalytic Perspectives.* Hillsdale, NJ, and London: The Analytic Press.

Schafer, R. (1988) 'Those wrecked by success.' In R.A. Glick and D.I. Meyers (eds) *Masochism: Current Psychoanalytic Perspectives.* Hillsdale, NJ, and London: The Analytic Press.

Schaverien, J. (1995) *Desire and the Female Therapist.* London and New York: Routledge.

Schneemann, C. (1979) *More Than Meat Joy.* New York: Documentext.

Schneider, R. (1997) *The Explicit Body in Performance.* London and New York: Routledge.

Scutt, R. and Gotch, C. (1974) *Art, Sex and Symbol.* South Brunswick and New York: A.S. Barnes and Co.

Shapiro, S. (1987) 'Self-mutilation and self-blame in incest victims.' *American Journal of Psychotherapy 51*, 1, 46–54.

Simpson, M.A. (1980) 'Self-mutilation as indirect self-destructive behavior.' In N. Faberow (ed) *The Many Faces of Suicide.* New York: McGraw-Hill.

Siomopoulos, V. (1974) 'Repeated self-cutting: An impulse neurosis.' *American Journal of Psychotherapy 28*, 1, 85–95.

Slivka, R. (1999) 'The dynamics of destruction.' *Art in America 87*, 1, 84–89.

Smith, P. (1994) *Dark Night.* Exhibition catalog. New York: A.I.R. Gallery.

Spero, N. (1992) 'Tracing Ana Mendieta.' *Artforum 3*, 8, 75–77.

Tansley, D.V. (1984) *Subtle Body: Essence and Shadow.* New York: Thames and Hudson.

Thunder, M.E. (1995) *Thunder's Grace.* Barrytown, NY: Station Hill Press.

Tierney, P. (1989) *The Highest Altar.* New York: Viking Penguin.

Vale, V. and Juno, A. (1989) *Research # 12: Modern Primitives.* San Francisco, CA: V/Search Publications.

van der Kolk, B.A. (1996) 'The complexity of adaptation to trauma self-regulation, stimulus discrimination, and characterological development.' In B.A. van der Kolk,

A.C. McFarlane and L. Weisaeth (eds) *Traumatic Stress: The Effects of Overwhelming Experience on Mind, Body and Society.* New York: Guilford Press.

van der Kolk, B.A. (1997) Lecture given at the Jewish Board of Family and Children's Services, May 14, New York.

van der Kolk, B.A., Perry, J.C. and Herman, J.L. (1991) 'Childhood origins of self-destructive behavior.' *American Journal of Psychiatry 148*, 12, 1665–1671.

Wideman, J.E. (1995) 'Russel Means.' *Modern Maturity*, September-October issue, 68–79.

Winnicott, D.W. (1953) 'Transitional objects and transitional phenomena.' *International Journal of Psycho-Analysis 34*, Part II and In D.W. Winnicott (1958) p.89–97 *Collected Papers: Through Paediatrics to Psychoanalysis.* London: Tavistock Publications.

Wojcik, D. (1995) *Punk and Neo-Tribal Body Art.* Jackson: University Press of Mississippi.

Woods, J. (1988) 'Layers of meaning in self-cutting.' *Journal of Child Psychotherapy 14*, 51–60.

Yaryura-Tobias, J.A., Neziroglu, F. A. and Kaplan, S. (1995) 'Self-mutilation, anorexia, and dysmenorrhoea in obsessive compulsive disorder.' *International Journal of Eating Disorders 17*, 1, 33–38.

Zusne, L. and Jones, W.H. (1989) *Anomalistic Psychology: A Study of Magical Thinking.* Hillsdale, NJ, and London: Lawrence Erlbaum Associates, Publishers.

Subject Index

Author
Index